THE FASHION
PHOTOGRAPHER

THE FASHION
PHOTOGRAPHER

ROBERT FARBER

WITH DONALD GODDARD

Documentary Photographs by Judith Asher

Amphoto
American Photographic Book Publishing
An imprint of Watson-Guptill Publications
New York, New York

Paperback Edition
First Printing 1984

First published 1981 in New York by American Photographic Book
Publishing, an imprint of Watson-Guptill Publications,
a division of Billboard Publications, Inc.,
1515 Broadway, New York, N.Y. 10036

Library of Congress Catalog Card Number: 81-10989
ISBN 0-8174-3850-5
ISBN 0-8174-3852-1 pbk.

Distributed in the United Kingdom by Phaidon Press Ltd.,
Littlegate House, St. Ebbe's St., Oxford

Printed in Hong Kong

1 2 3 4 5 7 8/89 88 87 86 85 84

"One man's fantasy is another man's job."

To the industry for making it all possible. . .

and to little Lee.

—Robert Farber

I would like to thank the following people for their help in making this book possible:

Judith Asher	Robert Houseman	Janet Rogler
Bill Berta	Beverly Johnson	Ken Roupenian
Bob Billings	Harvey Kahn	Royce Graphics
Leland Bobbé	Lily Kimmel	Anne M. Russell
Lynn Brooks	Harry King	Bill Ryan
Geri Carranza	Stan Kovics	Jack Scalia
Lawrine Childers	Leslie Kramer	Tom Smallwood
Gloria Chu	Gary Lawe	Tui Stark
Wendy D'Amico	David Leddick	Dr. Jerry Stolt
Raina Domevich	Alexander Liberman	Joseph Strear
Rusty Donovan	Jackie McCord	Tekno/New York
Leah Feldon	Brian Mercer	Guergen Thiessen
Eileen Ford	Debbie Milbrath	Edward Tricomi
Larry Fried	Joey Mills	Beth Vogel
Joanne Gindek	Kay Mitchell	Susan Wood
Don Goddard	Pam Moffat	Allan Zackary
Karen Graham	Robert Norwood	Zoli
Mike Green	Michael O'Connor	and the bookers of:
Ellen Greene	Monique Pillard	Elite
Patti Hansen	Pinsher Associates	Ford
Maria Hanson	Ed Pluzynski	Legend
Karen Hilton	Victor Podesser	Wilhelmina
Pam Hoffman	Leonard Restivo	Zoli

C O N T E N T S

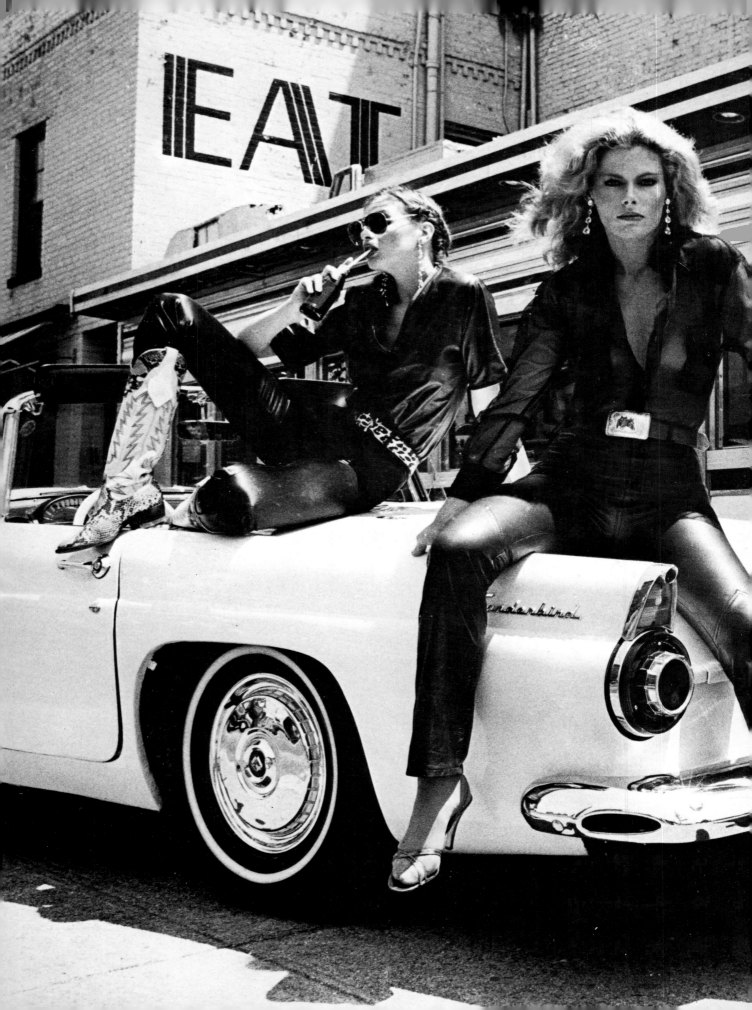

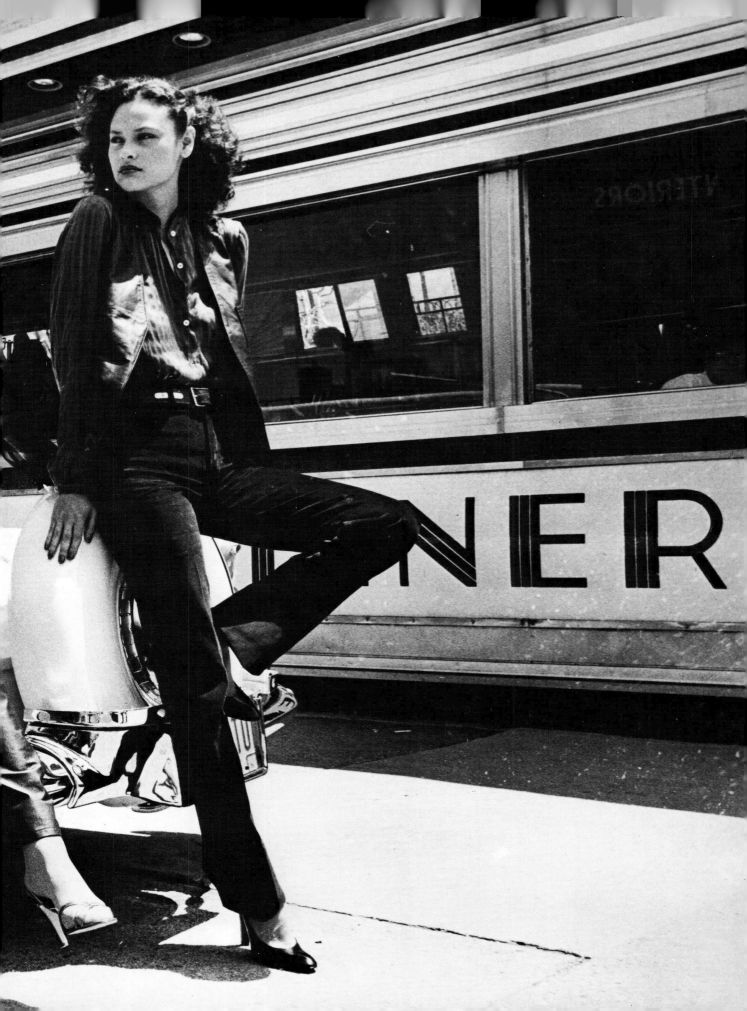

INTRODUCTION

In my earlier book, *Professional Fashion Photography*, I attempted to give the reader an inside view of a field that previously had been written about only in technical terms. I was concerned with questions that young photographers had asked me and that I myself had asked when I first began to photograph fashion—questions about the differences between editorial and advertising fashion; developing and dealing with clients; putting a shooting together; working with models, stylists, hair stylists, and makeup artists; shooting in the studio and on location; and creating a portfolio and presenting the finished work. Along the way I described the roles played by fashion editors, art directors, creative directors, clients, advertising executives, models, stylists, makeup artists, hair stylists, assistants, and others with whom the photographer is involved.

Now I would like to turn the tables and present not only the fashion world as seen by the photographer, but also the fashion world and the photographer himself as seen by some of the most prominent and experienced professionals in the field. Each of them is a creator in his or her own right—of editorial concepts, of advertising images, of beauty, of careers, of line, color, and form in clothes, of hair styles and makeup—so that what finally appears in a fashion photograph is not, as it perhaps once was, the achievement of a single imagination, the photographer's, but of several imaginations working together. What I see as a photographer, how I use light, work with models, and choose locations, what I bring to the job from my own experience is certainly crucial, but the contributions and judgments of others are often equally and sometimes more important, both in creating individual images and in determining the direction and style of images in general.

Into this pool of talent flows a whole range of ideas, approaches, and thinking processes to which I am constantly exposed in my work. They concern not only the working habits and procedures that affect the production of fashion photography, but also the economic, social, personal, and stylistic issues that are part of its very existence. While sharing a common aim that has to do with the creation of the most contemporary and effective images, each participant brings to the task his or her own distinctive point of view concerning many questions that go beyond the work-a-day process of taking pictures. Is fashion photography art? Should it serve an educational purpose or be frankly escapist? How does it reflect changes in cultural attitudes? Are the images of women and men enhanced by the way they are depicted in magazines and ads? How important is sexual appeal? How have ideals of beauty changed?

Then there are practical questions that affect every professional in the field. What do art directors and fashion editors look for in a photographer's portfolio? How do the agencies develop models and what effect can they have on their careers? Are models and others in the field overpaid? Who runs the show at a shooting? Are clients too timid in seeking new photographers, new models, new ideas? How

Striking photography is an integral part of the billion-dollar fashion industry. The images that spring from the cameras and studios of fashion photographers help create—and sell—the latest "look," clothes, and beauty products across the world.

does the star system affect the general climate of fashion and photography? What are the differences between the European and the American approaches? Is it advantageous for a photographer to have an agent and when should he get one? How important is it to change with the times? And, of course, how do the various professionals included in this book function in their own particular fields?

The fact is that fashion photography has packed in a great deal during its seventy-year history and has become increasingly important both as a creative activity and as a means of selling and disseminating ideas about our culture to an ever broader audience. Those who are involved in it have therefore taken on a greater responsibility toward the people they are addressing, and that is what I think comes through, along with a sheer fascination with its dynamics and subject matter, in the comments of those most deeply engaged in the art and business of fashion photography. We are fortunate that this responsibility involves a message of pleasure and beauty, which is sorely needed in our contemporary world.

 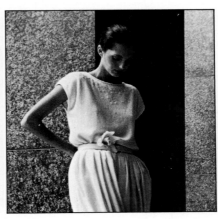 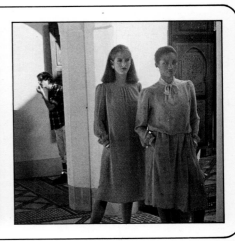

The Client and The Message

The field of fashion photography is enormously complex. Its cachet depends not only on the strength of an image, its evocation of beauty, sensuality, and glamour, but also on the glimpse it offers into the world of fashion itself. Every image of a beautiful woman on a magazine cover or in a cosmetics ad carries with it the mystique, both desirable and remote, of the people who produced it and their somehow magical association with creativity, power, money, and sex. One has a sense of the romance of the business—of breakneck relationships among people and ideas, of liberated life styles and hectic movement—which becomes perhaps the essential ingredient of any given picture's message. That is what we respond to, as much if not more than to the specific image itself, and it is what the advertiser or magazine editor depends on for our response—the range of excitation that the fashion and beauty industries in general, and fashion photography in particular, creates.

Other professions are also endowed with some form of romantic aura. Think of the movies, journalism, or medicine. Even coal mining has its lore and its heroes. Romance is necessary for survival, for escape, for rising above the ordinary, and in this respect it achieves its most extreme expression in fashion photography. In no other profession is the romance and mythology of it so much part of the end product. The reason is to be found, despite the tendency in the 1970s toward realism, in its built-in artificiality. However closely the picture attempts to capture a real-life quality,

there is always the understanding, the precondition, that the situation is unreal, set up, much more so than in the movies or the theater, where we suspend our disbelief in order to partake of a new reality. We always know that the models are posing, that the purpose is to sell or present clothing, jewelry, or cosmetics, and that everything in the picture has been arranged to achieve that purpose to maximum effect. In other words, we do not believe fashion photographs, but we accept them and are fascinated by them for the very reason that they are unreal, out of the ordinary. They represent a world in which it is perfectly normal to be outrageously beautiful and sensual and in control of one's physical and emotional being.

If, as Alexander Liberman suggests later in this book, fashion photography is not art, it is because it depends on too many givens, and because it does not reveal layers of meaning. It is not profound in this sense. Rather, artificiality is the glory of the medium, and it can be a supreme form of creative play in which color, light, form, texture, line, and the human presence are interwoven in a subtle or direct evocation of sensuous beauty. It describes and reflects a very special world, which is in turn connected to the vital functions of commerce in a society dominated by commerce. And we sense that too—the identification of the fashion vision with money and power. Like all advertising media, it is part of the life blood of the nation's business, but as the most refined, dazzling, and distinctively creative branch of it.

Does the romance that we perceive as being inherent in

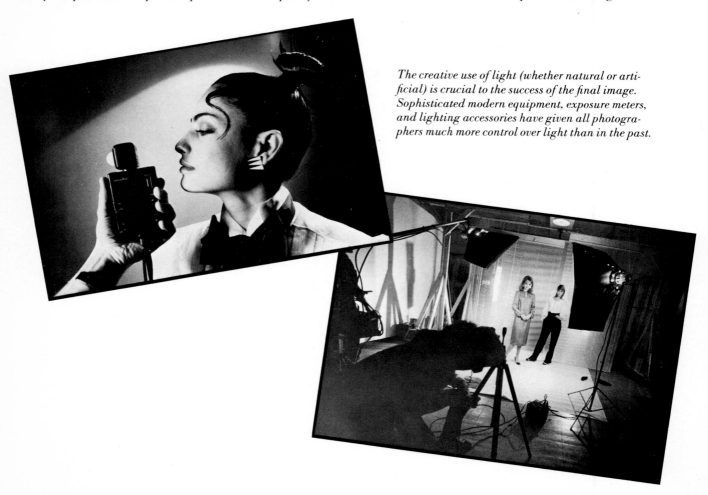

The creative use of light (whether natural or artificial) is crucial to the success of the final image. Sophisticated modern equipment, exposure meters, and lighting accessories have given all photographers much more control over light than in the past.

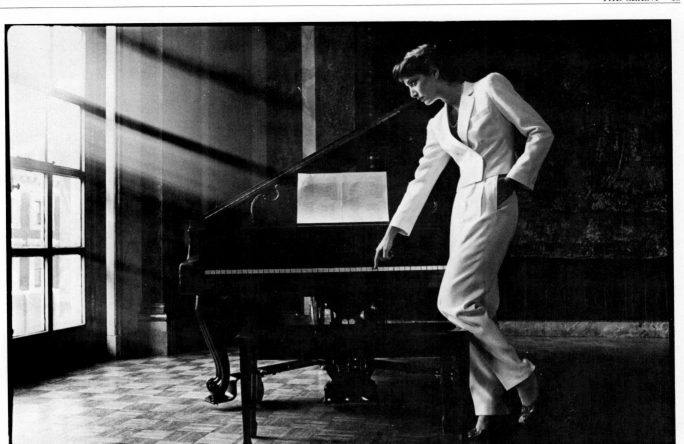

The highly directional quality of the window light in this photograph from an advertisement for Ann Taylor was further emphasized by Farber's use of a filter coated with petroleum jelly to create the light streaks.

fashion photography actually exist? That is difficult to say; one person's romance may be another's job. But all the elements are there; abundant good looks in thousands of models, enormous amounts of money, fame, travel to all parts of the globe for photographic sessions, fast-moving life styles to match the escalating fees of models and other beauty professionals. This is not to suggest that the romance is totally idyllic, nor that everyone involved actually lives at this level of hyperactivity and conspicuous luxury. The consequences of so much money, of people being "on" all the time, of instant stardom, and of misused power can be dire, but the nature of the business remains romantic, whether it is paradise or not.

The other side of the coin, of course, is that the maintenance of this aura of glamour depends on a great deal of short- and long-range planning, attention to cultural trends in general, and a constant influx of new ideas from every profession in the field, from art directors and photographers to hair stylists. The most significant and influential role in keeping the engines of renewal going is played by the editors and art directors of fashion magazines and the creative directors of advertising agencies, the arbiters and philosophers of the field. While photographers may be the initiators and innovators who push the limits of photographic style at any given moment through their own personal visions, it is the editors, creative directors, and art directors who ultimately determine how far and in which direction the

limits can be trespassed in the presentation and dissemination of beauty and fashion pictures. Their choices can be conservative and uninspired, but fortunately for the photographer, and for the public as well, the leaders among them do take risks and are open to new ideas. In fact, they must be to function with the dynamic of change that is endemic to fashion. And since they are the people who hire photographers, it is within the framework of their judgments that a photographer must work out his own vision as it can be expressed in magazines and advertising.

As a young photographer, one approaches such people with some trepidation. But the respect that art and creative directors have for originality and enterprise in photography is usually commensurate with the respect in which they themselves are held. They are, ideally, connoisseurs of creativity, talent, and beauty, and in that sense collaborators with the best that a photographer has to offer. This is not always the case. There are many more run-of-the-mill jobs than ones that encourage originality. But even these require sensitivity and flair. If a client wants simply to give "fashion information," to clearly detail a dress or suit without creating a stunning image, that is an important function of the business and should be treated with care. Knowing the requirements of the more mundane jobs and seeing them through with style and professionalism are essential to a photographer's livelihood.

Although some large manufacturers of clothing, jewelry,

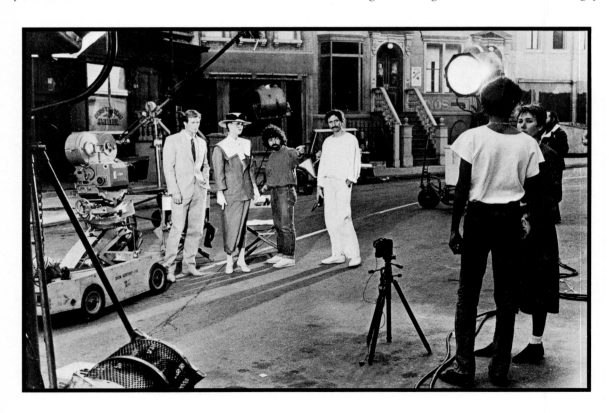

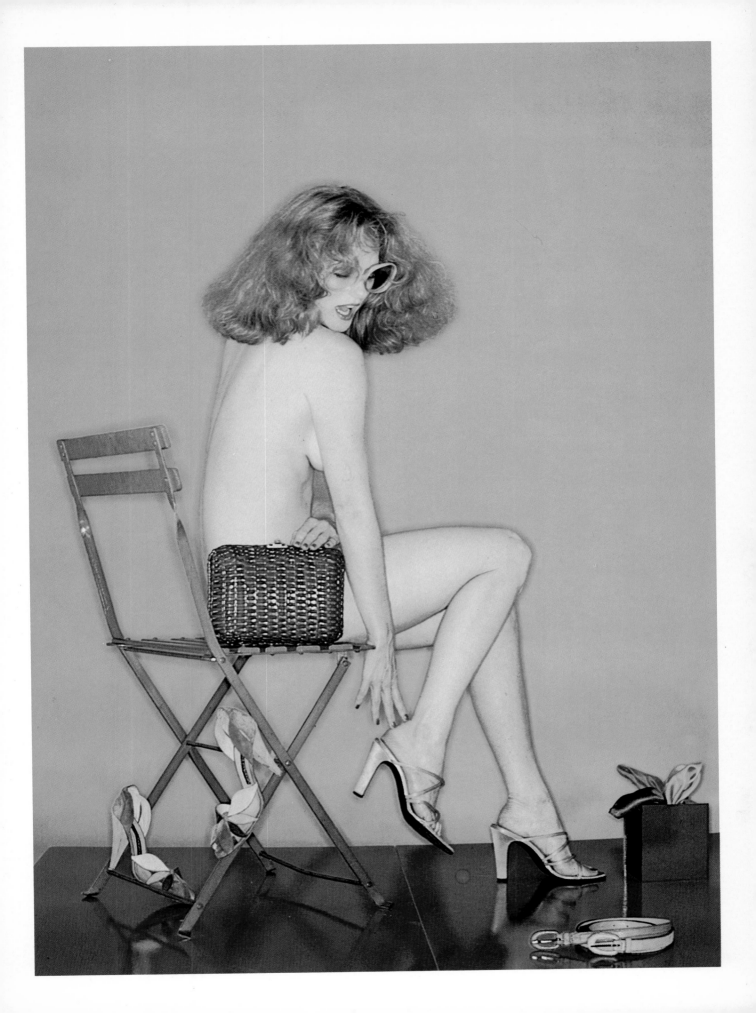

and cosmetics maintain their own in-house advertising staffs, most advertising fashion photography in the United States flows through independent advertising agencies. New York is the center, as it is for the fashion industry as a whole, although there is abundant activity in most cities of any size. In a typical large agency there is a great deal of specialization. Each client works with an account executive, who deals with the business arrangements, and an art director, who handles the creative end. If the account is large enough, it may require the services of several executives and art directors, with a creative director overseeing the entire effort.

The general drift of advertising fashion and beauty is toward the repetition of those formulas that have been successful in the past. Clothing, in particular, is a necessity, and focus on the product is the paramount concern. Clients are often unwilling to go beyond a straightforward presentation in which there is as little distraction from the detailing of the product as possible. The feeling is that the consumer does not want to be encumbered by exotic settings, unusual behavior, and artfully arranged compositions, or the costs may be too great to indulge such effects. The appeal is to practicality, to the direct needs of people. The conservative approach is therefore understandable, especially in comprehensive department store catalogs and newspaper ads, as long as it continues to work.

But times change, and in some cases that approach may not work anymore. The greater diversification of clothing styles, the increasingly active role of women in public life, the greater emphasis on men's fashions, and the introduction of "designer" clothes to a far broader audience, have led many manufacturers to replace the standardized approach with distinctive images and "concepts" that say something about the possible life styles of the people they wish to reach. Department stores such as Saks Fifth Avenue now go to Thailand, Utah, Egypt, and Morocco to achieve a theme in terms of design and location that suggests more than would be possible in the studio. In the cosmetics field, for a company like Revlon, the advertising agency (Grey in this case) develops elaborate scenarios for international print and television ads that support the message being conveyed about a particular perfume or item of makeup. For the fragrance *Jontue*, for instance, creative director David Leddick evolved a series of dreamlike images of models in the French countryside with chateaus, peacocks, and horses to illustrate the concept, "Sensual, but not too far from innocence."

Though the ultimate decision rests with the client, who may or may not be forward-looking, the agencies have become the primary source for fashion and every other kind of advertising over the past twenty-five years. When a photographer takes an advertising job, the idea has usually already been established and the planning done, along with copy and layouts. The photographer may have input, even during the planning stages. Indeed, an ad or campaign may be suggested in the first place by a particular photographer's

The photographer usually shoots a series of test Polaroids before exposing any 35mm film. This gives everyone the opportunity to see how the light really falls, how the background looks, and how the clothes appear, and to make any corrections or alterations on the spot, before a lot of time and film have been expended.

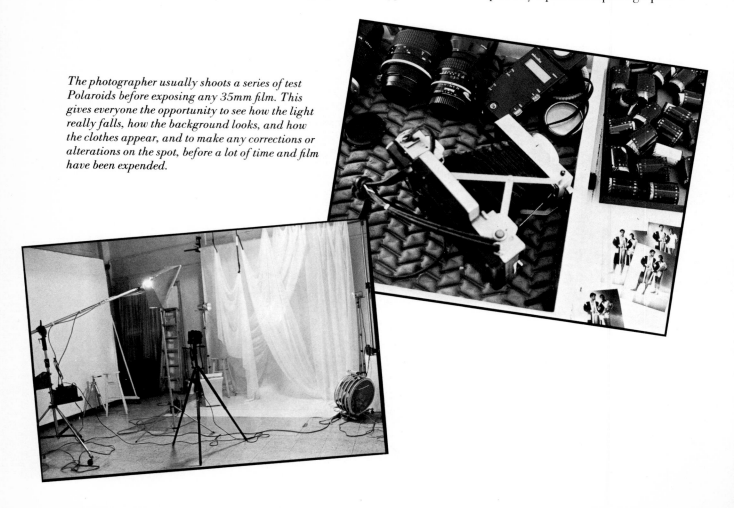

imagery, handling of light, or use of locations. At the very least, he is hired because his approach is appropriate to the job. In addition, though the photographer enters into such situations to carry out ideas that already exist, his own imagination and improvisation is usually crucial to the final outcome, and it is here that the collaboration between art director and photographer can be both creative and rewarding.

Editorial fashion, on the other hand, allows the photographer a good deal more latitude to impose his own style, and to expose a more personal vision. Indeed it is the business of magazine editors and art directors to seek out and reflect the most contemporary styles in fashion itself and in photography. Their publications constitute an international compendium of extraordinarily diversified tastes that serve as a reference for everyone in the field, from fashion designers to stylists. They are international sounding boards for the talents of photographers, models, hair stylists, and makeup artists, and they are sourcebooks for advertising art directors on the lookout for new ideas and new talent unfettered by the demands and restrictions of commercial work. For the photographer and others, they are far less rewarding financially. One might get $250 for a photograph in a fashion magazine that would command $2,000 or $3,000 in an advertising context. But the rewards in terms of prestige, exposure, and freedom of expression more

than compensate if it also leads to jobs in advertising fashion.

Editorial fashion is, however, a function of editorial policy, and this can vary a great deal. In the United States magazines such as *Vogue, Harper's Bazaar, Glamour, Cosmopolitan, Gentlemen's Quarterly*, and *Mademoiselle* are made to appeal to a mass audience, and their emphasis, with significant differences among them, is an education in the everyday aspect of fashion and beauty, as well as, in some cases, health and culture. In Europe, where magazines such as British, Italian, French, and German *Vogue*, French and Italian *Bazaar, Elle*, and *L'Uomo Vogue* are sold to much smaller and more restricted audiences, the appeal is to sophistication and elitism in a way that allows for the more extreme, rarified, and outrageous, even in advertising layouts. But the communication between the two worlds represented by America and Europe is constant, and to professionals in the fashion field both approaches are necessary.

It has been said that the magazines and the advertising agencies have exercised too much control over the expression and direction of photography. The same is now said about models. But in reality the photographer has an enormous range of possibilities and opportunities open to him on an international scale, in both editorial and advertising fashion. It is a matter of priorities, and that no magazine or advertising executive can determine for the photographer.

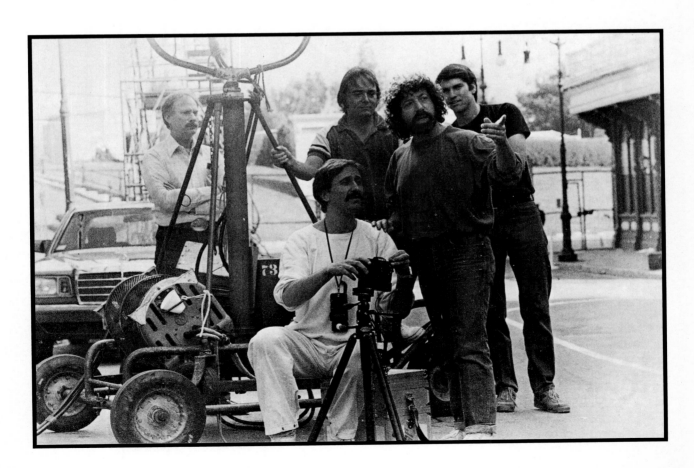

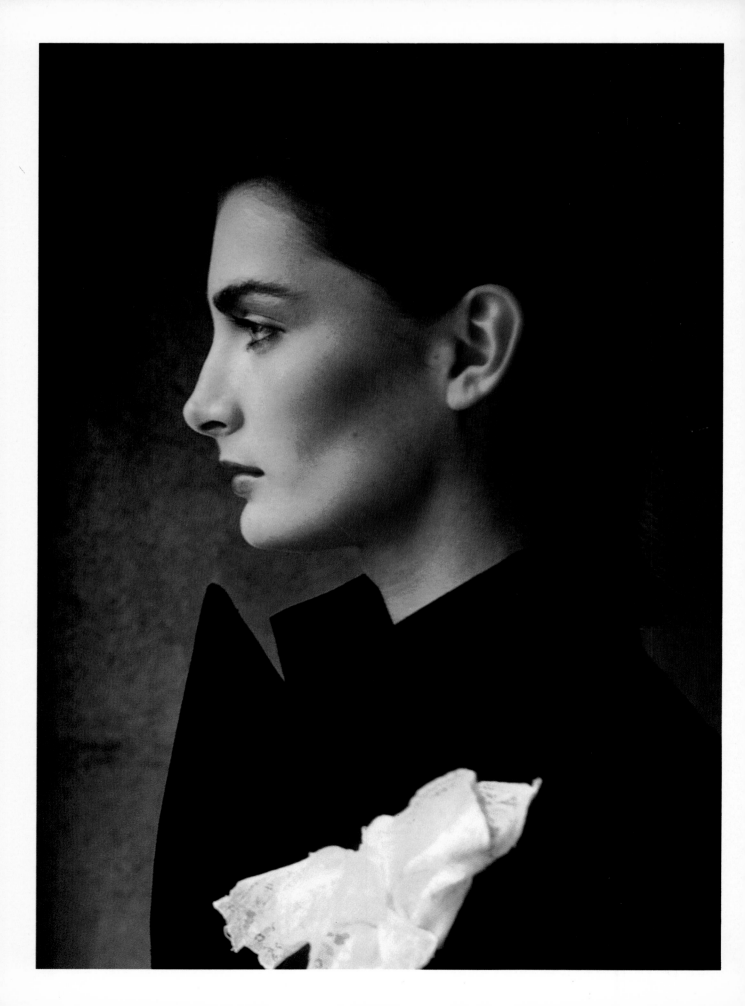

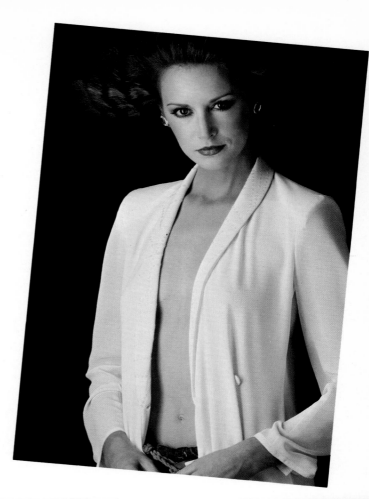

Black-and-white clothes can be surprisingly effective when photographed in color. These pictures of Farber's show that not only is the contrast of tones graphically dramatic but the starkness of the clothes often highlights the delicate tones of the model's skin and hair.

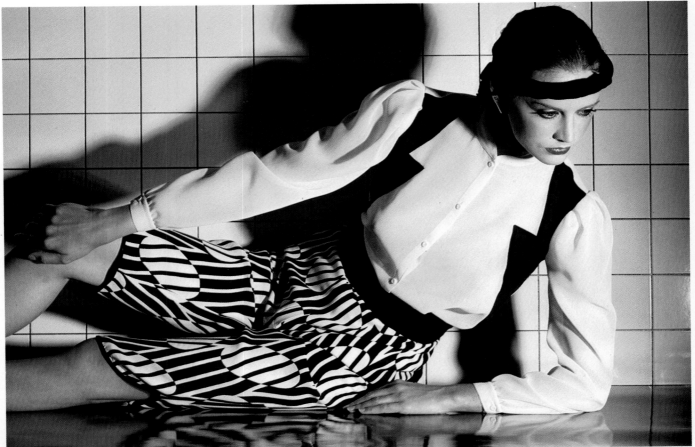

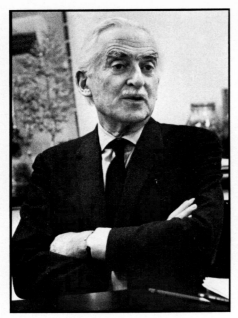

ALEXANDER LIBERMAN

As art director of *Vogue* magazine in the 1940s and 1950s, and as editorial director of all Condé Nast publications since 1962—including seven international versions of *Vogue*, plus *Glamour, Mademoiselle, Self, Gentlemen's Quarterly*, and *Bride's*—Alexander Liberman has exercised an unparalleled influence on the course of fashion photography over the past forty years. Through his auspices most of today's outstanding fashion photographers have gained recognition. It is somewhat daunting that throughout this period he has become and remained one of America's major contemporary artists. His abstract paintings and sculptures are owned by museums of modern art throughout the world, and in recent years he has created a number of imposing monumental public sculptures. As a photographer, he has published two sensitive and penetrating studies of art and artists: *The Artist in His Studio* (1960) and *Greece, Gods and Art* (1968).

How has the nature of fashion photography changed since you first came to Vogue *in the early 1940s?*

Perhaps there is less demand on creativity. I think people today have a clearer judgment of what is art and what is not art, and the period when photographers had ideas has really passed, as far as the magazines are concerned. Reality has sort of taken over. Most photographers who interest us are the ones who can capture women as "modern"—the word that is used today as opposed to "beautiful"—which means to portray women who are part of their time. Photographers are much more modern and aware themselves, and this is what is in demand and what is happening. Art has gone out of the magazines, for better or for worse . . . I think for the better. It was always phony art rather than real art, assuming my premise that basically photography is not an art. It's a different kind of very creative form of expression, which is not necessarily comparable to an established art like painting. The mistake most photographers made for a long time was that they were too involved with aesthetics, and I think the modern photographer is much more involved with catching the reality of life, as if he were penetrating into the intimacy of a woman's life and attitudes. The photographers who are most successful today are quick with a camera. They can portray action. The papparazzi tradition has blossomed into professionals of the papparazzi, which is a marvelous development.

What bothers you about the "arty" approach?

It's slow . . . it's pretentious . . . it's unable to catch what modern clothes and attitudes are meant to convey. Women are no longer treated as clothes hangers; they are treated as human beings. That's why I always prefer to look at contact sheets. Most photographers come in with set pieces—large, carefully printed documents—and I always ask to see the contacts. Because, first of all, you can see much more quickly how an eye and a mind work.

What defines a good or great fashion photographer?

They have to be good photographers first. Anyone who is only a fashion photographer is of very limited value, because he or she is not able to catch reality. Photography that is of real interest is a gamble, a chance; you either catch it or you don't catch it. So I suppose the successful photographers are like baseball players who can hit more often. It comes down to batting averages. It means quickness of eye and quickness of intelligence . . . and also quickness of erotic response. It is something that is difficult to understand. Sometimes photographers come in and they have what look like good portfolios, but why do we pick one instead of the others? They don't always understand. We pick the unexpected, and the unexpected doesn't mean that the girl has to stand upside down or be surrounded by men in masks . . . it means just a wonderful head, like Dorothea Lange's heads for the FSA, or Edward Steichen's heads. Those are memorable, eternal pictures.

How does that kind of talent fit in with the demands of fashion magazines?

To be fair to photographers, the needs of magazines are very diverse. You have some areas where a more important opportunity will be given to the photographer, and then there are other needs that are more commercial, where you have to give the reader certain fashion information. And that takes a different approach, a different breed of photography, to simply portray attractively, in the studio, the look of a certain kind of clothes. It is a separation of abilities. This is where an art director's role comes in. He has to decide not to waste a certain talent where there is no opportunity, where chance to a great extent has to be limited. Then we still need someone who will do it with good taste and technical ability.

So, a magazine art director is basically a little like an orchestra conductor; he has to have several instruments to solve various problems. But, also, one photographer may not like to photograph personalities, or he may not be good at it; one is better with color, another is better with black-and-white; one doesn't like any action, another does. There are many varieties of abilities and inabilities. Some don't like to show clothes or photograph fashion, but then there is beauty photography.

I think that what has happened, to a certain extent, without the photographers themselves even realizing it, is that they are specializing themselves into their own strengths, which is perhaps a very good thing, instead of trying to do everything, they know their own preferences. In the old days *Vogue* had a

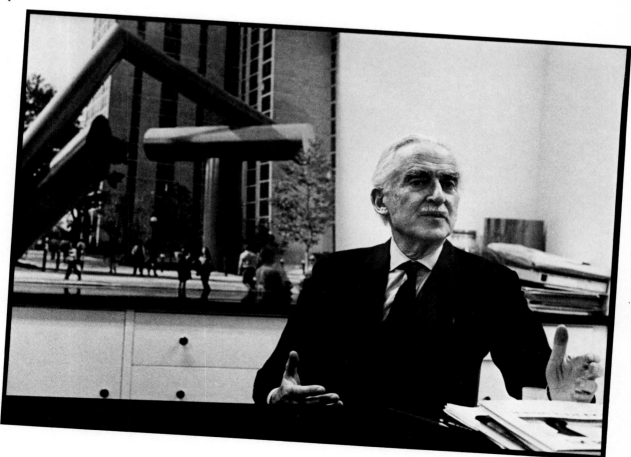

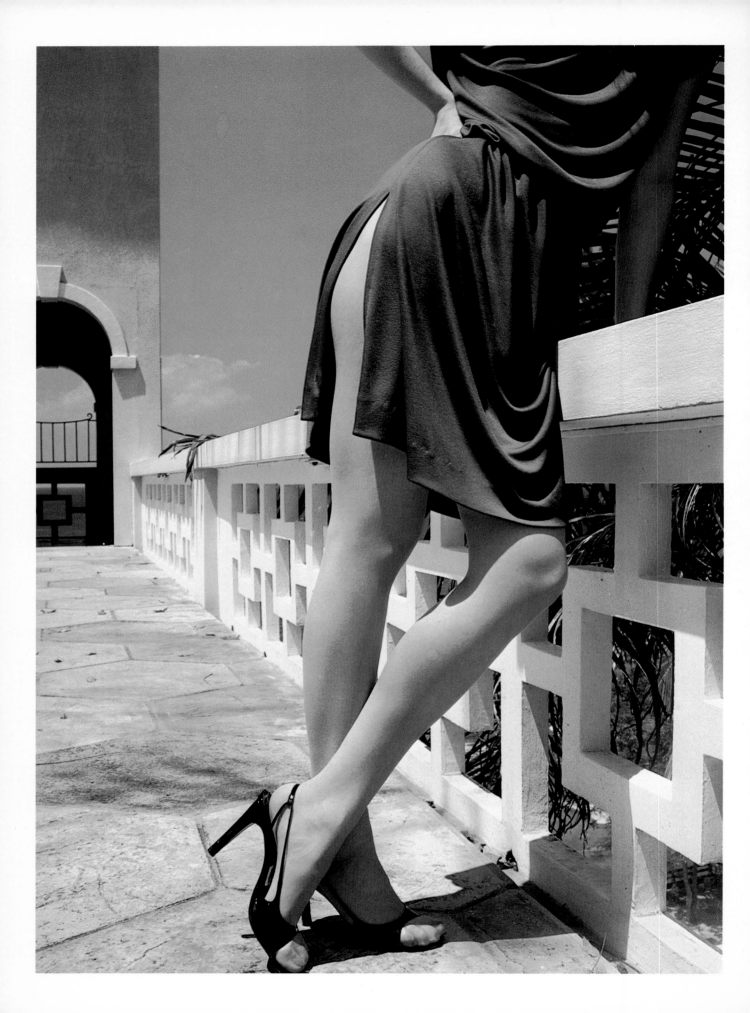

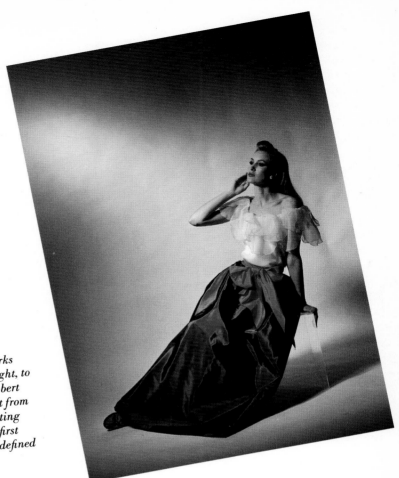

The lighting conditions a fashion photographer works with run the gamut from studio strobe, to natural light, to a combination of both. In the photograph below Robert Farber combined a slow shutter speed with the light from an electronic flash. The result was that both the setting sun and the flash contributed to the exposure—the first making a blurry image, and the second a sharply defined image superimposed over the blur.

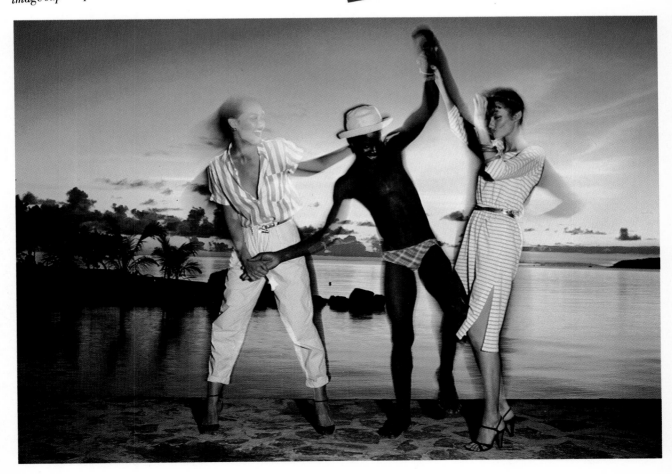

studio of its own. Photographers were hired . . . they were retainers and they were sent things to be photographed. That has changed, and I think very much for the better, because the magazine is now enriched by this variety of abilities and talent. It used to be much more cut-and-dried . . . there's a black dress, an evening dress, there's lingerie, next day there are shoes. Mind you, certain photographers can do it. Others cannot.

How did photography get out of the studio?
I suppose it was partly economics. Very few photographers today can afford a studio. They do it on a group basis or they rent a studio. To set up elaborate sets is impossible. In a way, economics has forced a much more realistic photography. You go into the street to photograph, or you go into somebody's bedroom, or you go on a trip—so there is an entirely different approach to photography.

But things are going to change drastically because travel is becoming prohibitive. On a fashion trip today you have to send an assistant, a makeup artist, a hair stylist, an editor, models—seven or eight people at least—with rooms and planes and cars and whatever other expenses, extraordinary costs . . . it's like a TV production. In the old days there would be one photographer and a model going around the world.

How does the European approach differ from ours?
In Europe you have to face a certain reality. Most magazines have a very limited circulation in Europe. Let's say a magazine might have 50,000 circulation in Europe, and the equivalent here might have millions. So we reach a much wider audience here; and certain high-luxury effects, acceptable in Europe, are certainly not acceptable to a wider mass of readers. It's a more elite audience in Europe, but I don't consider an elite taste, a rich taste, necessarily a better taste. Frankly, it can be a worse taste. And intrinsically, I find, the fact that we have to reach a wider readership does not preclude our reaching a more intelligent readership. This is what has happened to *Vogue* and certain other magazines, where a lot of subject matter has become very serious, whether it is art, culture, medicine. It became, and still is to a certain degree, paradoxical—if a magazine has serious subject matter and is addressing a cultured level of the population—to include stupid concepts of women, just because it's a photographer's whim.

Do you find that attitude offensive toward the humanity of women?
Yes. But sometimes we have printed a more amusing type of photograph meant for provocation. Otherwise we would have a boring publication. You have to spice it with something more erotic or provocative, with someone like Helmut Newton. But even his pictures published in America are quite different from those published in Europe; it's a different audience and subject matter. European magazines live much more on the freedom of the photographer. Sometimes

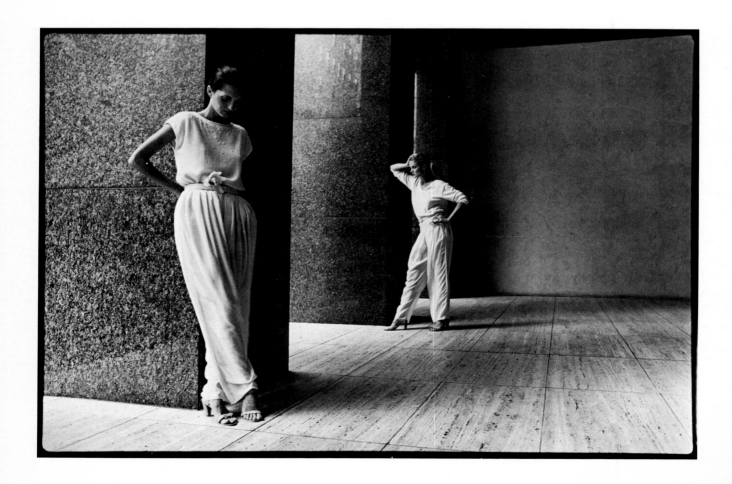

European photographers have difficulty working with us because they want to do crazy hair, or something. For the editor of a magazine, it's wrong, because American women look to fashion magazines for advice, implied advice, and they want to see an image of what they themselves would like to look like, and not just a makeup artist's or a photographer's pretty picture. So we don't publish the photograph, and there is a lot of disappointment, maybe, from the creative point of view, but we believe this is what modern fashion is about.

And the "more creative" picture is something else?

It's entertainment, and I suppose there is a place for it, but it doesn't belong in a serious magazine, and *Vogue* is a serious magazine. There is *Interview* and other magazines where everybody can be experimental, and even *Interview* is quite sedate. Their portraits are quite conventional. It's very retro. And I personally think that *Vogue*, with the photographers we use, is perhaps more avant-garde in the sense that it is trying to be up to today, or ahead of today.

What is the attitude toward women you try to project in your publications?

We admire enormously what has happened in recent years to the activity of women—and this is a very important point—the approach to women should not degrade them or show them in a sex-object light, but should go beyond that. There is such an attractiveness and interest . . . women work, women have active lives, family lives. They are beautiful and loved and enjoyed and are visual masterpieces. All this has to come from an inner respect for women, and this is something one senses in photographers very quickly. A man like Irving Penn, if you ask him why he does this or that, he will say, "I just like to take pretty pictures of pretty girls." Of course, he makes magnificent statements at the same time. But the basic ability to sense and translate feminine beauty in modern terms is what fashion photography is all about.

Photography will always show a dress. People who try to photograph dresses and make them beautiful also photograph women, and the great ones or the good ones are the ones who make women look marvelous. That's why I separate art very carefully, especially from fashion photography. The control of the photographer is very limited. The subject matter is given, the model is chosen in advance, and the location is given. So, I don't find it in general a personal statement. The interesting thing is that some are able to give a personal imprint to their work where so much is given.

Outdoor locations may vary from Manhattan's Park Avenue to Marrakesh, but whether at home or abroad location shooting demands an ability to work with the environment.

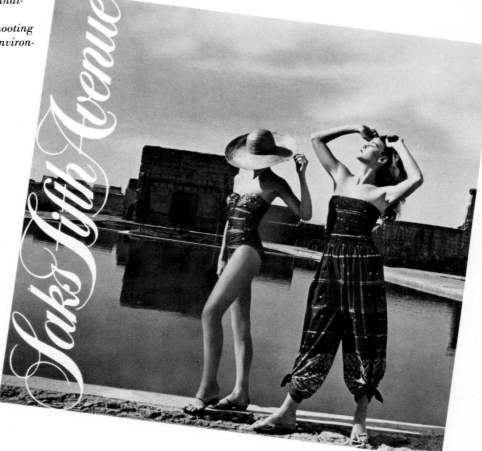

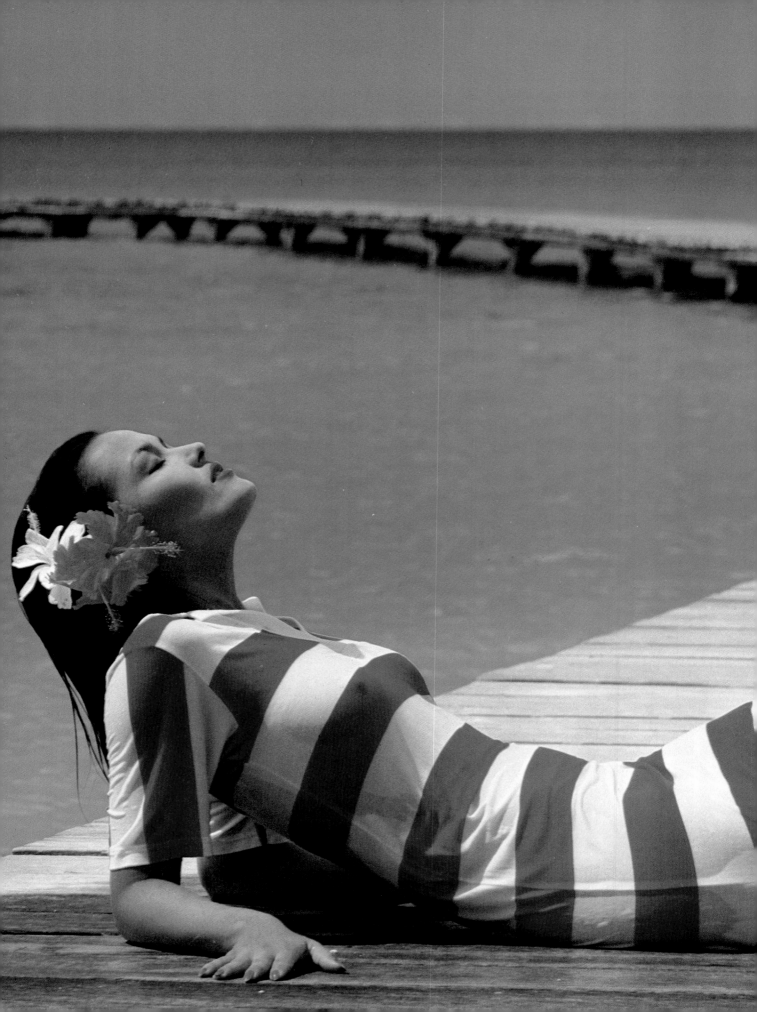

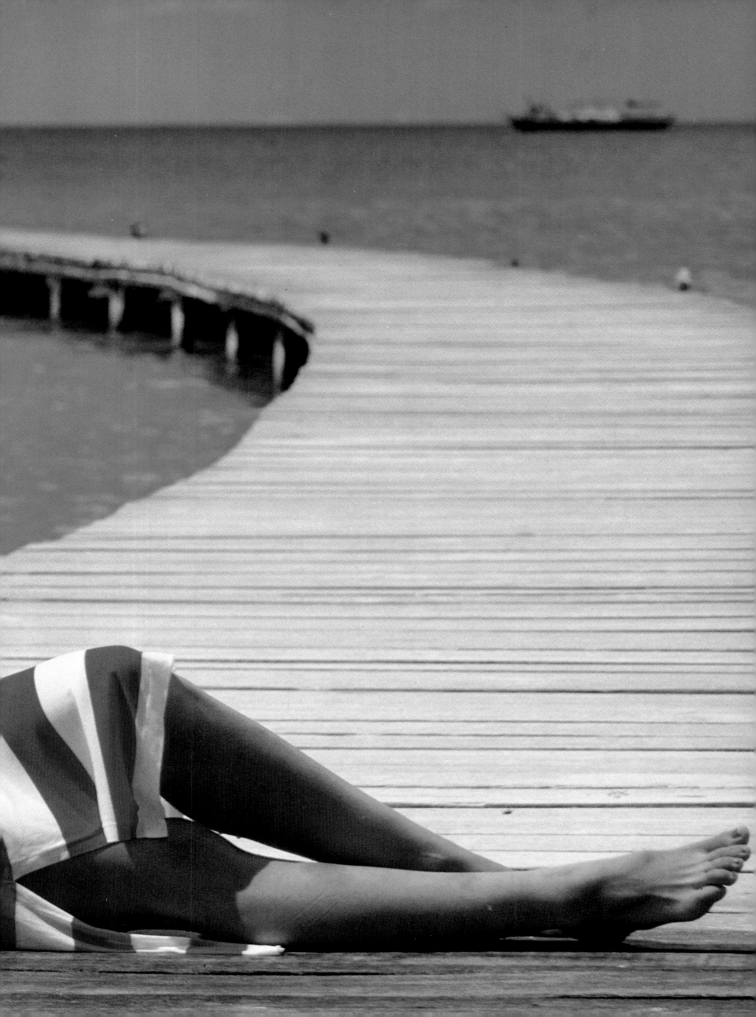

David Leddick is creative director of the Revlon group at Grey Advertising in New York and responsible for most of Revlon's print and television advertising throughout the world, one of the largest single accounts represented by any agency. He has spent most of his career in the advertising industry, following in the footsteps of his family, but started out as a dancer and for a time headed the Robert Joffrey ballet school and company. His imaginative approach to advertising reflects his broad cultural interests and creative background.

How is Grey set up to produce ads?

The Revlon group at Grey is divided into two divisions, international and American. We are probably the only advertising company that does all the advertising for a single company for the whole world. Most companies work locally. Mr. Revson always wanted everything to be unified, and so we have always done everything here. The heads of those divisions are responsible for all advertising, but as worldwide creative director I have to supervise both divisions to make sure that what they do is consistent and also to see where they can mix and match, if what one is doing the other can utilize.

How do you actually work with the client? Do they have a preconception of what they want?

When we are given an assignment by the client, very often the client will be wrong. They will not truly understand the nature of what they have asked you to do. They will have a mascara and believe that the attribute is waterproofness. From our vantage point we will know, for instance, that there are a lot of waterproof mascaras and that, in fact, this mascara does a better job on length. So we will go back and say that we believe we should do it on length. And then the job is not just to do advertising about longer lashes, but to do something that is provocative and interesting and *above* the level of advertising. Remember that whoever is using that mascara has a lot of problems and a lot of interests and is a woman with

a life that is far more complex than simply choosing what mascara she uses. Mascara plays a rather small role in her life.

The problem with most advertisers is described by the Chinese prayer wheel theory. They think that because they are advertising, somebody is reading the ad or looking at it. It's not true. Most advertising is quite boring and has no relevance. It lives in the world of advertising. It's like living behind a counter in Bloomingdale's basement. It has nothing to do with how people really live, what they are really interested in. So I try to get advertising so that it is not slice-of-life, not into the kitchen, but on a dream level that functions within people's true dreams. There is a fantasy level we all have to keep ourselves going, and the reason women use cosmetics is to make themselves more beautiful so they are qualified to get closer to their dreams. Advertising is like aspirin—very often it's a buffer against reality. Marshall McLuhan said that television reflects a world that was gone twenty years ago. People prefer to live within the world of television and not deal with what is actually going on around them. Advertising, to a degree, functions like that.

One criticism of advertising is that it brainwashes people into buying what they don't need. Do you see it that way?

I don't think women are sold a bill of goods. Women are more beautiful than men and they are therefore entitled to decorate themselves. In our culture, which is very puritanical and very nervous about sexual polarization, it is made very clear—women are the ones who wear color on their faces and color on their bodies and men are the ones who do not. We make a very sharp distinction. It is not just whimsical, and I try to get my staff to think on that level when they are creating. If you can touch a trigger in someone to say, "Yes, I need this, this is for me, my life requires this," then they will be interested in the product, and I think the product will deliver. I don't think we are lying. I always say, "With treatments you have done what is possible, and with cosmetics you have done what is affordable." With treatments, if you are a certain age, you cannot become remarkably younger, but you have at least made every effort. Your conscience is clear. Women's lives are much more difficult than men's. They need all the ammunition they can get to be fulfilled in their lives.

How do you know in which direction to go in order to be current with, or ahead of, the times?

I live in France about half the year, back and forth, and I keep making presentations to the client as to what fashion will be doing in a year. France is always a year ahead as a rule. We always have to try to project. With the international division we have to project very far ahead because the advertising won't appear for a year. But Revlon is a fashion leader. Whatever they show isn't *Vogue* magazine avant-garde, but it has to be right for their market. They have to consider what is just beginning to be shown as far as hair styles and clothing and makeup. Then you have to seek inspiration. You cannot logically arrive at a good idea. You just keep trying until you

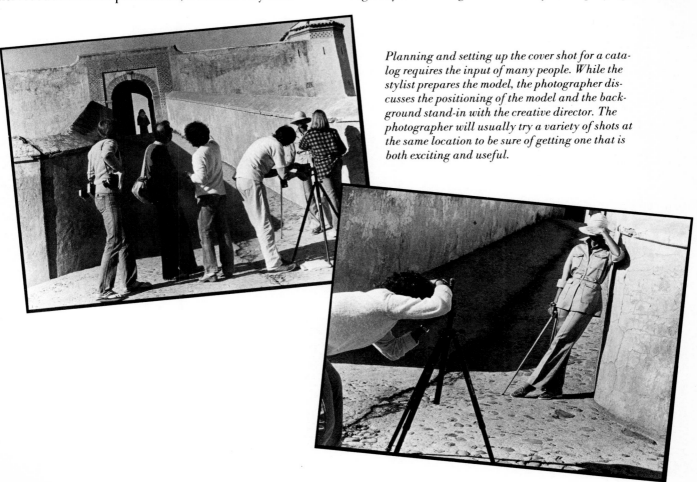

Planning and setting up the cover shot for a catalog requires the input of many people. While the stylist prepares the model, the photographer discusses the positioning of the model and the background stand-in with the creative director. The photographer will usually try a variety of shots at the same location to be sure of getting one that is both exciting and useful.

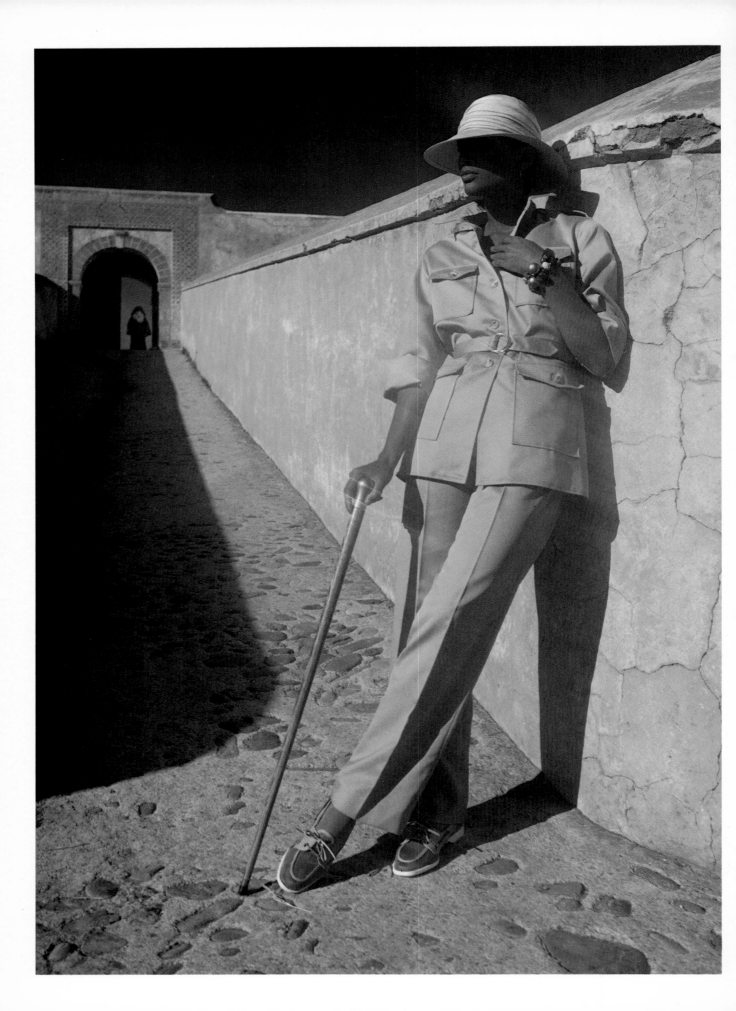

know you did it. Sometimes it comes . . . I will usually mull it in the back of my head for a couple of days, and suddenly I know. But there is no one final position.

You mean as to the quality you are trying to convey about a product?

Well, for instance, the TV commercials and print ads for the fragrance *Jontue*: "Sensual, but not too far from innocence." *Charlie* had just come out, and *Charlie* is for the young, aggressive career girl, so the next fragrance had to have another position that the same woman could identify with. The fragrance itself is very romantic, so we had to try to think of something romantic, but it had to be a romanticism that was not out of step with what a woman thinks inside. So we went to France and did prototypical dream images of the chateaus and the peacocks and the horses, the kind of things you dream of if you are running through the fields of France. We had, "Sensual, but not too far from innocence," so we were not talking about remaining a virgin forever; it had a little edge of sexuality. We kind of stumbled on the horses as an image of sexuality. In the first commercial we didn't use them, but for the second we went to the Camargue, and the horses became a very powerful image. That was the male image. The man himself is a very modest part of it, but we have always kept the horses since then.

Most of it is trial and error, but a lot of it is subconscious intuition as to what should be said to someone to make them want this product. That is just developing a sense of what it is for and not thinking it is like soap, or like cars. But very often for American women you have to validate that it lasts twice as long, that it is in six new colors, or something that can justify why she might buy it. The initial reason for wanting it has to be much more emotional. Americans, I find, are extremely divided. They are very emotional, but they are not very much in touch with their emotions. They believe that they are actually doing things rationally. The reason they have chosen this person or this house or this place is for reasonable purposes, when actually it is not that at all.

Doesn't advertising feed into a kind of conformity?

In my experience, advertising is more a result of what people want than of guiding them. It's very hard to make people buy things they really don't want, and I think the big careers in advertising are those of people who have a sense of their country and can trigger something that will be fulfilling. We don't have a very gratifying country. We are a peasant culture. There were never very many aristocrats. And what peasants want, in my opinion, are physical comforts and appurtenances like cars and refrigerators, but there is very little grading of quality. As long as they have enough to eat and are warm and their children are going to school, they have made it. We are just beginning to phase out of that now . . . people are getting more critical about the quality of their lives. They realize, "Yes, I made it, but I'm not happy." It isn't enough.

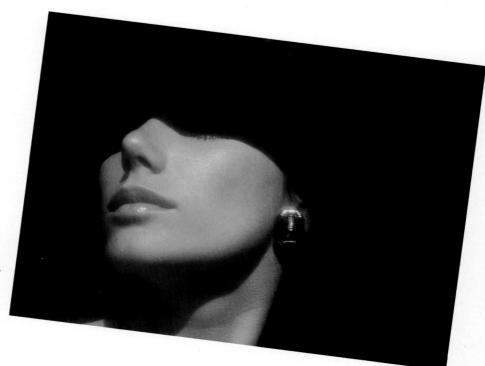

Although soft lighting is usually preferred for beauty shots, here the harshness of sunlight makes a dramatic contrast with the delicacy of the model's features.

This may seem all very high-fallutin' just for lipstick advertising, but it is part and parcel, and I try personally never to do advertising that I myself wouldn't like to look at. I tell myself, "Don't think that the people who are buying this are below you." If you don't like it, don't expect anybody to like it. I don't think you can push people around. I think you have to simplify a lot, and for myself I like to wrap things in dream images. I like to suggest to them that life can be wonderful.

So, essentially the search is for new images and new faces as well?

Refreshing images, because images wear out. Film stars change all the time, and models change. It's not that they are too old to model, but that people are tired of looking at them. There are very definite types. The type of model that is coming in now is a very classic, Garbo, perfect kind of model, whereas we have had people like Lauren Hutton who were very recognizable, real women. There are certain women who wouldn't have had careers ten years ago, who have worked in the past five years. The big, important women who are coming in, who are making a lot of money, are very perfect beauties. They're almost interchangeable faces. No idiosyncrasies. And blondes . . . I think this country always takes refuge in Anglo-Saxonism.

Do you find that photographers are in touch with these changes . . . or in advance of them?

I see tons of photographers. When I am not too overwhelmed, I will see somebody every day, because otherwise I fear I will miss something. In principle, younger people should be doing and experimenting with new things. But the problem with photographers is that, for the most part, when they look through the camera they are only seeing pictures they have already seen. They are not looking at the subjects, so most portfolios that come in are identical. I could never tell you whose work they are . . . same women, same poses, same background, same lighting, same everything. They have an idea that fashion and beauty photography is a certain kind of thing and they have seen other portfolios and worked in other people's studios and they go and replicate all that. It's very rare that somebody will actually look at a woman and what she has on, and think about an unusual way to photograph her that will make someone look at it again. Usually their ideas for making you look at it again are to change the background or the woman's pose. And I don't think that is it . . . very often it's the photographer's attitude toward the person.

I imagine that most photographers, when they go around, feel the need to have portfolios that are not very alarming, because most art directors are intimidated and put off by work they can't use if they don't immediately see how to use it. There has been a death of the imagination in this country. I don't know why, but fifteen years ago most writers and most art directors were far more individual, far more experimental, far more interesting as people. They were witty and amusing and looked like something. People now are no longer very attractive because there is no point in being attractive. It

In the studio the photographer creates an environment from the ground up. Working with his assistants and others, the photographer directs the construction of a set and the arrangement of the lights.

works against you. There is a great leveling off . . . let's all look alike, let's all be similar.

That's purveyed in the advertising industry, but I perceive that as passing away. The 1980s will see that ending. I see it with our clients. They can't sell on a formula basis. I'm being called in to work on a lot of projects that I would ordinarily never work on, but it's because they can't sell by formula. Sales are slipping and our clients realize they have to motivate people beyond a reasonable, rational level.

How does that work on a practical level in creating an ad?

Say we are doing a new fragrance . . . everybody in the division will work on it and we may do twenty or forty different layouts. We look at them and decide where we are heading. I try not to direct them too tightly because their brains can stop working. I don't say, "It must be a cowboy theme," and then they can't think of anything because Marlboro blocks them. It has to be looser than that. Ideas come from anywhere. Someone who hasn't any experience can have an idea that is just as good. But they have to be encouraged to draw from their own experiences, their own points of view—to do something they would like. You can do that indefinitely as long as you don't lose that sense of what you would like to look at.

Do ideas come from photographers too?

Very often. If I have been inspired by a picture in a magazine, and it is a successful presentation, I always try to give the job to that photographer. I feel we owe that to him. I wouldn't have another photographer work from his idea. Photographer's ideas are very sacrosanct to me. If he had the idea, then he is entitled to develop it and do it commercially for us. It could come from an editorial layout or from a photographer's portfolio. Sometimes a photographer may come in and have a terrific idea that may not be exactly what we are doing, but I can see how to use it.

Would you allow him the freedom to develop it?

Always. All clients want to have a clear idea of what we are doing, so what I do is exactly what the client expects, and then we will do other things too. Then I will go back to the client with two or three things. Seventy-five percent of the time the client will go with the experimental, the new thing. But Revlon is terrific that way. Much of our attitude comes from having them as a client, because they insist on being new. The biggest problem with most clients is that we have all these ideas and they never want them, and the biggest problem with Revlon is that they want so many ideas. You go out of your office and wonder how you can go on thinking of new things. It's exhausting, but it is a good thing, because then you are constantly reading and going to movies and traveling and doing everything in an effort to keep yourself full of new ideas.

In many advertising situations that kind of freedom is not possible. Can a photographer

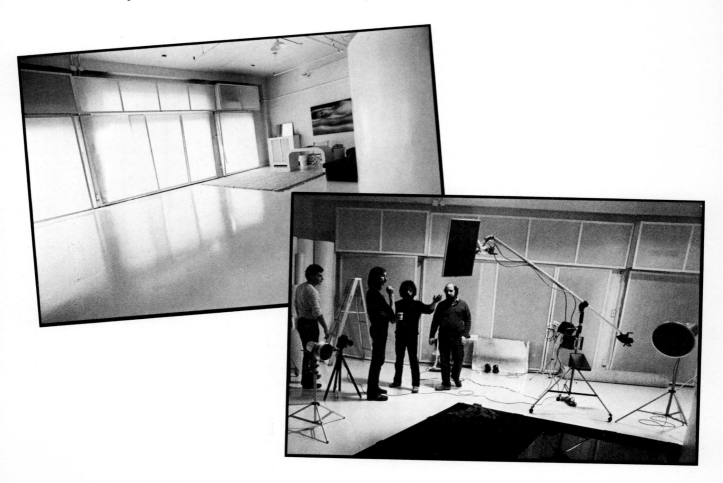

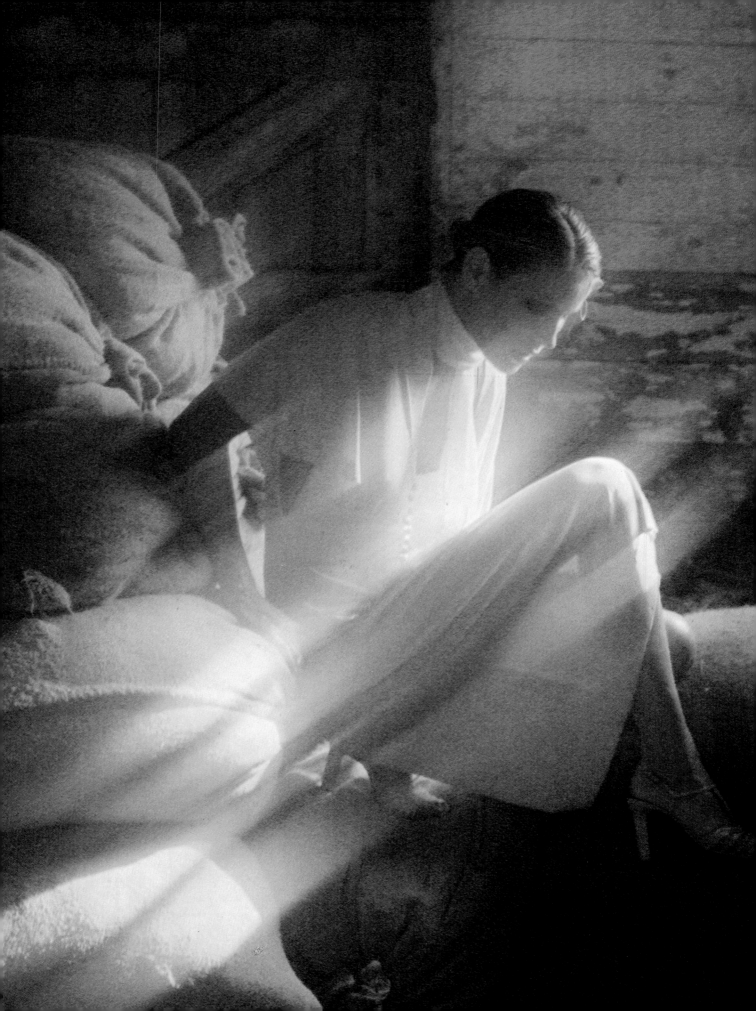

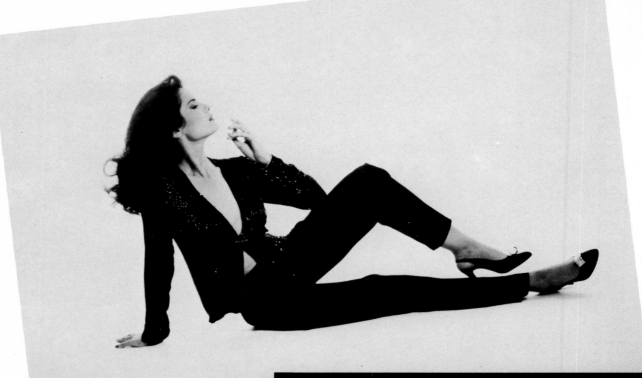

maintain his originality in those circumstances?

Being a photographer is a gift. Some people can sing and some people can dance and some people can take pictures. More than having a technical command of the camera, they see things in a certain way. They have a world they wish to evoke, using a camera instead of a paintbrush. The one thing I would urge on everybody is not to believe you have to be like everybody else to make it financially. So I always urge people to go to Europe and keep doing what they are doing, and if they have to do commercial things, fine, but they shouldn't lose track of their own visions. A lot of what we do is very commercial, but we have to be creative to do it. The photographers have to do editorial work and be very aggressive about seeing people and imaginative about seeing other kinds of magazines that have nothing to do with fashion or beauty.

Part of the reason for going to Europe is that fashion magazines in America are very much dominated by their advertisers. They have to have an editorial image that suits their advertisers, whereas in Europe it is very often not the clothing manufacturers but the fabric manufacturers who are supporting the magazines, so they are a lot freer. Also, in non-television countries like France and Italy, where television doesn't dominate people's lives, magazines are much more important.

In the United States people have to be separative, it's such a mass culture. People are motivated to believe they must conform, but in fact the only ones who really make it are the ones who bring something different to the marketplace. You see that with fashion design; you see it with everything. We have to have news, and people who can make news will make it. It's very defeating, very dispiriting, when people commence, because I know they go around and nobody is interested and they can't get appointments. No one likes their work and they ask themselves what they are doing. There is a certain amount of corruption in the business too . . . people want payola and things like that. I try very hard when I see people to let them know that somewhere in the industry there are people who are trying to do something because they really want to do it and because it's good. It shows in the people they are working with because they think they are the best for the job. So, if you know that, even if everybody else is a turkey, you know at least that you *can* do it, because it is being done.

Do you go on shootings?

I supervise everything. I pick the women, the clothes, the jewelry, the location, the photographer, and I have to be present at every moment. My art directors do shootings without me, but I try to go on everything because I have a certain thing that I feel represents Revlon. It isn't anyone's fault, but it is just that when you have worked for a long time, you have a certain level and coherence that you want the ads to have. Also, what we are internationally is not exactly what we are domestically. We are a more expensive product and more glamorous image internationally, so that has to be

supervised because it is hard for art directors to realize it is a different market. If we are doing something only for England, only for France, only for Italy, we will groom it for that market because what is considered beautiful there is different from what is considered beautiful here.

Obviously there are a lot of cross-currents between Europe and the United States. How does that work?

There is a ping-pong effect. America has a lot of ideas and doesn't know what to do with them. Then Europe sees them and makes them into something comprehensible as a trend. Then they ping pong back here and become fashion. For the most part, American designers don't really have confidence in something until it's been worked up by European designers. What they have done is take the old Best & Company look and convinced people it is fashion. It's a lot of money for a cashmere pullover with a tweed skirt, and it's not fashion. It's all part of reassuring people they are doing the right thing. Everyone is on a bandwagon. When you see the collections they have no personality. They have a bit of everything. The same clothes all come down the runway, no matter whose collection you see.

Are there original spirits in photography?

I think so. I'm very cranky, I guess, because I don't like to work with people I don't like. I will if I feel they do something unique, but what someone is as a person affects my feelings about their work very much. There are only three reasons to know someone—if they are beautiful, if they are interesting, or if they are good. If they don't have any of those things, then there is no point in knowing them because there is no

interaction. When I tell that to people their immediate reaction is, what if they can do something for you. But nobody can really do something for you personally, and all your career is for is to make your life better. I think people forget that. It happens to a lot of people in New York. They become less nice because they think anything is worth the price to make it, but making it isn't anything. If you are earning a living doing terrific work, what more could you want? You see that in people's work. You can see when people are really interested in women, I don't mean sexually, but when they really like what they are looking at through the camera.

Isn't there a danger of looking at a model as an object?

I think we are lucky if we are sex objects. It's very easy to not be one because most people aren't. I don't think there is anything wrong with being depersonalized . . . that's the sex object's problem. If people see you as a sex object and you can't then make them see that you are also a person, that's your problem. People are sex objects, and sex objectivity is very crucial . . . it is one of the most exciting things that happens in our lives.

Everyone wants to photograph top models because they are top models, and seventy-five percent of the time they are not well photographed, but the prestige of their aura carries the project. Most women have to be photographed in a very specific way to be their most beautiful, and if the way she should be photographed is contradictory to the way the photographer works, then you are not going to get a great picture. Any woman can be photographed badly . . . no one is so impervious to the camera that they will always be beautiful.

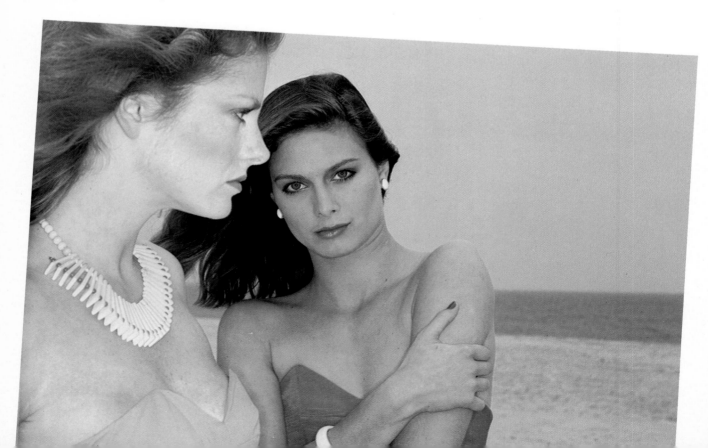

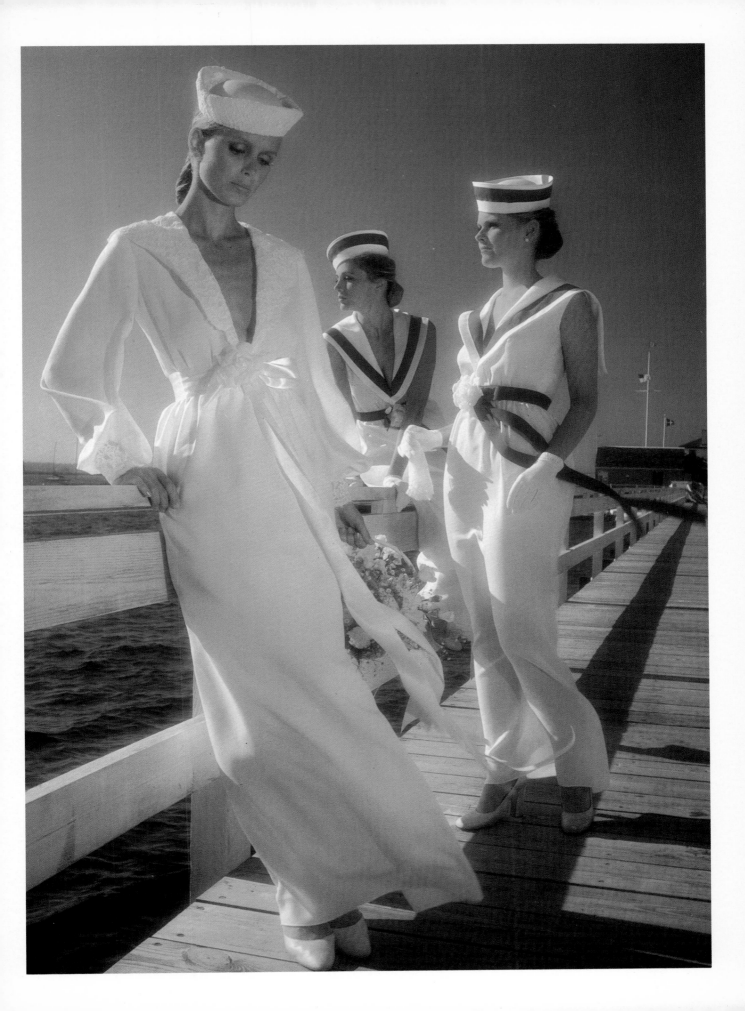

Leonard Restivo is creative director in charge of all catalog advertising at Saks Fifth Avenue in New York. Their major fashion statement is the magazine-format *Folio*, used by Saks's branches throughout the United States, with national distribution of more than one million copies. Mr. Restivo previously served as an art director at Bloomingdale's and Macy's department stores in New York.

What is your concept in creating the Folio *for Saks?*

I try to do the books so that each stands on its own. You can tear a page out of any book and put it back in the right one because each is coordinated individually and has its own integrity, whereas a lot of catalogs are pretty much standardized, the same thing every time. I try to keep people guessing and aware of what the store is doing by producing something that is unique and different.

How do you put the book together?

First I see all the merchandise and then it is paginated, put in sequence. All the categories have to be worked out—knits, suits, etc.—so that you don't suddenly have an evening dress next to a plaid shirt. When I pretty much have the idea for the book, I select the photographer. If it's a book like the one Robert Farber did with me in Morocco, we have to deal with travel agencies and tourist bureaus. There is a lot of just getting things organized. I usually work about three months in advance, but sometimes it's six months because we have to work with other countries.

After we've had our meetings and done the pagination, I work with my staff, and my art director, Debbie Milbrath, as to what we are going to do, how we are going to lay out each page. She follows the principal design and gives me a general design for what will be on each page, sketching in the figures

and layouts. That has nothing to do with the final design or how the pictures are taken. I don't even want the photographer to see this. It's only a point of reference so we know what is going in the book and where it goes.

Do you have a theme or design scheme for each book?

Well, for Morocco a natural theme developed because of the red stone of Marrakesh and the white stones and tiles of the palaces. So we started with the conceptual idea of red and white and broke up the book on that basis, making each section a different color theme. We know automatically where each piece is going to be shot before we start. Then my staff stylist, Tui Stark, gets all the clothes together according to the day's shooting. She always has to know a day in advance what we are shooting, so we give her a list of the pages the day before.

How do you select a photographer for the job?

I call in several photographers. I see what their responses are and if they have the kind of enthusiasm that is necessary. If they don't, I kind of stay away from them because I'm not sure whether they want to do a good book or just make money. So I usually pick someone I can work with who also has ideas and some excitement about the possibilities. Sometimes I don't mention the location, but see where they would shoot it.

After I have seen what the photographer can do, I'm not concerned about it anymore, and then we will sit down and talk about how we are going to do it. We discuss what is available in the location and whether we want to spend all our time in one city or use other cities as well. With my experience on location, and knowing that we have to produce about sixty pages, it's not wise to do too many locations, because we have to take a whole entourage—the photographer, a couple of assistants, models, a stylist, the art director. Each move becomes very costly. We want to do the book as simply as possible.

When does the photographer get into the planning of the book?

He comes to the store before we leave to look at the merchandise so he has a general idea of what he is shooting. At the same time he sees the layout, and by this time we know how we are shooting it. He knows which pictures we are putting emphasis on, the ones we want to get the maximum out of. When we do the actual shooting, he does a Polaroid and I attach it to the layout so that when I put it through the layout department they know how the final picture is going to be put on the page. There is a general look as you flip through so that the right-hand pages are balanced with the left-hand pages, usually a single large picture on the right and smaller pictures on the left, with spreads and bleed pages mixed in. Each section should have a certain continuity. Then you have to do stills—shoes and handbags and gloves—and you need a photographer who can do not only great fashion shots, but has

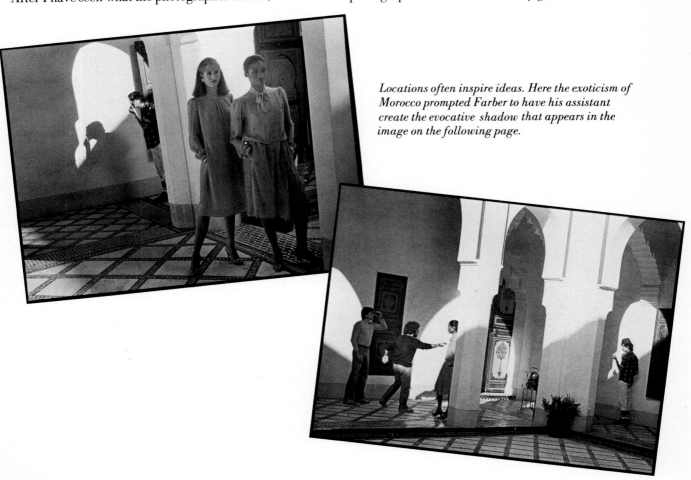

Locations often inspire ideas. Here the exoticism of Morocco prompted Farber to have his assistant create the evocative shadow that appears in the image on the following page.

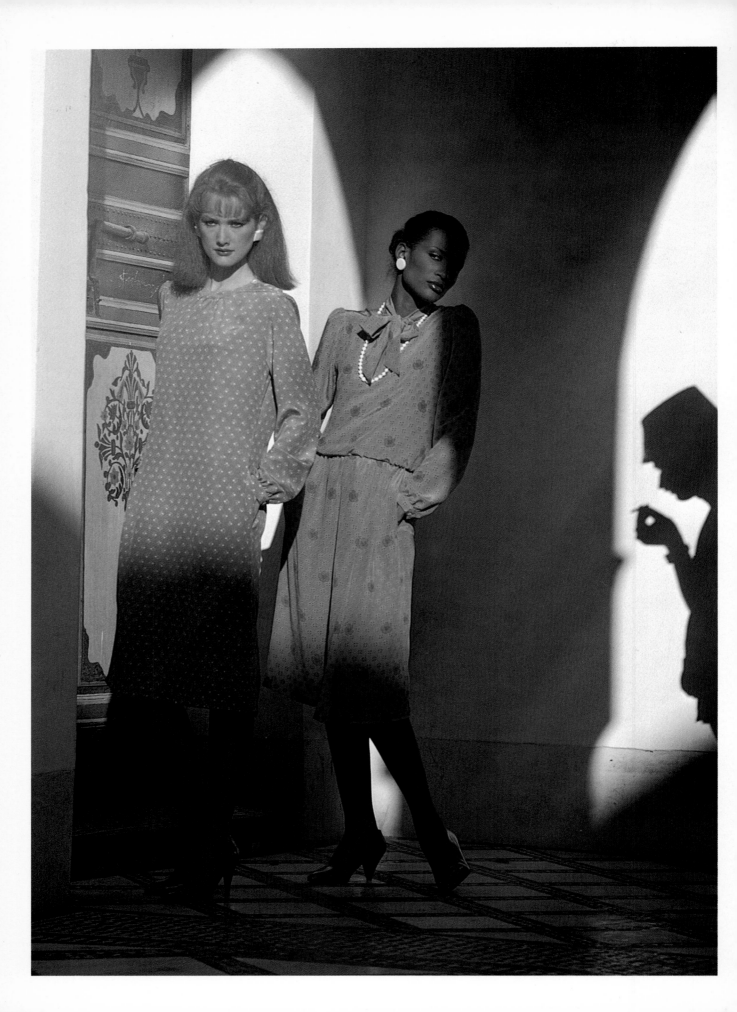

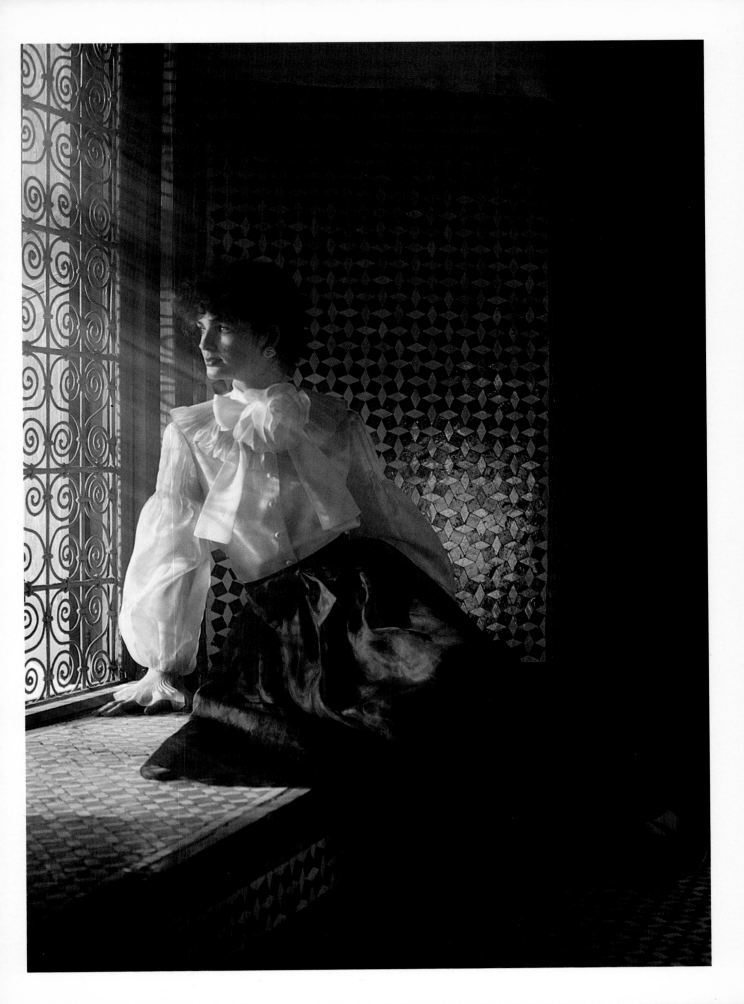

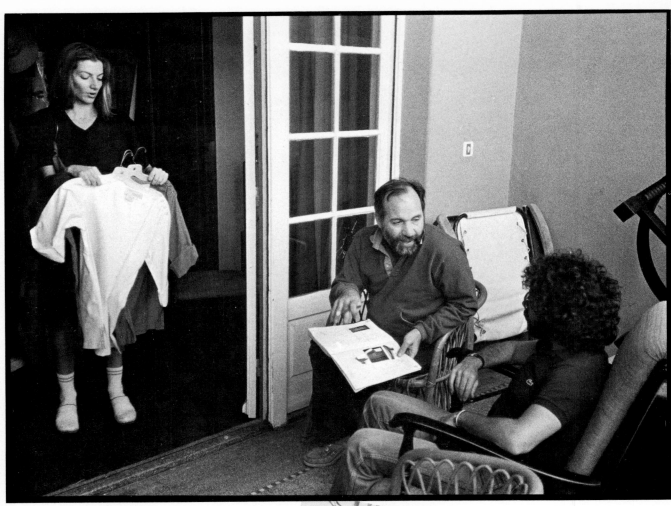

Before the location shooting begins, Polaroid photographs are usually taken of possible settings. These test shots are then reviewed by the photographer and the creative director to coordinate and refine prospective locations and layouts. Here, the stylist (Tui Stark) shows the clothes at the same time, so that color and style can be considered.

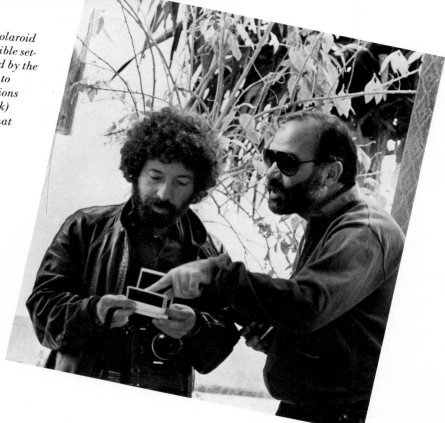

the patience to do stills as well. When you are selecting a photographer, you come across some who can't or won't do still lifes, but you have to have as much emphasis on that as on the fashion.

How did you make the choice of photographer for the Morocco book?

I did a small book with Robert as a sort of test to see what Morocco would look like. I was interested in his treatment of light, which would be so important in the setting of Morocco, which is a unique place for light. There seemed to be so many different kinds of windows and arcades that produced interesting effects of light and shade. When you go to a location and you've never been there before, you don't really know what you are getting into. You hope it is going to be what you visualized and you do as much investigation as possible.

Was it as you visualized it?

Not really. I thought we were going to have a lot more windows, but what we found was something better—courtyards in the old palaces and rooms upon rooms with gardens and terraces. Because of the big courtyards and the way the sun was moving, we had the models in shadow with the light coming from behind no matter what the time of day. It doesn't always work out like that. Sometimes you get there and it isn't at all what you wanted or expected—for instance, there may be no sun. I guess you go on a lot of luck. With Robert, I discussed whether we should take heavy strobes,

just in case. I usually don't get too involved in that because the photographer knows exactly what he is after and what I am after, so I leave it pretty much up to him.

How much are you involved with the photography itself at the shooting? Do you direct the photographer or leave him on his own?

The way I generally work filters through to the photographer, but I don't try to give him boundaries and say you can't do this or that. I try not to say anything negative, and when I do I think very carefully about the reasons. I don't want to stop him because the book is going to be only as good as the photographer. The only time I'll stop him is if he is shooting a piece of merchandise totally wrong, but even then I would be reluctant to stop him because it is only a few shots, and you can always ask to shoot it again, changing the angle. If you leave the boundaries as wide as possible and try not to give the photographer too many negative remarks, then the possibilities build up and he responds and goes further than he really has to.

Do you ever revise the layout once you are on location?

I can take a certain amount of latitude. You always have to show the merchandise and fit the space of the page you are shooting for, but I will change from the layout if, for instance, a spread seems to work better than a single page, or if the photographer has captured light in a way that shows off a

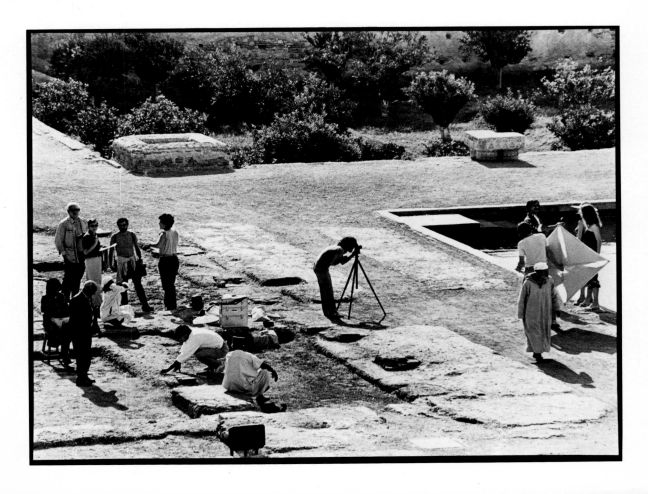

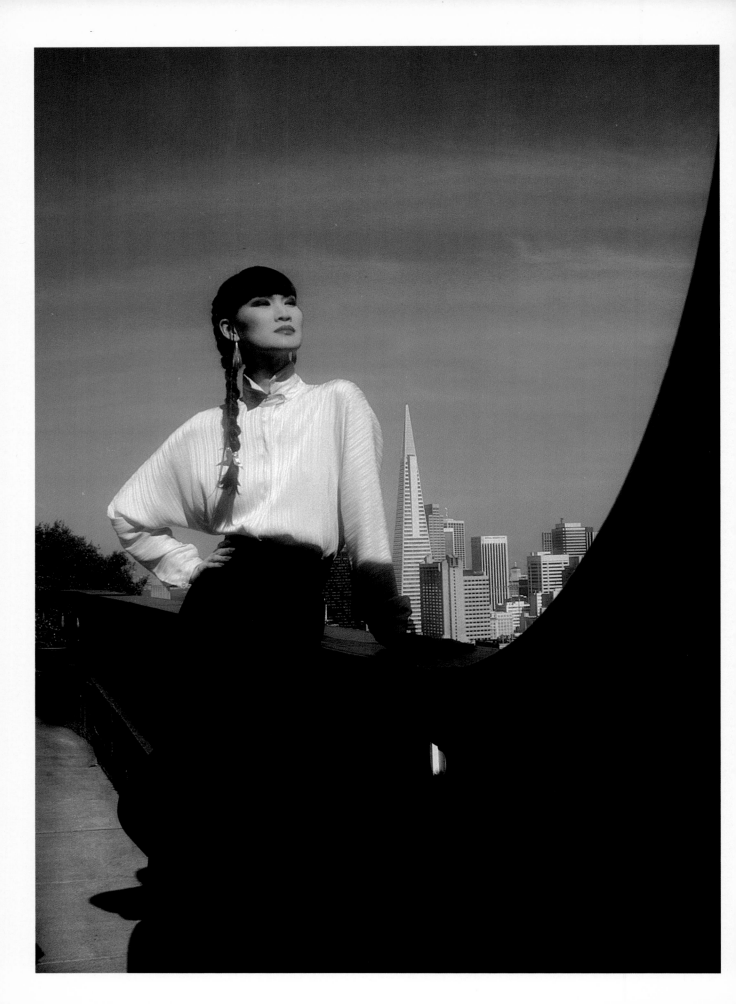

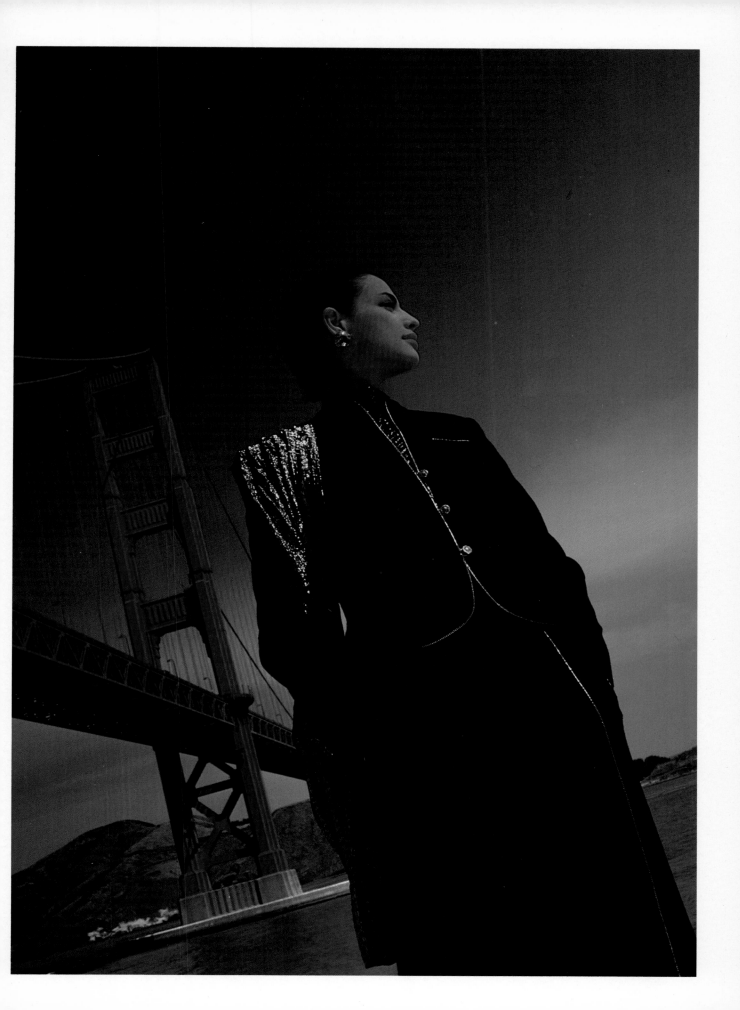

dress beautifully but in a different way than I might have imagined. Sometimes I can't tell what the photographer is seeing, even if I'm only a little bit off to the side. He may see a composition, or a nuance of posing, or an effect of light that I don't, so that even when I have doubts or objections, I don't interfere because I've placed my confidence in him in the first place and I want him to make full use of his talent and what attracted me to his work. That is the way you get the freshest, most exciting photography, and the most striking book. When it comes to the shooting itself, after the basic continuity and concept have been discussed and worked out, he has to have the major input and control over what he is doing, how the shooting proceeds.

Is there any difficulty getting models for an extended shooting on location?

You really have to deal with top models if you want a good book. Sometimes they are not interested in going on location, but a place like Morocco is probably interesting for most people, so there is no difficulty getting good people. We booked our models about two months ahead of time. We were holding four models but didn't confirm until a couple of weeks before the shooting. You keep them on tentative, which the modeling agencies sometimes don't like, but you can't really confirm until about a week before you are scheduled to go because there is always that outside chance that something might happen to cancel the trip . . . then you have three models to entertain on your own time.

What kinds of problems do you run into on location?

I've never had any severe problems like being rained out completely and having to pick up and go to another location. These are the things that always go through your head, that you are horrified by. On one shooting we went to a place during the rainy season, which the tourist bureau hadn't told us about, and when we got there it rained intermittently with very little sun. On the last day, when I was going to lose a model the next day, it looked like it was going to rain all day, so I just told the driver to take us where it wasn't raining, which took about six hours, and that way we finished the shooting.

But you want to make the shooting as easy as possible, because you want all your energy to go into the shooting itself rather than getting there and wearing everyone out. You want to concentrate on what is going on at the location, on setting everything up properly and getting the best possible shots. Some photographers work all through the day. Robert likes to work with early morning and late afternoon light. Everything looks very warm in that light. The models look best in that light and they know it — they respond. They will always give you their best then. You always know when they are feeling good . . . you can always get a good sense from the model as to how the shooting is going.

Have the tremendous increases in models' fees affected your job or fashion photography in general?

That's a touchy question. I don't think any of us are happy with the rising fees. An experienced model can come out with what you want in a few minutes. She knows what she is dealing with, what has to be shown in the merchandise, so you don't have to waste a lot of time, especially on location. It

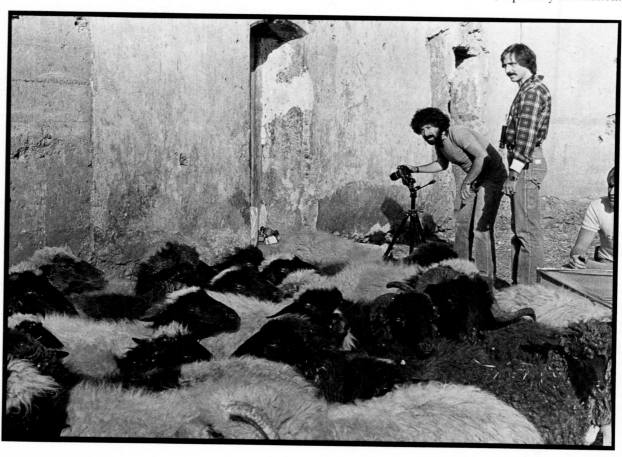

seems to me that she is worth more than a model who has just started out, who might even be more attractive or beautiful, but who is going to take a while to learn what to do. I don't think the scale is appropriate. When you are paying someone, they should be worth it to you, so there should be distinctions based on experience. The existing day rate is much too high and it might force us to cut back eventually. We are thinking of using European models, because we do a lot of location shooting. Or we might change over to drawings in some cases. I love fashion drawings anyway.

*You can't really roll back the fees though
now, can you?*

It's the top models who are getting outrageous new rates every time you turn around, and suddenly it pulls everyone up again. People who weren't even thinking of raising their rates suddenly are forced to. When a big company doing national ads sees that a model has lower rates, they think maybe she's not as good and they don't use her. The model then has to demand the rate or she won't get the work. But we can get a more reasonable rate because we take models for a certain period of time and guarantee them the work.

*What do you look for in a photographer's
portfolio?*

Primarily I look for an identity. I look for those shots that belong especially to that photographer. He must have technical excellence. Then, after I see that he knows what he is doing, I want to see what he can create. He can take a picture correctly, now what is he going to do with it? Other than just showing the model, how does he present her? If he is a straight mechanical photographer, I can't use him, but if I can see he is an artist, then I am interested. Even if he does something crazy in his work, that can be good, because if it has design and composition and other qualities, it might show that he is thinking.

*Do you find that photographers hold on to
their original impetus after they have gotten
into their careers?*

Some do. Others sell out and just do work, forgetting what they started out with. That can be a great embarrassment on a difficult shoot. That's why I like to talk to them beforehand, because I get very nervous about whether they can handle it. He has to have a certain range in his work, but if he is creative he will be able to handle any situation. Photographers do have to specialize, but if they don't have the basic sensitivity about fashion then you might end up with a model just standing there. Even the simplest catalog shot should have something, a sense of design, graphics, composition. At the same time you can't destroy the merchandise. You work with what you have.

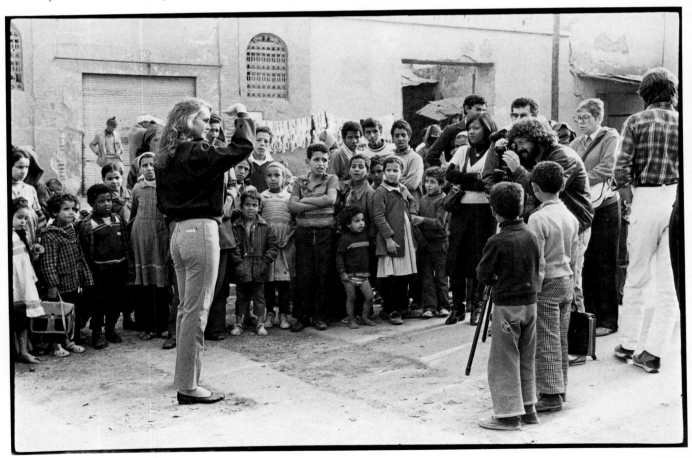

No matter what the surroundings actually are, the photographer must produce a finished shot with the illusion of elegance, style, and atmosphere necessary for a successful fashion photograph.

Models and Modeling

There is a certain poignancy in that brief moment of contact between model and photographer when the picture actually occurs. It is in the nature of photography itself that what is recorded in a millisecond of exposure has neither a history nor a future. It simply *is* what existed at that very narrow, but very full, slice of time—a gesture, an expression, a concurrence of events or forms that yet carries with it its own past and future.

The camera never lies. In a sense that is true. The photographer is simply recording what is there, but as an artist he is molding that material, that subject matter, according to his own vision, in a way that makes sense to the structure of that vision, and ultimately does or doesn't make sense to the viewer. So the camera does lie. It is selective. It frames out a great deal from what is available and chooses the moment. What appears on film may be entirely misleading in regard to the continuous movement and meaning of the scene it is aimed at. This has been proved over and over again in famous pictures that seem to be something they are not in actuality. But who is to say where truth lies. In photography, as in any art form, the falsification of factual reality becomes the basis for another kind of truth—an aesthetic, emotional, or spiritual truth.

Within this definition of photography, working with models is a special case. Models participate in their own re-creation as images, although the idea for the image may be that of the photographer. They create the moment in which the message of the picture exists, and it is up to the

photographer to capture it on film. The special poignancy that I mentioned above results from the process through which they shape their own human selves and their own natural beauty into a heightened beauty, elegance, charm, playfulness, vitality, and seductiveness. They must, in other words, exaggerate their own personalities and characteristics in order to achieve the perfect line or the perfect expression. They must falsify, in the artistic sense, their own human multiplicity for a moment of pure expression. That is what is poignant. They must pose; they must act. Yet, in acting, they don't have the luxury of developing a character, of comprehending and revealing its complexities. Their efforts are turned, rather, to evoking a rarefied, almost abstract, image of beauty, however realistic the picture might otherwise be. There are no words to be said, no lines to be spoken, no explanations to be given —only a picture.

This pursuit of perfection places the model in a rather peculiar position as the human vehicle of both an abstract ideal and a commercial message. In any shooting, the tension that results from so much talent, energy, money, and beauty being funneled into the essentially narrow confines of fashion and beauty photography is felt by everyone involved. It is a major factor in engendering challenge, excitement, and a finely tuned picture. But it also can produce a good deal of stress, again felt by everyone, but seemingly focused on or embodied by the model. She (the case is somewhat different for male models) is usually the youngest and best-paid member of the cast, in addition to being the most beautiful. If

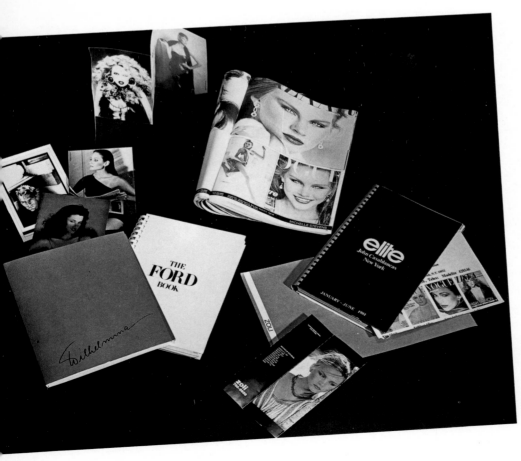

Modeling agencies produce lavish "books" of their models. Besides showing the models in a variety of clothing styles, the composites list the model's height, coloring, dress size, shoe size, and other relevant features.

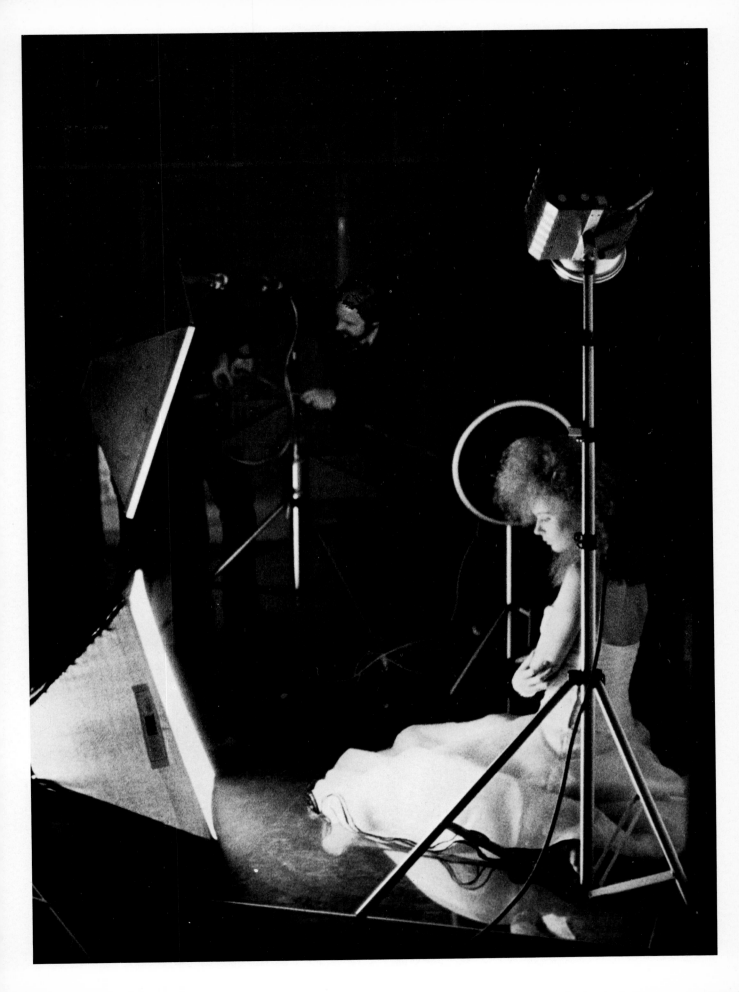

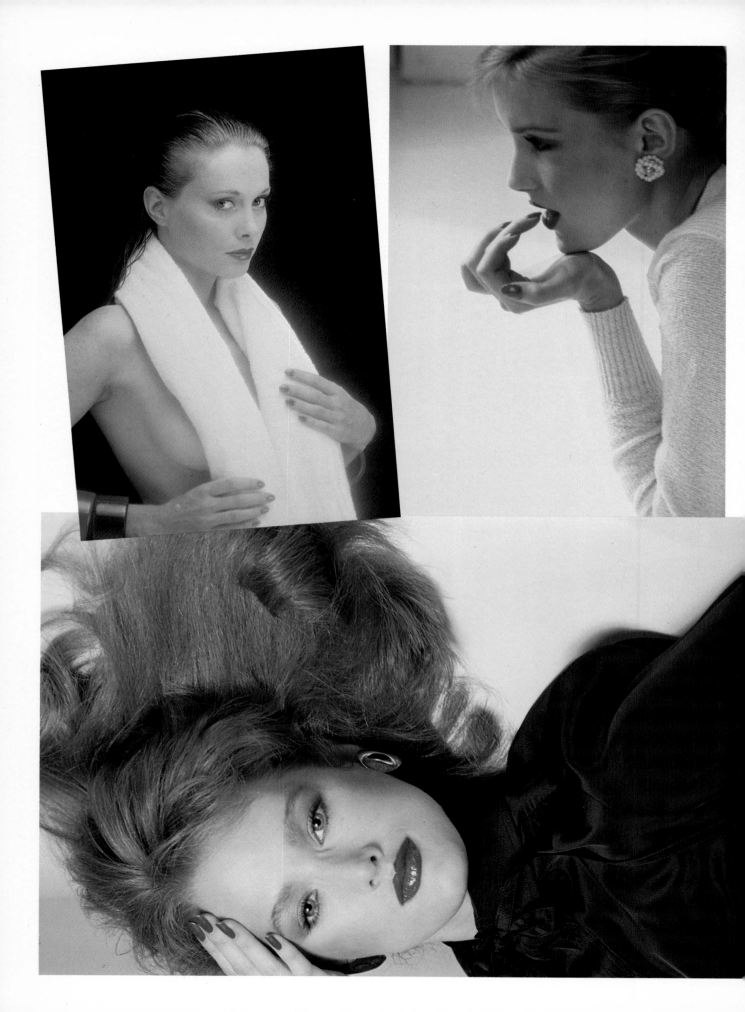

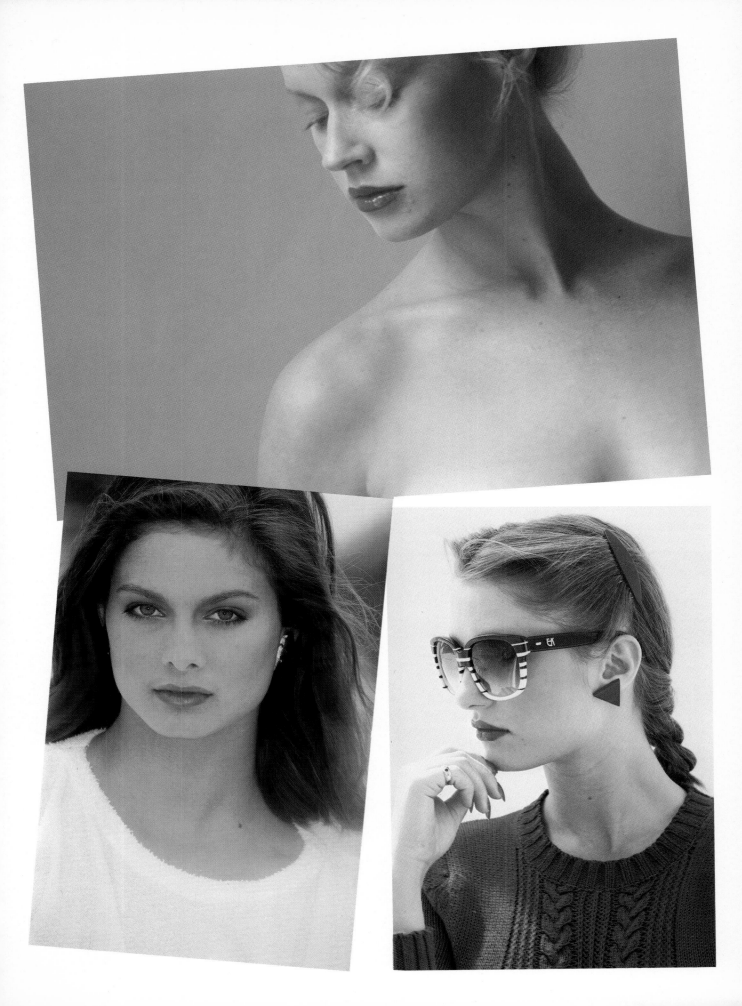

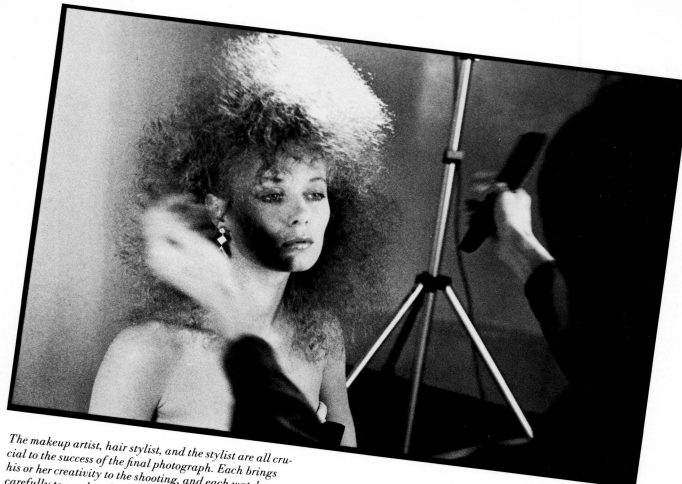

The makeup artist, hair stylist, and the stylist are all cru-
cial to the success of the final photograph. Each brings
his or her creativity to the shooting, and each watches
carefully to see that the different elements stay in order
throughout the shoot.

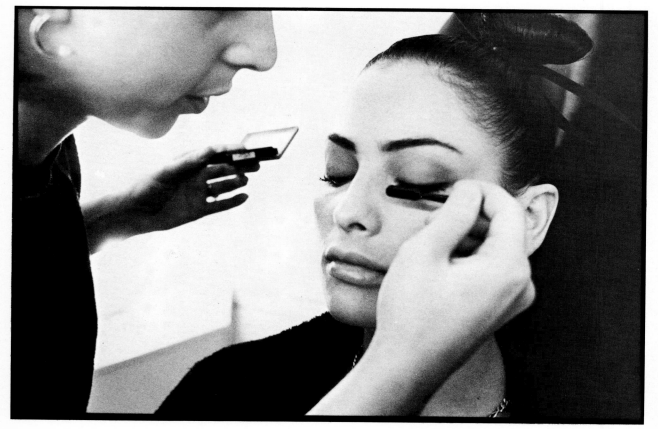

she is well known or identified with the product, her presence is perceived to be absolutely essential. Whereas the rest of us can get away with physical self-mistreatment, a model can't for very long. Her looks and how she learns to use them are her profession. And yet she can be, and ultimately will be, replaced by someone whose youth, at least, surpasses her own.

It may be disingenuous to emphasize the pressures that confront a model. She occupies, after all, a position of privilege. The money she makes, from $1,000 to $2,500 a day or more in New York, is out of all proportion to her age, if one can look at it that way. During the shooting, all her needs are ministered to —she is dressed, made up, coifed, fed, and pampered in general. Her agency takes care of all business arrangements, from scheduling jobs to negotiating contracts, though in the end she makes the decisions about which jobs to take, or whether she wants to sign a long-term contract with a cosmetics firm or clothing manufacturer, and on what terms she will accept it. She also has access to a social world and social temptations that are not even remotely available to the vast majority of people. Her status, like her beauty, is elite.

There is nothing new about the problems attending that position, the opportunities for abuse. In terms of professional fashion photography, they translate into showing up late for shootings, showing up unprepared, not showing up at all, and making demands that befit a distorted notion of a rising or achieved stardom. The model is not special in this respect. Any field involving creative people encompasses a good deal

of erratic behavior. But the spotlight is literally and figuratively on her and she becomes a focal point. Add to that the fact that most female models begin at the age of seventeen, eighteen, or nineteen (male models are generally older when they start), some of them making enormous amounts of money in a very short time, and one can further understand the imbalances and difficulties that sometimes occur.

If I have drawn the lines around models and modeling a little too tightly, it has been in an effort to describe and define the aesthetic and professional extremities of the field, to expose something of its inner life and what both models and photographers face in working with each other. The usual reality is not so tautly stretched, so exacerbated by purist aesthetic considerations, clashes of personalities, or commercial demands. It is generally more relaxed than that. Things work out, beautiful images are created because people are willing to work together, to bounce off one another in a reciprocal and very intimate relationship. If that openness were not there, that willingness to enter into a sustained mood, nothing of value would be produced.

Neither is modeling as ethereal or abstract as I have presented it. Like fashion photography itself, it might or might not be termed an art, but it is certainly a skill, a craft, a profession, a business. Obviously, a model must do more than simply stand in front of the camera relying on her natural endowments. Great models are perhaps instinctive, but successful models are those who constantly deepen their

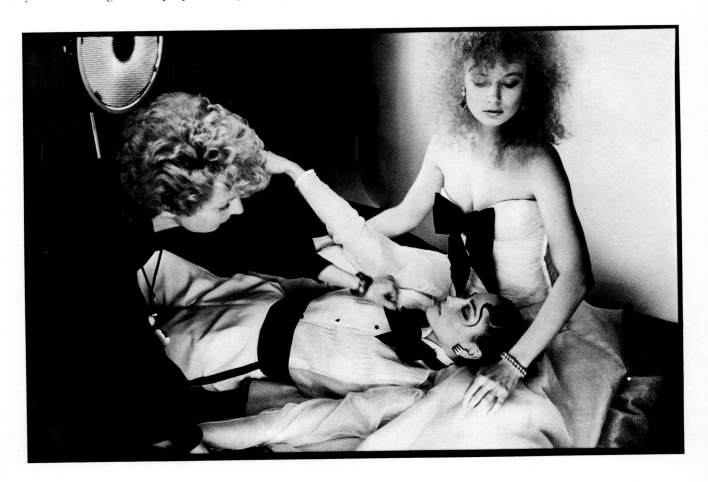

talent through self-knowledge, by learning how to transform their own beauty to something beyond its mere physical attributes. It is a process of constant refinement that begins with basic training in makeup and hair styling, learning how to move and gesture for the camera for test shots, all with the purpose of developing one's own particular talents, of becoming a distinctive presence. When a model begins to take on jobs, she learns in an entirely different way, responding to the styles of different photographers and the demands of different clients. Every job has its own requirements. She becomes involved in various images, in the way clothes are shown to their best advantage, in a multitude of movements and expressions. Even in the most straightforward catalog shot, she must have an appreciation for what she is wearing and how far she can go. In other words, she becomes increasingly aware of the many frameworks, from the most rigid to the most outrageous, within which she can still express herself. The photographer, as much control as he might have, depends on that kind of creativity and inspiration.

Modeling also has a tradition and culture of its own which substantiates the present, lending it continuity and, therefore, rich potential. One can extend back through the history of art, through the pictorial representations of feminine and masculine beauty that have evolved since ancient Egypt. Photographic modeling itself has gone through a historical development of great variety that reflects not only changes in society as a whole, but also the transformation of the profession of modeling itself. During the early flowering of fashion photography, in the early teens and twenties of the twentieth century, models were often drawn from the ranks of high society and thus exuded the elegance and haughtiness of

their class, an association that seemed suitable for high fashion. In the thirties, and especially the forties, this elitism began to break up, perhaps encouraged by the democratizing effect of the Second World War, and models of a less socially exalted but no less beautiful cast began to emerge. The fifties saw the co-existence of New Look elegance and All-Americanism, the sixties an infusion of fantasy, and the seventies an emphasis on realism, until today there is almost an accumulation of styles, a completely open field both for types of photography and types of models.

Models thus have a legacy that has brought them into the present to the point that they are now fully represented, have far more clout and recognition, face a more complex set of opportunities and possibilities, and have perhaps a greater influence on the outcome and direction of photography than ever before. Once abandoned to a kind of free-lance existence, they now enjoy the kind of organization and representation that Eileen and Jerry Ford first introduced to the industry in New York in the late forties. With the growth of the Ford Agency and the emergence of Wilhelmina, Zoli, Elite, and other agencies over the past fifteen years, the degree of model power, status, and identity has increased steadily with the competition between agencies for the best models. Models are now sought all over the world and work all over the world. They are assiduously recruited and groomed by the agencies, hopefully for stardom, more usually for the enormous range of less heady possibilities that is open to them, not only in editorial and advertising fashion, but also in television. Modeling is now accepted and aspired to, as it was once looked askance at; it is a profession, a business unto itself, one that attracts women and men of intelligence and ambition.

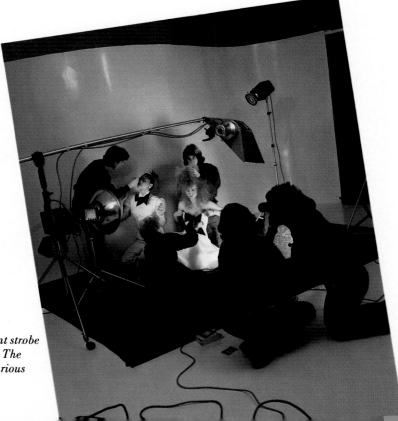

In the finished photograph on the facing page four different strobe heads were used to achieve the soft, glowing illumination. The smaller background shot shows the setup, as well as the various beauty professionals at work.

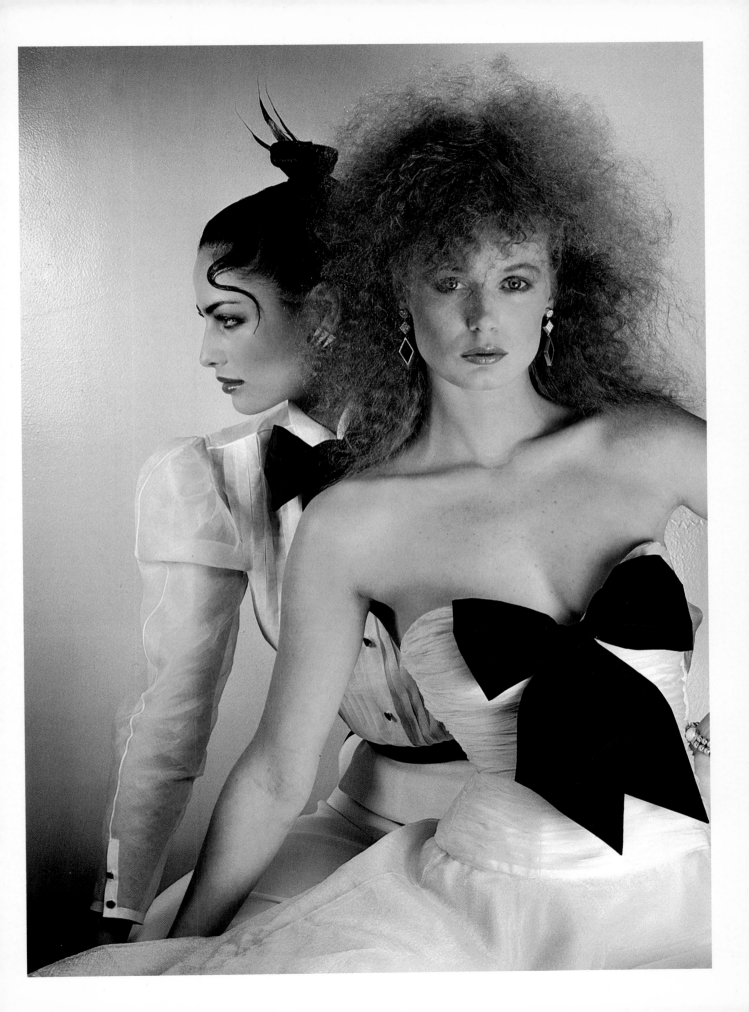

The modern modeling agency was initiated and established in 1946, when Eileen Ford and her husband Jerry Ford opened Ford Models, Inc. in New York. Despite intense competition from new agencies in the 1970s, Ford has remained the largest, representing more than 400 women, men, and children. Among the models who have risen to the top of their profession under her aegis are Suzy Parker, Wilhelmina, Jean Shrimpton, Karen Graham, Lauren Hutton, Candice Bergen, Ali McGraw, Cheryl Tiegs, Brooke Shields, and Jack Scalia. Mrs. Ford is the author of several books on beauty and modeling, including *Secrets of a Model's World* (1970) and *Beauty Now and Forever* (1977), published by Simon and Schuster.

E I L E E N F O R D

What is involved in being an agent aside from representing models?

I like to take people and teach them everything from the beginning. The hardest job I ever had in my whole life was to teach one girl to walk like something less than a baboon. Models don't have to walk well, unless they do fashion shows, but she walked like Groucho Marx, with a swayback. She was my triumph over absolutely impossible odds. Nobody in this whole agency believed she could be a model no matter how pretty she was. The main thing is getting into somebody's head and making them think like a model thinks. But, I think a really great model is instinctively good. She comes alive in front of the camera.

But can you bring out those instincts?

Sometimes. Sometimes you wonder why you said those words. I have a girl who is just now beginning to work after two years. But I finally figured out what was the matter with her . . . she spoke English with such a heavy Brooklyn accent that nobody was attracted to her. It was really awful. I got her to a speech class and she finally speaks English. It changed everybody's view of her. It's very interesting what affects people.

Where do you find models to begin with?

They usually come to me, although I go out, to Rome, Paris

. . . later on I'll go to Scandinavia, then to England, then to California for a month. There are modeling agencies and schools all over the place. I found Karen Graham at Bonwit Teller on the steps. But you have little enough time, because the best place for a models' agent is in her own office, helping her own models. The more you are away from your own business, the less it functions.

How long does it take for a model to develop?

It depends on the girl. We had the girl I mentioned for two years . . . other girls will come and work within the week, without any prior experience. Those are the girls it comes naturally to. All morning on Friday we have makeup classes. We get makeup artists to tell them what to do, hairdressers to help them with their hair. The most important training comes with test shots, which means sending them to photographers who take pictures of them for nothing, or for film and developing, because it has gotten so expensive these days that most photographers can't afford the processing costs.

Do you recommend dramatic training?

Only if she wants to be an actress. But lots of models want to become actresses. We have lost Brooke Shields, Candice Bergen, Ali McGraw, Jane Fonda.

You were the first agency to fully represent models. What was the difference in your approach?

We made it into a business. There is nobody else who did it

. . . everyone else did it to drag it down. Jerry Ford is really the one who made all the changes from a business point of view. When we started, models didn't get paid for fittings; they had no protection against cancellations. A client could just say I'm not going to do it and that would be the end of it. No model got paid by the week. No model got paid by the length a picture ran or for the kind of picture it was. If the model didn't get to the right place at the right time, the agency couldn't care less. In the old days the agencies were just there. It was an impossible mess when we started, and I have a passion for getting everything arranged properly. And I love fashion. I always like to have the right model in the right dress at the right time. The right model for the right job. Jerry, on the other hand, is very good at the overall economic picture. Everything he has said would happen, has happened. It is he who has done all the innovating, while I am the supersalesperson and caretaker. We've protected models against people we didn't think would do them any good. We've just made it how it is. We have made it into a place where a mother can send her daughter and feel safe about it, as safe as she can feel anyplace.

What changes have you seen over the years?

The thing that is consistent in our business, and it's amazing to me, is that the public likes pretty women. So the business doesn't change lookwise. Most of the women in the famous 1947 photograph by Irving Penn weren't still modelling by the time I came into the business and they are still as beautiful

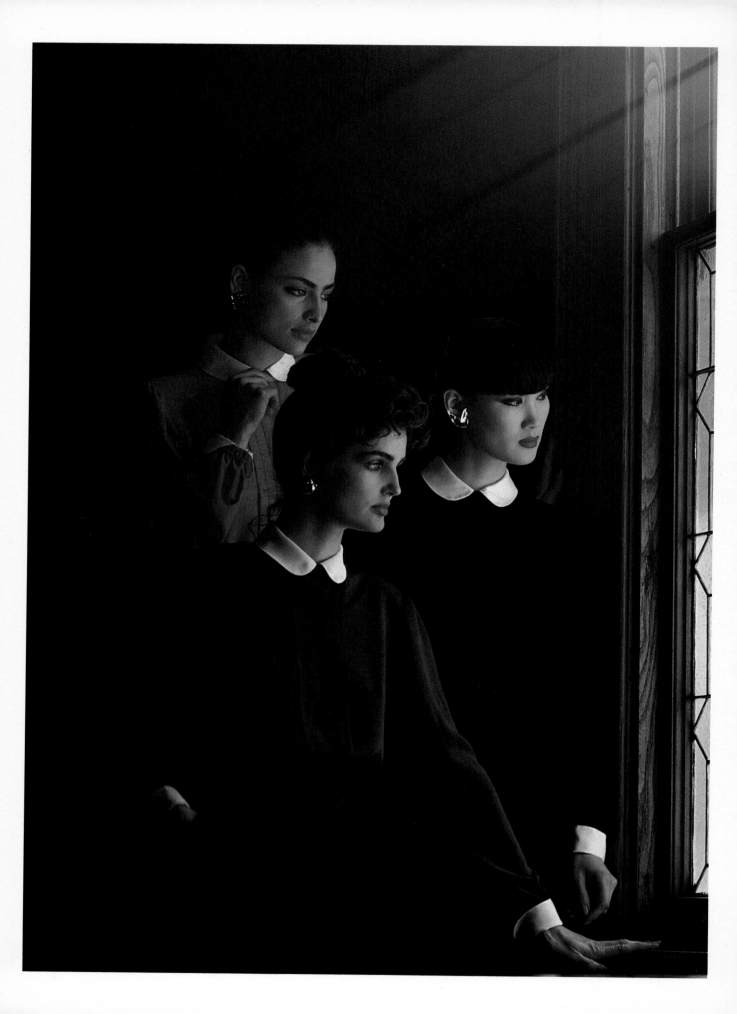

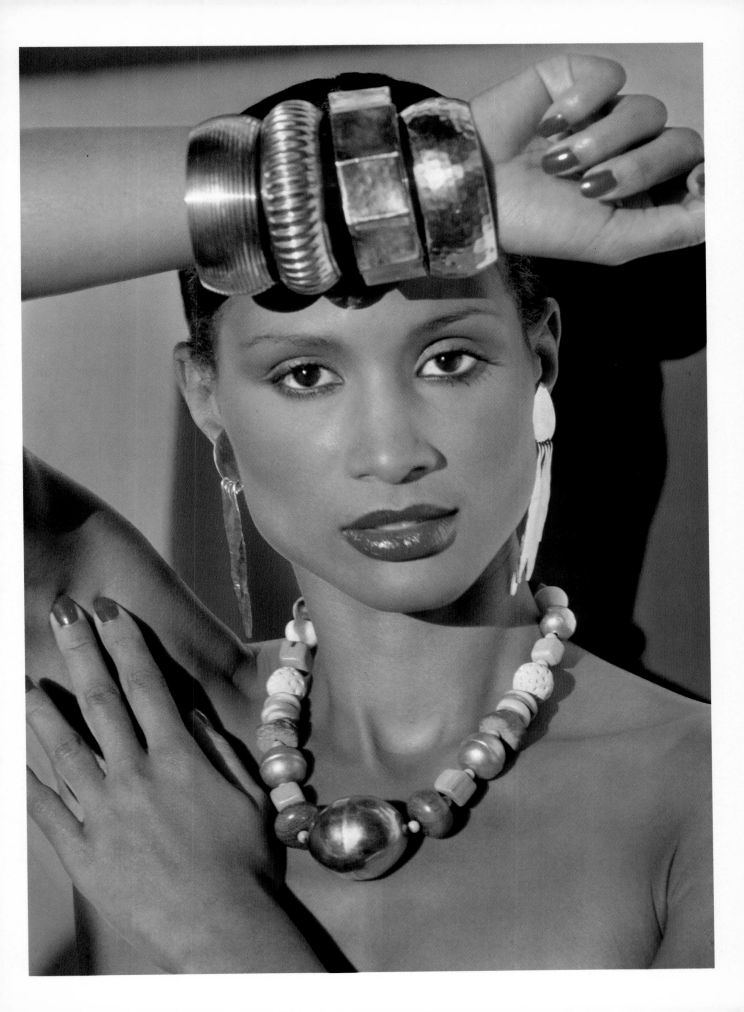

to us today as they were to other sets of eyes in those days. If I were able to find Dorian Leigh or Suzy Parker or Marilyn Ambrose today, I would be very happy.

Have the models themselves changed?

Some. They are a lot tougher. The girls are less professional. They don't take the same pride in their work. Some of them do, but I can tell you the girls who do, whereas before I could tell you that my whole agency did. They're showing everybody what big deals they are, and sometimes it's juvenile. But the business itself can't really change because it's a business of girls being photographed or walking down a runway showing clothes from season to season. It can only change economically, and the names will change. But if you look at the *Primavera* or anything of Botticelli's, you will see an ideal model. It never changes.

How do you react to the complaints about rising model fees?

The model fee is such an infinitesimal portion of what is spent on advertising. Sears and Roebuck gave as an excuse for moving to Chicago that model fees are cheaper out there.

They didn't move because of the model fees. The model fees have nothing to do with it at all. When a model is responsible for selling millions of dollars worth of merchandise—lipsticks, hair products, vodka, whatever it is—when she is used as a salesperson, how can you say she is overpaid? Without her, maybe they wouldn't sell those things at all. Montgomery Ward used mannequins for two or three seasons and it almost put them out of business. *Harper's Bazaar* lost its readership when it used real people. Really good models sell clothes, and the public is very picky about its models.

What do you see in the future for models and agencies?

My own feeling is that second-rank models are going to be a thing of the past pretty soon with model fees the way they are. People will use very good models or no models at all. The girl who was just making a living and who now insists on raising her rates to the level of the top models is going to be out of business. Those who can't afford the fees will have to go elsewhere, to other cities for less expensive models. I'll be very careful about how many girls I take to train.

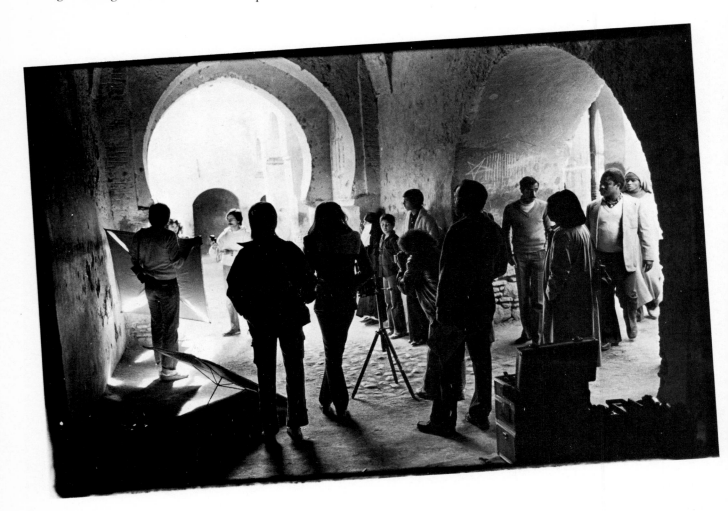

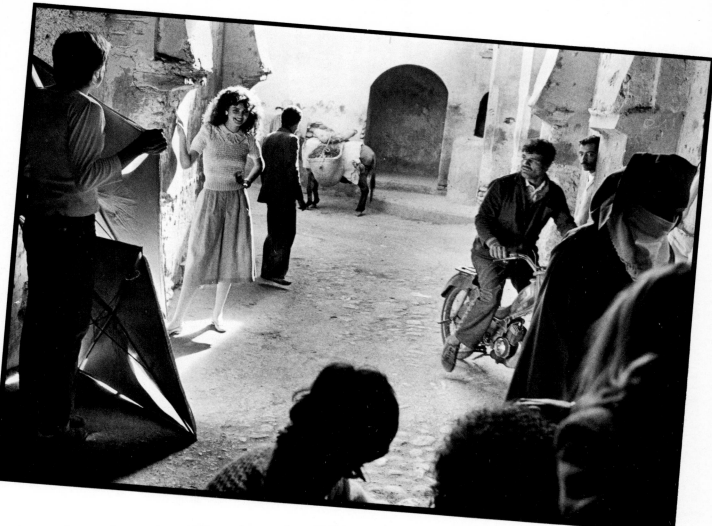

In these photographs an assistant holds a reflector to throw fill light onto the backlit model, while the photographer (and others) watches the stream of passersby come around the corner of the Marrakesh alleyway. When Farber saw a type of person and reaction he was looking for he shot a series of pictures, the final one is on the following page.

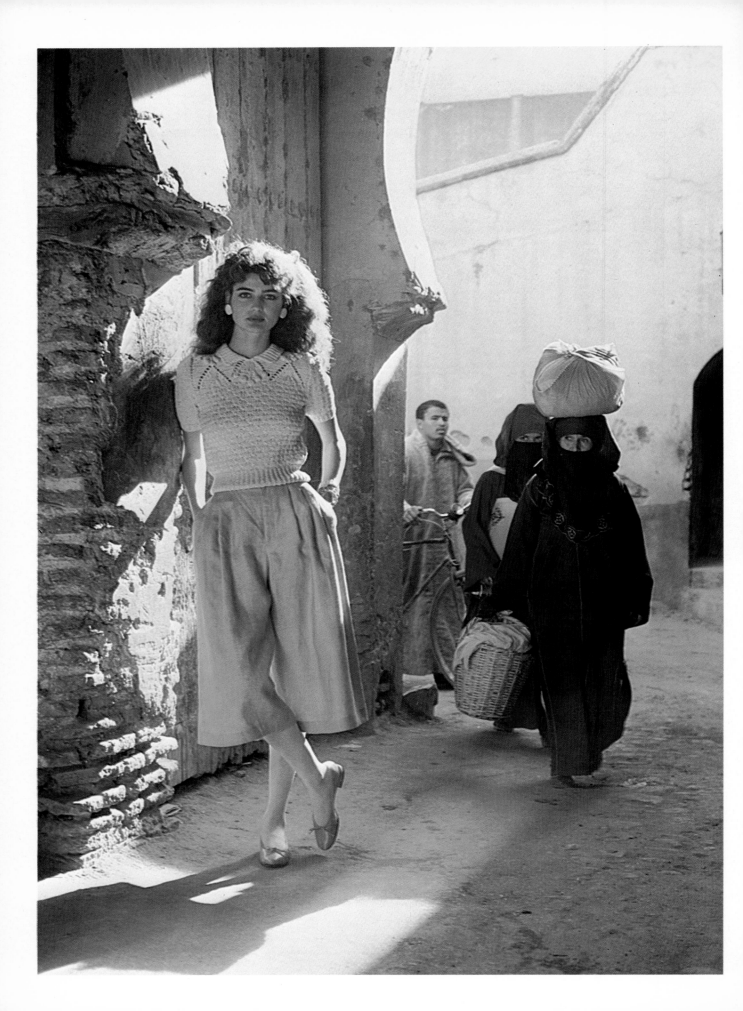

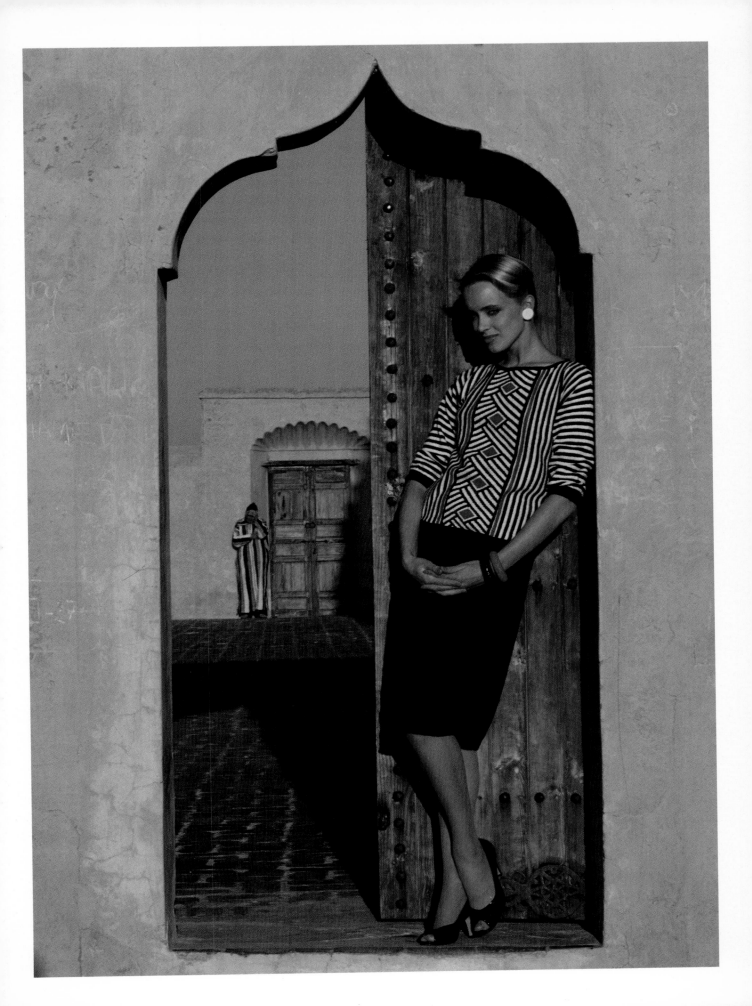

Zoltan Rendessy (Zoli) is the owner and president of Zoli Management, one of the four major modeling agencies in New York. He has been in the business since the age of seventeen, and served as director of the Paul Wagner modeling agency until 1970, when he opened his own offices. Starting with nineteen models, he has expanded his representation to 250 models, about evenly split between women and men.

What is a top model?

The easiest way to define a top model is to say that she makes top money. If a girl makes over $200,000, that's a top model. But there are girls who make less money who have all the aura and publicity going for them. She may do other things, like acting, or she may just work a few days a year and be paid very well for that. She doesn't go after every single job and work every single day, although she could if she wanted to.

Is it difficult to tell if a young woman will be a top model?

Sometimes it is. I have turned away beginners who have subsequently become top models. I have taken people I thought would become top models, but didn't. Then there are the obvious people who, when they walk through your door, there is no way they can't be. Rare, very rare.

What do you see when that happens?

Everything is there. The looks are shining. The personality is right. What that is I don't know, but it works with that person. It could be one way or the other. It could be very shy with one person and very attention-getting with another. Or it may be something you have never seen before, something unusual that everyone will remember.

What goes into the development of a model? How long does it take?

A new model has to give herself a minimum of four months,

just to be able to start getting off the ground. It's a trial-and-error thing. She has to learn how to move and do her makeup, what to give the camera, how to behave in front of a camera instead of how she has been brought up to do things. And the only way to do that is to have pictures taken and see what's wrong. An editor or photographer says, "Do this trick, do that trick," and she has to find out what works for her and slowly adapt all that into her new image so that it becomes quite second nature. She knows that it works because other people are using her more and more.

Are you involved in their training?

Not directly. I'm not out there on the set telling them what to do. I'm here in the office. My job is to get them there. When they bring pictures back, that's when we find out what can be done. This works and that doesn't. Let's try the eyebrows differently. Let's try more expression . . . it's too serious or too stony looking or you have to give a little something more. Don't hold your legs like that, or let's cut your hair . . . you have no neck in these pictures. Then try that and some improvement will be seen, and then you pick on the next thing . . . five more pounds on or off, or whatever.

Is there a different approach to men?

Not really. Women, because they are younger when they start—usually around high school age—take a little longer because they haven't been on their own. They are more insecure. The average male, however, is about right when he

hits twenty-eight, so at that point they already know something about the world. They are a little easier to deal with in that respect; I don't have to hold their hands so much.

What is it about younger men that doesn't fit in?

Well, usually a man is used for suits or cigarettes and other products that the public isn't going to buy if a seventeen-year-old is advertising them. There are lots of young guys, around eighteen or nineteen, but they don't hit their income peak until about twenty-eight, and then then they can keep going on until their fifties, if they age well. There are eight or nine male models around now who have been going for thirty years. Women, on the other hand, can go on until they are thirty-five. After that, if they are actresses or not too fashiony-looking, they can go into the TV commercial end of the business. A lot of models are too extreme in their fashion looks to start selling spaghetti or aspirin, but there are exceptions. I have one model who is fifty and is making her comeback as a fashion model. She was taken for *Harper's Bazaar* for four pages last month and went to Paris for the collections. It is possible that the older model might become more prevalent.

What do you look for in a new model?

Of course, the looks. And then, if that person can cope. In the beginning, especially, when she doesn't have any pictures, nobody knows who she is, she doesn't know what she is doing,

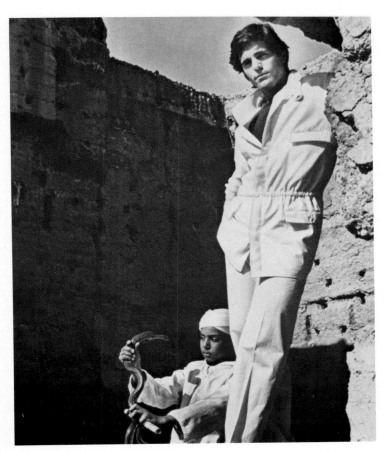

A young boy and his snakes add background interest to this fashion advertisement. This snake charmer performed regularly for tourists, and the photographer's crew hired him to sit for some photographs.

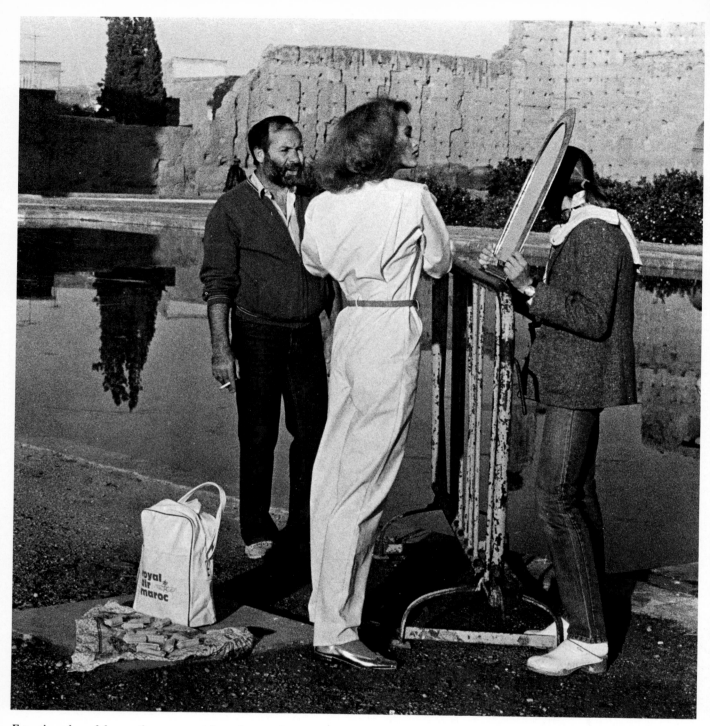

Even though models are often prepared for a shooting by a team of professionals, a good model must be able to prepare herself when the situation demands. Here an old prison reflecting pool provided a dramatic background for the white jumpsuit, but the location offered none of the amenities of a photographer's studio.

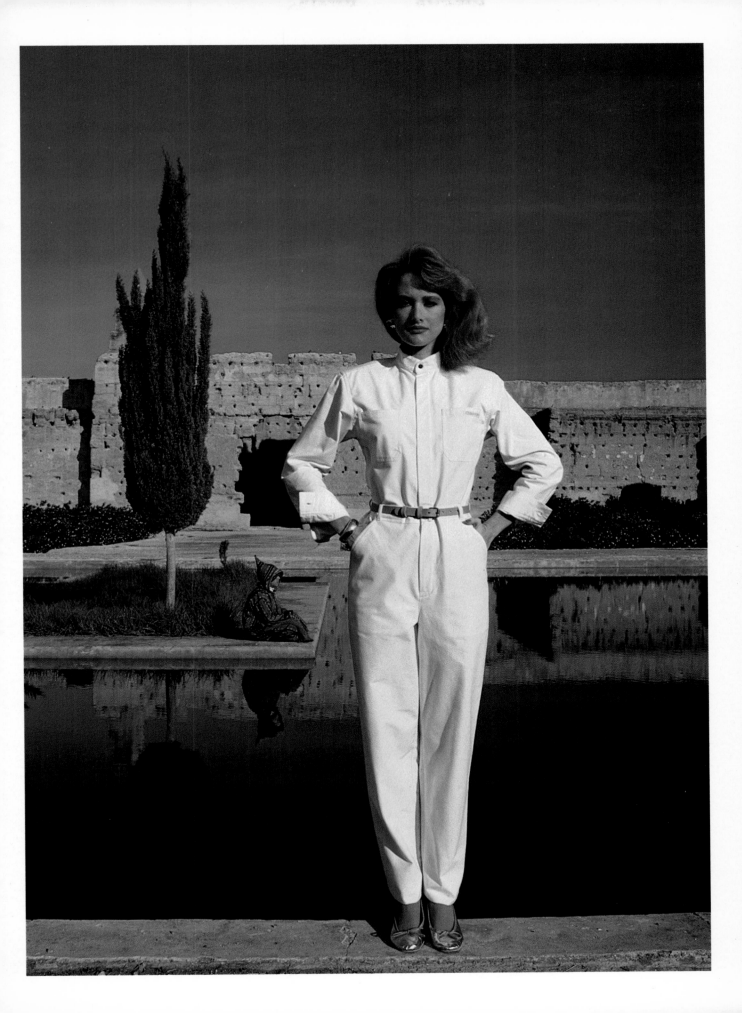

and she is here in New York all alone, she has to be able to cope with a lot of rejection. She goes from studio to studio trying to get pictures, work, experience, all those things, and trying to get known. First she goes to photographers to see if they will take pictures for her portfolio and to learn what she has to know by actually doing it. A lot of people will say, "No, I'm too busy . . . no, I want a blonde . . . thank you very much, I'll call you." Whoever starts out has to be able to handle that part of it. So I try to take people I think will be able to see it through, because if they give up in two or three months, we don't make any money either.

Do you take people on immediately, before they have pictures?

At times. Although they usually have snapshots. Then we help them get a portfolio together. Once they get on the right track and we find the right look and the pictures reflect all that, everything begins to fall into place and we have to start publicizing them, not only to photographers, but to clients, ad agencies, and magazines. Clients will not call up an agency and say, "Send me a blonde who is five-foot-eight and twenty-one." They say, "I want to see so-and-so." And our job is to make sure they know what these people's names are.

Do the established photographers look for new faces?

All the time. They'll find a new face, use the girl for three or six months, photograph her from every angle, and then get tired of her. They need someone new for inspiration. There is nothing wrong with the girl and there is nothing wrong with the photographer, but they just need something new to inspire them, or a new personality, because they spend a lot of time with each other on trips and in the studio. Then they might go back to someone they used a lot two or three years ago. They are old friends and it's been a while. It goes in cycles.

How important are the fashion magazines for a model's career?

Very important. They are showcases for models. They will accomplish more in one issue, if the booking is a good one and the pictures and layout are good, than she could running around for two months on advertising shootings. Everybody in town is going to call for her and want to use her. "If *Vogue* is using her, she must be all right," they say.

Are blondes still most in demand?

They still are. Blondes make more money. It's easier to sell them to TV. Lately we have had a whole rash of blondes in the magazines. They are still identified with the healthy, outdoor American look. It will change. In the 1950s it was auburn hair. They all looked like Wilhelmina, with high cheekbones, severe hair, big lashes—a haughty, sophisticated look. Blondes seemed sort of trashy then, plus the bleaches weren't so good. Now a lot more girls can be blonde and look natural.

Is dramatic training helpful for a model?

Yes, because they have to sell themselves, and it helps to be able to talk and present themselves in the best light. So if they

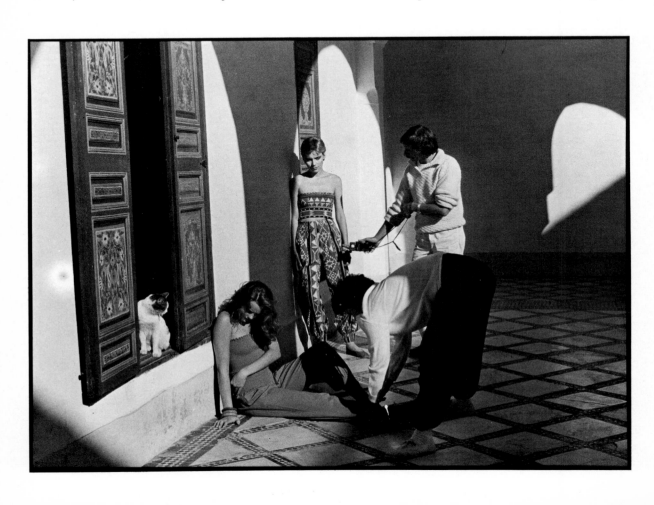

have to get up in front of a group in acting class, it helps to give them confidence for that part of the job. Some girls have to be held back, but others are shy and sometimes frightened and it helps them. We have a different ad agency or free-lance casting director here every week giving a class with a videotape machine so the models can see what they look like and how they act. So they will get up in front of the video camera and fall on their faces, and do it again and again and get input from different people every week.

What other outlets are there for models?

A lot of them go to Europe or Japan. It's easier to get started there, easier to make money, and of course they can get the pictures and experience. In some places in Europe, and Japan, naturally, there is less competition and therefore more opportunity. Americans are in demand as something special and different from whomever the local models are. In Milan, for instance, because models don't make their homes there, photographers and designers are always looking for people. Models go there and work and live in hotels for two or three months and then come home or go somewhere else. The same is true of Zurich, Munich, and even London to a lesser extent . . . lots of work and no local models. In Japan there is always a need for new and more Western faces. There is always a huge traffic back and forth because the Japanese like American and European advertising and merchandising techniques and use a lot more of our models. The models usually come back from these places with excellent money. It's good experience, they work very hard, and most of what they make they bring back home, so that keeps them going for three or four months here while they are establishing themselves.

Do you get involved in the personal lives of the people you represent?

You really have to sometimes. If someone calls crying her eyes out, you certainly have to help with whatever the problem might be. You become friends, naturally, when you work together. If they can't pay the rent, you have to help out. You have to support them, not only financially, but morally. They are awfully young and they don't know. Every five minutes some guy on the street is going to give them free advice. So they get to know us and they trust us. And if somebody trusts you and they need help, you have to come through. A lot of them really goof up and oversleep and don't show up on time, so then it is a personal problem that is making them do that, and you have to become their father confessor.

What image does the public have of models now?

It has changed a lot, thank God. Until the 1960s modeling was not thought of as being a very legitimate job. Whenever some unemployed lady would get arrested, the *Daily News* would say "Model Arrested," because she would say she was a model. So most people got the wrong idea that models were always in trouble. Then, with Jean Shrimpton and Twiggy

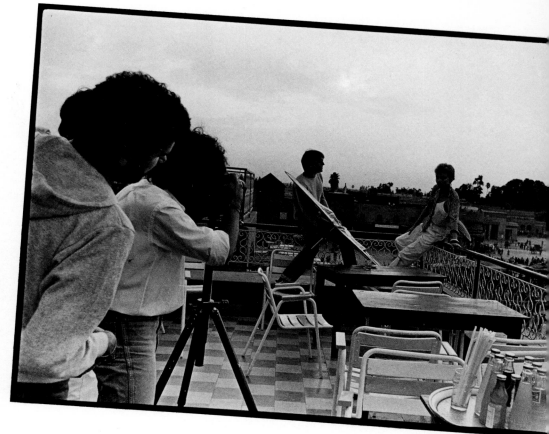

The warm, golden quality of late afternoon sunlight is very flattering to skin tones. In the photograph on the left an assistant checks the light level of various parts of the picture, while the stylist corrects the lines of the clothes and the cat watches the action. In the photograph on the right an assistant holds a reflector to light the model's face. In the background is the Souk, the central marketplace of Marrakesh.

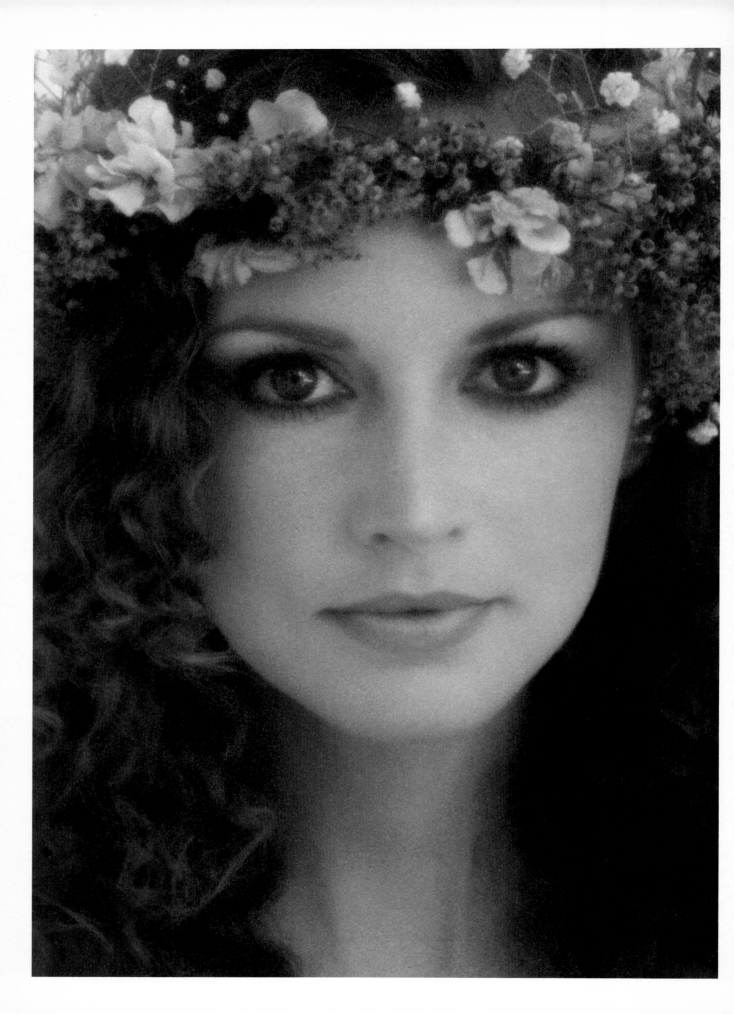

and Lauren Hutton and Cheryl Tiegs came the PR, and the image changed in the public's mind. If you took a poll now in every high school, modeling would come out on top for choice of profession. Every kid wants to be a model, whereas it used to be movie star. Same for men. Whereas before to be a dancer, hairdresser, or model was always tabu, now many of the athletes right out of college want to be models.

How do you deal with complaints that model fees have become prohibitive for advertisers?

We are talking about top models, because people are certainly not complaining about regular models' rates, which are not that high. The rates go now from $1,000 to $2,000 a day and anywhere from $100 an hour to $250 an hour. Of course it gets into time and a half after 5:30 PM or before 9 AM and travel time on trips, as well as residuals, not only for TV commercials but for reuse of photographs. Now there can be an agreement that a photograph will be used for three months only, whereas in the past the model would get paid her $60 an hour and, for ten years, the photo would be all over the place. For $60 that model was the corporation's image for ten years. She was also prevented from doing competitive advertising in the same field for the same kind of product, so she lost other work. Now an advertiser has to pay for each use for a magazine campaign, a billboard, a counter display—each is considered a different exposure, a different use to be compensated. And the longer they use it, the longer the model gets paid, because if they use it for five years—if the model is tied up as the Winston man or woman, for instance—not only will no other cigarette company use the model, but hardly will anyone else. It's like Lauren Hutton and Revlon. If you now would see Lauren Hutton in any other ad, Revlon would flash, at least subliminally.

Do you think, because of the pricing structure and the emphasis on top models, that eventually only they will survive?

They are the only ones who survive even now. But the need for models below the top level is really increasing, as far as I can see. In fact, the agencies used to be much more selective. Now we will take on numbers, and if the model makes it, fine. It's not a practice I agree with, but at the same time the business has grown, so we need lots of models, otherwise we won't survive as agencies. I grew very slowly until the last couple of years. Of course, by that time I was established, and the influx of models coming to me was greater, but I also found that in order to keep up with the competition I needed the numbers because clients were reserving more and more models. We need them just to fulfill all the requests. Some models are good for TV and not for *Vogue*, others are good for *Seventeen* and not for cigarette ads. There is more variety and more media today to satisfy. We need redheads and we need housewives and we need teenagers, all kinds of types. That means that some models will not develop as quickly or as completely as others because their type may not be in as much demand. Others may be easy to help, or need very little help, to get their careers going. For those new models who need the attention, there are smaller agencies who have the time to give it.

Is there anything you would change about this field?

One thing is that clients, as much as they yell for new faces, always hold on to the old faces. They complain about models being expensive, so I say that there are plenty of new, less expensive models around who are dying to work and want the opportunity. Take two days out of your life and see them all. Make yourself a list. But usually they would rather line up and be tenth on the list for one day of a top model than give the new ones a chance. They are afraid to take the risk and they don't want to take the time.

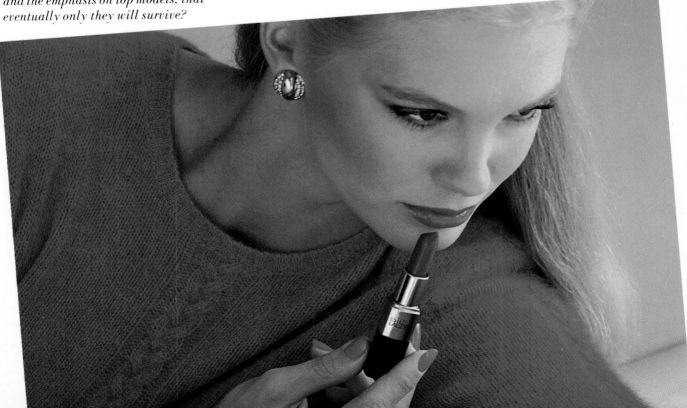

Karen Hilton is director of the women's division at Wilhelmina Models, Inc. in New York, having risen from the ranks of booker and assistant to Wilhelmina herself. She first joined the agency as an agent in 1968, shortly after its opening. She then spent several years working in television production for PBS. Following that, she worked as a consultant on drug rehabilitation in Massachusetts, and returned to the hectic world of representing models in 1978.

Do you know if a model is going to be a star from the beginning?

One of the owners here, Fran Rothchild, has said, "You can always pick a winner." But it is taking the girl who has potential and knowing what to do with her that's the hard part. That's the agency's job. You see a Kim Alexis or a Shaun Casey and, knowing what's popular and what the market is right now, you pretty much know what to do with her. You know she is going to be a star, and in exactly what category.

But even the instant successes take some time to develop. What is the agency's role in that?

Usually the development lasts anywhere between three and six or seven months. During that time we conduct classes that the girls attend. They are taught makeup, hair, how to walk, how to pose. Photographers come in to teach them. An advertising person will come in and tell them what they are looking for. I check on their progress every month so that I can see what they are doing right and what they are doing wrong, if they really have the potential we thought they did when they first walked in, or if we haven't followed up enough or if they haven't. Sometimes they just somehow lose the potential along the way in the hustle. During that period I might call different photographers and ask for a reaction. Or I will talk to a model editor at a magazine. There are girls who

can be strictly catalog models and we try to stick to that in developing them. We don't try to get them editorial exposure. Others may be good for beauty work or for TV commercials, so we guide them in that direction. I'm a firm believer in not promising a girl that she can be on the cover of *Vogue* or *Mademoiselle* or any cover at all until she knows what she can do.

How much control does an agency exercise over a model's career?

It is possible to control a model's career, plan it and control it, starting at day one up to day 365. If a girl has potential, is cooperative, and understands that the agency is really guiding her, we can make her as much or as little as we want.

Isn't that dangerous?

Very dangerous. That's why I think it's important for talent to pick their agents carefully and to get opinions from photographers and people who are objective enough to say, yes, you should do this for this reason and not for that reason. The standard that Wilhelmina herself set still goes and people remain here for that reason. We turn down money bookings just because they are not right for the model that the client happens to request. I don't know if sometimes that's stupid or smart. I know that some of the other agencies don't work that way.

Do you turn down editorial bookings also?

The agency turns them down at times because it is not most beneficial to the particular model involved. If you just take the view of the agency, then it's not the most wonderful thing for us, because then we don't get the publicity from exposure in *Vogue* or *Harper's Bazaar*. But Willie always ran this agency with an enormous amount of human interest, therefore we consider the model. This is a human service business as far as I'm concerned. The individual really has to come first. Sometimes a girl thinks she can do more than she can and we really have to hold her back, because she will burn herself out . . . she'll go too fast too soon. And it goes the other way too. With a girl who doesn't think she can do as much as she can we have to build her confidence and self-assurance. I have girls right now for whom the proper move is to go to Paris and work there for eight weeks. If they don't want to go, I will keep them here and take them with me when I go for the collections.

What is the advantage in going to Paris?

We can use our markets differently. In Paris it seems to take less time to have a model exposed editorially than in New York. We can send a model to Paris and within six weeks she can be working for *Elle*, which is the equivalent of *Mademoiselle*, or one of the European *Harper's Bazaar*s or *Vogue*s, whereas here it may take nine months.

Within the agency the booker is really closest to the model on a day-to-day basis. How does the relationship work?

In the beginning the booker makes appointments all day long

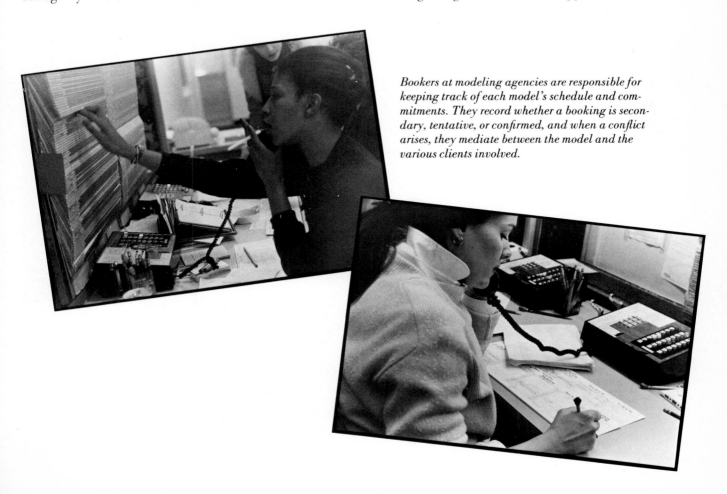

Bookers at modeling agencies are responsible for keeping track of each model's schedule and commitments. They record whether a booking is secondary, tentative, or confirmed, and when a conflict arises, they mediate between the model and the various clients involved.

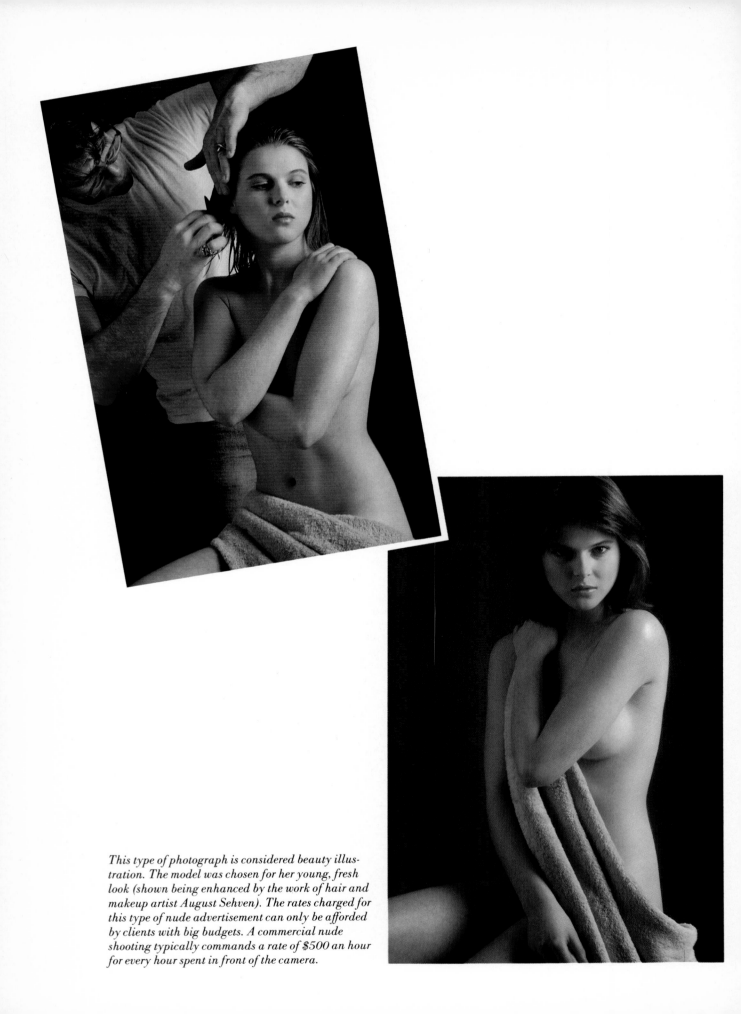

This type of photograph is considered beauty illustration. The model was chosen for her young, fresh look (shown being enhanced by the work of hair and makeup artist August Sehven). The rates charged for this type of nude advertisement can only be afforded by clients with big budgets. A commercial nude shooting typically commands a rate of $500 an hour for every hour spent in front of the camera.

"I don't use soap. I use Caress."

Caress is better than soap. Soap can dry your skin.
Caress is enriched with bath oil and delicately scented. It leaves your skin
softer and smoother than any soap can.

Caress® with bath oil.
For the soft you can't get from soap.

for a few models who are themselves just starting out. In the second and third stages of a booker's career, she becomes an agent and can negotiate contracts for products, point of purchase advertising, and other more involved bookings, as well as catalog bookings and other everyday work. Once a booker learns how to do those things, she can pretty much follow a set format for fees and conditions. If it goes beyond that, it goes to a higher-up in the company. The structure seems complicated until the booker learns where she can be flexible about fees. They usually consult with the models on certain kinds of situations (like cut-rate bookings) or very small and very large things, where the model's career is involved.

In what areas can you be flexible?

I think that is a dangerous question. My first answer would be that we are flexible with everything and, at the same time, we are not flexible. There are certain fees for certain situations—a booking is a booking—but sometimes factors come into play that make it possible to be flexible. If a girl is very, very new and needs the money, we still would not break the rule, but we would bend it.

Are you involved in the booking itself?

I'm in and out of the booking room all day. There are a few models who are more in demand right now and I go through their charts every day. Different photographers, magazines, and clients are constantly making requests for them, so that a model's chart is filled with questions which she has to make decisions on. She'll generally know which ones she wants to do and which she doesn't, but there are times when I will look through those charts and say no, no, no, she doesn't have to do those, and yes, yes, yes to others. The booker calls her and says, "Karen suggests that you don't need to do the following and you really need to do this." I try to give the models a combination during the month with the proper amount of editorial exposure and money bookings. They get really tired and don't always know which ones they should or shouldn't be doing. There are also some models who don't want to work with certain makeup artists or hair stylists or photographers. So, we find a way to say she isn't available without hurting the careers of those people.

Do tentative bookings create problems?

It depends on the model and the amount of pressure we are getting. If we have a tentative booking for tomorrow or next week and the other client calls and says he's ready to confirm, we put the client on hold who is ready to confirm and call the client who has the tentative and say, "You have fifteen minutes—or an hour, or thirty seconds—do you want to confirm or do you want to give up the time?" Depending on how much time they have, they will confirm or not. There are definite bookings, tentatives, and secondaries.

Is there a tendency for ad agencies and magazines to always want the models who are tried and tested?

Some clients want girls nobody has seen before, who are fresh, new, and haven't been exposed at all. They want the girl that fits the description, whether she is experienced or not. Of course there are always the clients who want the recognizable girl. Last year the economy hit in such a way that it seemed a lot of models who could have made a fairly decent living were kicked out of the ballpark, were totally eliminated. Clients thought that if they were going to pay that much money for a girl—$125 or $150 or $200 an hour or $1,500 to $2,000 a day—they might as well get a recognizable face.

How has the economic situation changed?

There was a time when there existed a certain stability in the model rates, now everything is negotiable and much more difficult for everyone involved.

Doesn't that drive prices out of sight?

Yes. To spend $200 an hour or $2,000 a day, I think, is a lot of money. Some photographers and clients have gone out of town. However, they don't find the level of professionalism that exists in the New York market.

You can't go backwards, though, and lower the rates.

No. It's the old peer pressure. If the models at one agency are getting $2,000 a day, I am sorry to say we have to do the same thing. I remember when the top rate was $40 an hour and it went up to $60. The catalog studios all got together and said they just wouldn't book those models, but they did. They have to use the girls and if they pay the rate enforced by one agency, the other agencies have to go along or their girls will go to the other agency. It's funny, because not all the models agree with this at all, with putting down $150 an hour or even more. There are others who say, "Fine, I have a limited time in this business and I am going to make as much as I can." These girls work really hard. I encourage bookers to go to a shooting once in a while so they will appreciate it when a model calls in the middle of the day and asks her to tell the photographer for the next job she is going to be an hour late— "I just got out of this booking . . . I still have feathers in my hair . . . these people made me crazy and I was crying . . . they burned my hair with electric rollers." Watch them do three shows in an hour, or be pinned in a catalog studio for an hour, watch what they have to go through putting makeup over makeup over makeup, hairdressers combing and cutting their ears, hot irons in their hair, then you have to say that maybe they are worth $2,000 a day.

Does the price structure mean that the agencies in New York will represent only top models?

I don't think the world is constructed in such a way that everyone can end up stars. One level of working models are being eliminated from this field. Ten years ago a young model could make $20,000 a year, and that was a healthy salary for someone who enjoyed what she was doing.

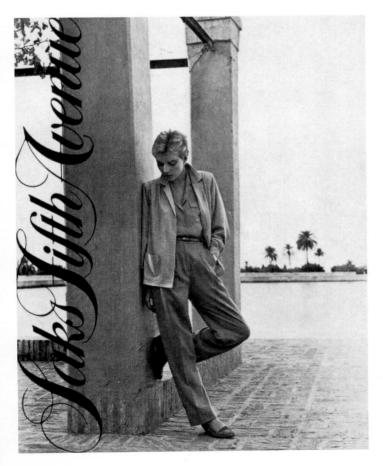

Since clients often run advertisements in both magazines and newspapers, many assignments involve shooting with both black-and-white and color film. When a photograph is designated to be in black and white, the graphic elements assume much more importance than they normally do in a color image.

But that doesn't happen too often anymore. Once or twice a year we review, like every other agency, and release some, and now when we take new girls on we are very selective and very careful. Because of the economy and the high rates, clients are just not going to pay the huge sums for girls who at one time might have made it on a more modest level. If they are not top models, they are still not going to stand there for eight or ten hours a day going through all a model has to go through and then take $500 when others are getting much more. And anyway, clients are going to choose, as long as they are paying the money, the models with better hair, better eyes, better legs, the ones who are just plain prettier.

Then models really expect to make it big?

There are some who do. Like anything else, some are more realistic than others. If the only way a girl is going to be satisfied is with a goal that is unrealistic, we can't do anything for her. In six months, when we couldn't do what she thought we should be able to do, she would leave anyway and we would have done all the work and made our investment for nothing. Let another agency try to do it. If they succeed at it, I think that is wonderful and she has my apologies and I have learned a lesson.

How important is the photographer to the career of a model?

There is no one more important in this business. He is the focus, the center of everything that happens. He is also in a difficult position. After they get the equipment and prove they can take a picture, it may take seven or ten years before they are recognized. Then they have to decide, if they get a rep, which rep. In a city like New York there are so many aspects of this profession. Now you have hairdressers and their reps, makeup artists and their reps, photographers and their reps, and so on. The photographer has a rough time because he is the one who is out there on his own and has to come up with the pretty picture, after trying and trying and trying. Then he is seeing models all the time. Just as they do for us, we do for them. We call and say, "I have seven new models. Can you take two hours out of your day and see them?" It's just like going to a convention, looking at a hundred or fifty or twenty girls and picking the one you think is wonderful from that group, but compared to what— compared only to that group. So the photographer has to be even more selective than we do. We take a chance on making a mistake, but he absolutely cannot, because if she can't perform, he can forget it. He's wasted his time and the client's time and may possibly lose the client, so they have a whole other set of difficulties to go through.

If you spent a day in a photographer's studio you would learn about the business from A to Z, and what he has to go through. He is the one who is producing it all and a lot of times he is the one who has to keep quiet, who unfortunately may not have the freedom that he might want to have. The photographer is also the one who bears the brunt when a model doesn't show up. We don't have to do anything about

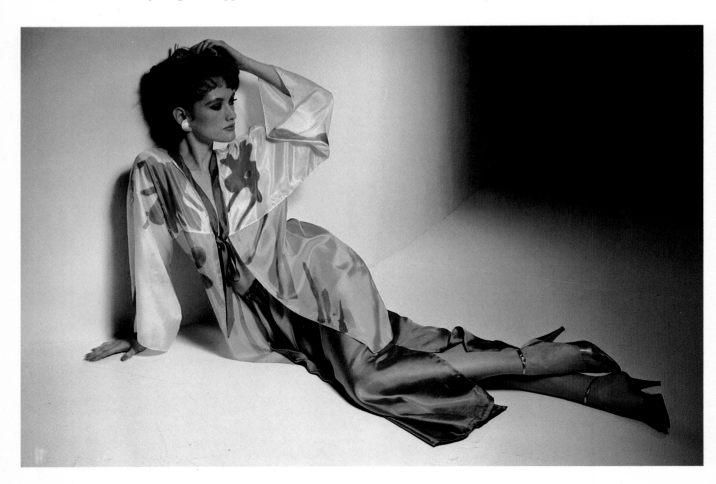

it. We don't pay anybody's fee. We all try to be cooperative, but he is left standing there with the camera. There have been a lot of occasions when we would say to a photographer, "You are taking this model at your own risk. If she doesn't show up, we are really not responsible. We advise you to book someone else just in case," But sometimes the photographer will book her anyway, and we really can't warn him any more than that. The girl doesn't show up the first time and the second time. This is the other side of the issue. When we warn them and they continue to book the model, they only encourage her behavior. But it's not always their fault. They have a client who insists on that model no matter what they are told.

What do you think of the image of women that is being projected now? How has it changed?

In Wilhelmina's day it was very sophisticated, very high fashion. I think it went from there to a more junior look, more realistic, more happy, bubbly—pretty teeth, great big smiles—in the 1960s and 1970s. Now both those things exist. A happy, sparkly junior model, big smile and all, really ought to be able to look sophisticated too. She has to be able to do that elegant, high-fashion look. But the modeling field does not change at all, because models are always portrayed as the cream of the women of the world in terms of looks. And that's what they are selling. If you are a manufacturer of clothes or soft drinks, you are going to use the model who will sell the most of those as possible. People make money from the way models look, and I don't think that has changed.

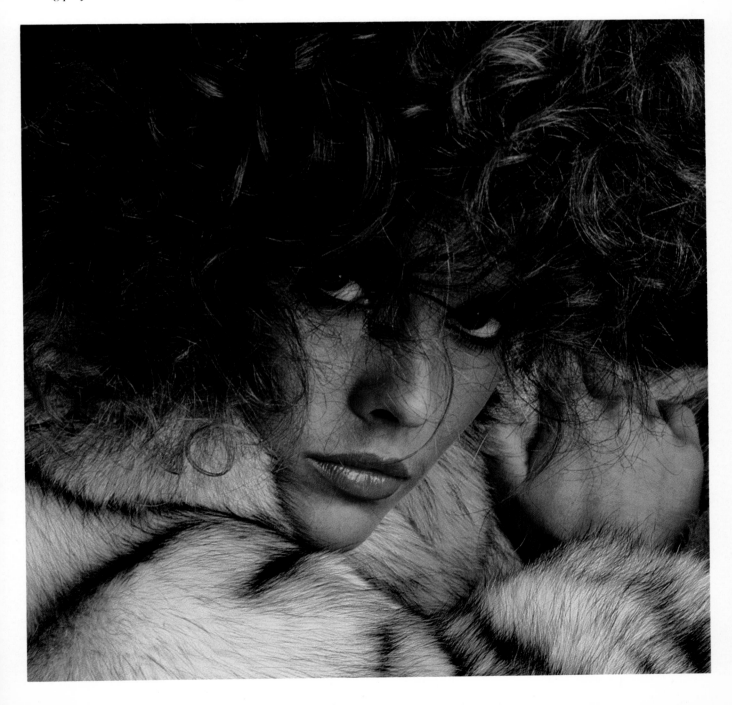

Karen Graham has been a top model since 1969, when she was discovered on the steps at Bonwit Teller by Eileen Ford. Perhaps the most elegant and coolly graceful of the models who came to prominence in the 1970s, she is known for her prestigious fashion and beauty ads and numerous covers for the major fashion magazines. In recent years she has appeared almost exclusively for Estée Lauder.

K A R E N G R A H A M

Your modeling career began almost accidentally. How did that happen?

I had just finished my master's studies at the Sorbonne in Paris and had moved to New York. One day while shopping at Bonwit Teller I got tired of waiting for the elevator going down, so I took the stairs and heard some footsteps behind me. When I looked back, there was a lady trying to start a conversation. I just kept walking, and when we reached the street she said, "Are you a model?" and I said, "No." She said, "I think you would make a terrific model, if you are interested," and told me her name was Eileen Ford and she had a modeling agency in New York. She gave me her card and I thought about it for two weeks before calling because I had spent my whole life studying for something and this was so incredibly different. That's how I got into the business, but that's not a guarantee of a job. In those days, anyway, all they did was to give you a list of names of young photographers who were trying to build portfolios for themselves the same way a model does. So for free you modeled and for free they took your picture, and hopefully about one out of a hundred would get a decent shot. Half the time you would go in to see how the pictures came out and they were out of focus. So it was a good three months before I ever built up a decent portfolio and, at long last, got my first job. I never received any kind of income during that period and I had no idea that models worked that hard. Just because Eileen or any other

agent says you should be a model, that doesn't guarantee that you are going to be successful. It's still up to you.

But it had never occurred to you go into modeling?

Not at all. I was never the type of girl who thought of making a living on my looks. I had the impression that models were "dumb blondes." It was the other girls who entered beauty contests. I think it is unfortunate that the modeling business has had a bad reputation. I was surprised when I went around and met photographers and clients and advertising agents that the business was so professional. On very rare occasions did anyone ever try to make a pass. I don't know what has happened in the last ten years because I haven't been looking for jobs. I'm called pretty much by certain clients and I go for the job, so I'm really not out there.

Are you working exclusively for Estée Lauder now?

I do out of choice. I made up my mind about four or five years ago that I had had enough of that everyday kind of thing . . . a fashion ad in the morning, then a cosmetics ad in the afternoon . . . just that fatiguing, nine-to-five everyday jumping from studio to studio, so I just narrowed down my activities and concentrated on a few jobs.

In the relationship with the photographer, how much does his style affect your style?

You're going to have a certain style no matter what. If you work with someone whose style is basically opposed to yours, neither one of you gets a super picture. For instance, I've always been the type who is reserved. I'm not flamboyant, so I've always found it hard to work with a photographer who likes a lot of jumping, swinging, and twirling. I like to work in a much quieter way. It's very hard to do something you are uncomfortable doing. It's not that I rebel or that the photographer doesn't try, but just that the picture ends up not having any real strength. With the photographers I like who are more reserved and controlled, some other models are miserable because they want to jump around and carry on. It's not that one is good and one is bad, just a difference of styles.

How much do you actually have to learn about posing and working with a photographer?

That's the funny thing. Nobody teaches you makeup, nobody teaches you how to model, and at first that disturbed me. I never had a course in modeling and don't think I have ever met another model who had been to modeling school, which I imagine are really more like finishing schools . . . it is certainly not essential for becoming a model. I was bothered because I didn't really know about makeup and had never bothered with fashion magazines. Photographers helped me more with the makeup than anybody else. And I also learned by looking at my own portfolio. I could see if there was too much shine or too much shadow. But as far as moving around

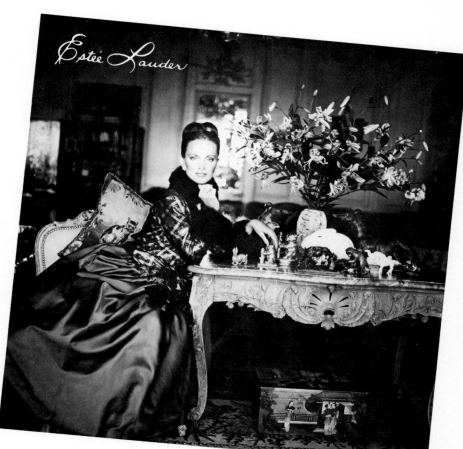

In recent years Karen Graham has appeared almost exclusively in advertisements shot by Skrebneski (as both these pictures were) for Estee Lauder. She has come to represent the stylish, sophisticated image of this perfume.

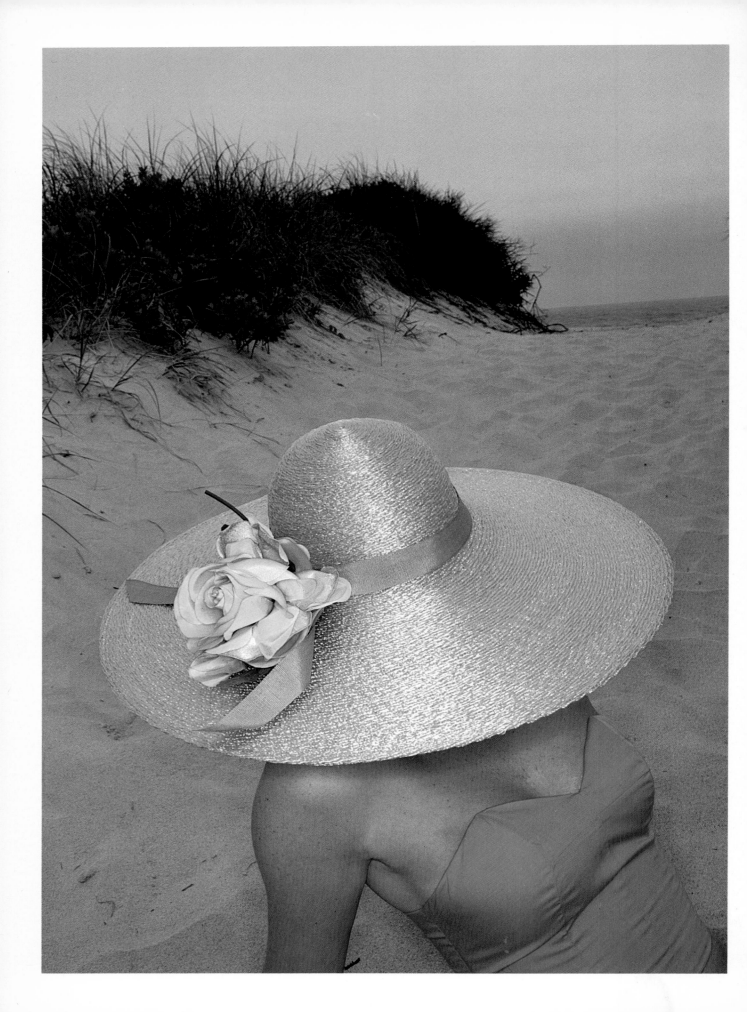

and the technique of modeling, there is really no one who teaches the model anything much except the photographer. She works with so many photographers in the beginning. In the first six months I would get out on the no-seam paper and the photographer would say, "Do something," and I didn't really know what do to. So, after a while I would just use my imagination. There is no real instruction. Now I realize that might be an advantage because it is the individual girl's personality that comes first. That is what a model really has to work on, but she doesn't realize that when she is first in the business. I always liked to know as much as possible about the job, and that would come from the photographer usually. I would ask him how he wanted me to move, what kind of expression he wanted. You have to think about modeling from the photographer's viewpoint. Ask questions . . . a lot of models don't ask questions. When I arrive in the studio I want to know if it's black-and-white or color, what the clothes are, or the cosmetics, etc. Once you get on the no-seam you get an idea of how he would like you to move or sit or whatever. Then you can come up with ideas of your own, if you know the whole story.

When you work with a photographer, is there constant communication between you?

Not too often. I get annoyed if the photographer talks too much while he is taking the pictures. There are instructions . . . the photographer will say, "We have covered it this way,

now let's get a few with a more serious look," or "with the arms stretched out instead of down." I appreciate that because it has to do with what is going on, but I can't stand it when the photographer keeps saying, "Oh, that's fantastic, that's fabulous." I very seldom run into photographers who act like that. It just makes me think he doesn't know what he is doing, that he went to see the movie *Blow-Up* and he is trying to act like a photographer.

What do you think of the situation in the fashion field today as compared with when you started?

I'm in New York one or two times a month and I only work with one photographer now, so I'm not aware of what is going on with other photographers and models on a daily basis, although I see people in the business for social reasons. But I get the feeling that some of the moral character is gone. It scares me when I see ten-year-old girls doing the kinds of ads they do. There are also a lot more shocking sexual photographs. I'd take the next plane home if we were on location, or walk out of the studio, if they asked me to do some of the things models are doing. I still like the magazines, but I don't leave them on my coffee table anymore. I'm more careful about the possibility of a child opening one up. I've seen less of that in the last year, so I hope that trend is over with.

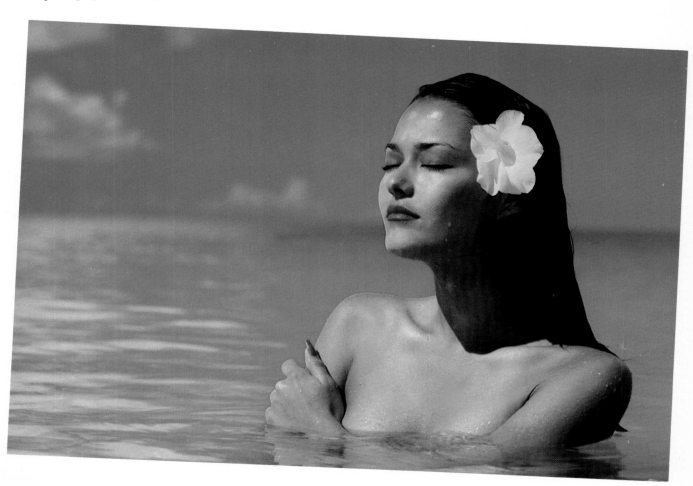

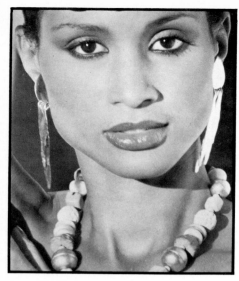

Beverly Johnson's eloquent and haunting beauty has graced the pages of major fashion magazines since 1971, when she first appeared in *Vogue*, *Glamour*, and *Essence* at the age of eighteen. Her multifaceted career has encompassed film roles and musical recordings including an album for Buddha Records, *Don't Lose the Feeling*, in 1979. Her book, *Beverly Johnson's Guide to a Life of Health & Beauty* was published by Times Books in 1981.

BEVERLY JOHNSON

How do you function best as a model?

It depends on the mood I'm in, how much sleep I had the night before. It depends on the photographer. Sometimes it can be really difficult and I do my best work. Sometimes it's really easy and I do my best work. It's whatever that magic that happens is. I can't really describe it. Even when I work with a great photographer and have the right makeup artist and hair stylist, it can be terrible. But it's a team effort and it really depends on everyone.

How do you prepare for a shooting?

In the beginning I tried to rehearse, but I'm at a point now where I go more on my creative instincts, to get some kind of spontaneity. I know what different people want. Like Saks Fifth Avenue wants a very clean line, a very sophisticated expression that says, "I've got all the money in the world," that kind of high-society attitude, or a very fresh, not offensive expression. If I am doing something for *Vogue*, I have more room to play, to be creative. I try things I have never tried before. Even with a catalog, although the expressions are all basically similar, I do try to use my imagination within that framework. But the editorial framework is bigger.

What was your first modeling experience like?

It was terrible. I was sent out on a ten-day assignment with a

photographer who was interested in throwing me into bed, and I was eighteen years old. So I went back to school. Then the check came in the mail and I came back. I started in 1971 when I was going to Northeastern University in Boston. I tried it for a summer. I did *Glamour* and *Vogue*. Then I worked part-time in a boutique and went to Brooklyn College as a prelaw student, and finally realized I wanted to be in the arts, so I switched my major to Strasberg Institute. Now I'm writing and recording albums and acting, but modeling is still my priority. It warrants the priority financially. If the book takes off, great . . . if another movie comes along, great, then I will see.

Did modeling come easily for you?

Instantly. As soon as I came to New York they liked me and used me. Then there were trials and tribulations. Just because a picture is printed once doesn't guarantee anything. But initially my first three jobs were for *Glamour, Vogue,* and *Essence* which gave me a kind of confidence.

You didn't have a portfolio or agency?

No. There was a woman I worked for in a boutique in Buffalo when I was in high school who said that if I ever got this dream of being a lawyer out of my head, I should call this woman in New York. Then I was working in Boston and there were a lot of New York City girls and they said why don't you model. So I talked to my mother, called the woman in New York, she called *Glamour,* and they liked me and gave me an

assignment . . . then *Vogue* did the same thing. When I went around to all the agencies, they all turned me down, even though I was working. I didn't tell them I was working because I didn't know anything.

What kind of assignments do you like best?

The ones that pay the most money. I wouldn't do a centerfold for *Playboy,* though they have asked me many times. Otherwise, if someone pays me $2,500 a day, I will do my best, believe me. But *Playboy* really hounded me. It was flattering at first, but at the end it was getting a little ridiculous. They said, "Well, you did a nude for Avedon in *Vogue,*" but I think there is a tiny bit of difference. I love the magazine, but for business reasons totally, I won't do it.

When you are posing, are you aware of how you look?

If there is a mirror there. I work much better if there is a mirror behind the camera. But then I never look in the camera, I just look in the mirror. Sometimes a photographer works that way, but if they see a model is going crazy, they have to take it away.

Is it hard to concentrate with so many interruptions and people moving around?

No, that doesn't bother me. It does bother a lot of girls, all the fussing. I mean, I can't even sew my own buttons on anymore; we are getting so spoiled. I go out with cleaner tags all over

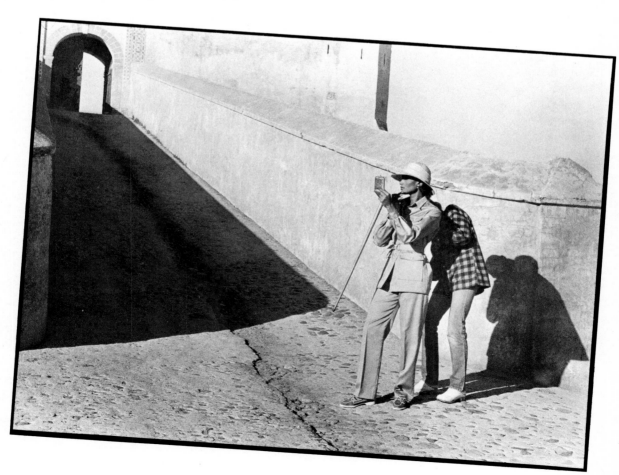

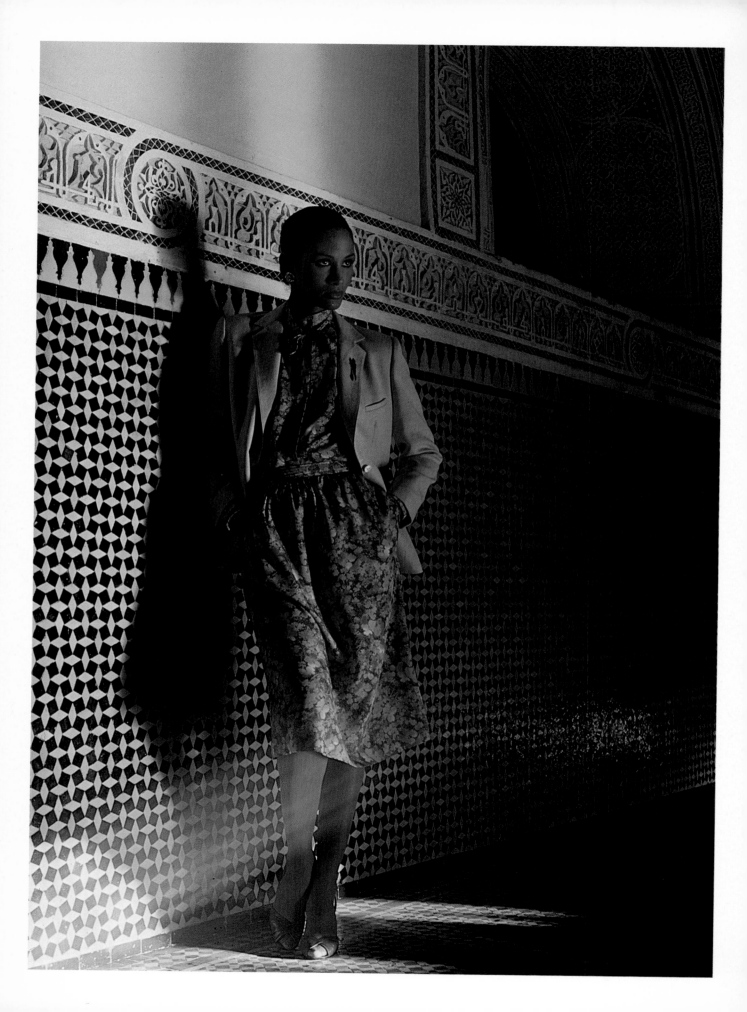

me, because I am expecting a stylist to come and throw me together. I can't wash my hair or anything. A lot of girls don't like it, but I think it's a luxury.

What criticisms do you have of the field?

I have no real criticisms, overall. It's been good to me, and all that. If you want to break it down into the racial overtones and the sexual overtones, if you want to get into depth and get a sense of what is really happening politically, it's hard to glamourize it. It's not really something that is overbearing, but it is an understood reality. The participation of black models, for instance, is unjust in proportion to the amount of money that is put into the industry by Third World people. The participation in the industry doesn't balance it. We spend millions and millions of dollars, but we don't get a chance to participate in the actual advertising and marketing. I'm only thinking of the economic side of it because the other side of it is everyone's own attitude. There are a few crumbs now, which is also economics. That's how we got into it, dollars and cents. When they took that first chance of putting me on the *Vogue* cover, which was the first to have a black woman, they didn't know it was going to double in circulation. Then they said in *Time* magazine that *Vogue* doubled in circulation based on the pictures of Deborah Turbeville. But it was because they had Chinese women buying it and Puerto Rican women buying it and Mexican women buying it. They can't deny it, but they don't publicize it. I get letters from magazines I have appeared in telling me they broke all records in sales for a product, and so forth. They can't hide it.

Then why aren't there more black and Puerto Rican models?

Why do there have to be? Why take the chance? I mean, why aren't there more black people in films? We go see all of them. Sixty percent of the film-going audience is black and Third World people. White people go to the theater and the opera. We go to the movies because they are three dollars, but we are not in them. They don't have to put us in them and we don't protest. That's the way it is.

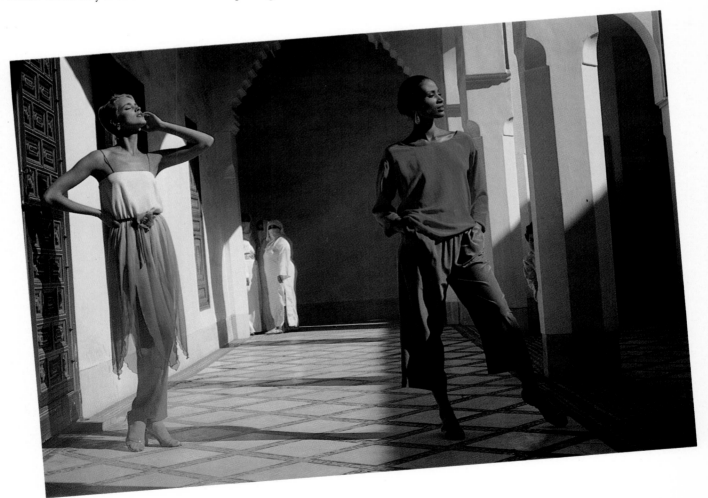

PHOTO BY ALBERT WATSON

Since she began as a model in 1972 at the age of sixteen, Patti Hansen has brought a rare variety and intelligence to her fashion and beauty images, from exhuberant youth to ardent womanhood. She has been photographed for nearly 100 magazine covers, fashion and otherwise, and has been featured in television commercials for Revlon and Chanel, among others. In 1981 she completed work on Peter Bogdanovich's film *They All Laughed*, in which she plays a New York City cab driver, co-starring with Audrey Hepburn, Ben Gazzara, and John Ritter. After eight years at Wilhelmina Models, she is now represented by Legends, established in 1981 by her long-time friend and agent Kay Mitchell.

P A T T I H A N S E N

How have you handled the return to modeling after working on a movie?

It's difficult, because people forget how times go by so fast. It's been two years really since I stopped modeling. I went to California and started acting lessons out there. Then I started working on the film, and that was a year. So, in the meantime, there has been a whole changeover in my personal self. People are still expecting to hire me and get what they saw five years ago. The young guys get real excited, you know, they see something new, whereas the older guys say, "Why don't you do this" . . . they want the control over me and they have no control. I can't subject myself to just being a piece of material. They know what they are getting before they hire me, so they can't complain. I've been trying real hard and looking at photographs and not being satisfied with what I am seeing.

Why is that?

Well, one job I just did the photographer wanted some heavy emotions. It was great while I was doing it, but of course the magazine couldn't use it because it was too heavy. He wanted tears and real dramatic pictures. Those personal things are great, but the ones that they printed were just so blah. They picked the ones where I was just staring off into space, totally emotionless. So I would rather have the energetic pictures, jumping up and down and laughing, but nobody wants me to do that anymore, because there is no such thing as a teenager. Everything is a hard, sexy life.

How have you changed?

It's always been a fight for me. Just as I am going into something else, they are picking up on the thing I just did and they want me to repeat myself. I have no complaints. It's a challenge. I know I do my own thing and I'm just pigheaded. They try to have total control, but they can't, and sometimes it works for me and sometimes it doesn't. Most of the time they want someone who will kiss their feet, but the ones who have beliefs as strong as mine will go along with me. *Vogue* is right when they say that they make stars. Once you are seen in the magazines, the advertisers, the ones who pay the money, pick up on the girls they see. So you try to put your best into the magazines. I've already got my foot there . . . I've been lucky that I have always done editorial.

Did you see your takes when you were doing the movie?

I was surprised . . . Peter allowed us to see them everyday. I totally separated myself from them, like watching my sister or something. It's strange looking at myself. When I was sixteen, taking commercial classes, people would say, "Don't ever lose that Brooklyn accent, or Staten Island accent." So I still talk with my hands over my mouth sometimes. When I watch myself on video playback I would say to myself, "Never again." It took years before I got out of that habit. I would refuse to go on commercial calls. I felt really ugly.

How can you say that, when you see yourself all the time in the magazines?

You're covered with pounds of makeup, hidden away. I've always loved makeup since I was a little kid. And it was such a battle having freckles and sisters who had blue eyes, blonde hair, and no freckles. I came out looking like my brothers. Then I started getting fan letters from kids saying, "I just love my freckles now . . . thank you." There are some people out there with freckles and red hair.

You were a kid when you started out. How did you get into modeling?

I started out with the late Peter Gert. Everything you have heard is true about selling hotdogs at my father's stand in Staten Island, coming into the city and meeting Wilhelmina and Kay Mitchell all in one day. I was sitting in my bikini with my girlfriend. It was summertime and I was burnt to a crisp and extremely skinny, and extremely innocent. This older man with a beard came to the hotdog stand to meet me. It's so weird to look back on it, it's like going back to Disneyland. The first time you are there it's so unknown and large and you go back and it's just there and you are like a giant. So he came to my father that night and said, "I think your daughter can be a model," and my father approved because we had grown up next door to the guy who introduced us. They put me in a blue and orange gown with black platform shoes. I used to wear false eyelashes and white lipstick and eye liner and they took it all off. That made me very nervous. They just put a little lipstick on my cheeks and I felt awful. I thought I looked like a little kid. Peter took me to this loft around Twentieth Street and we went up in this

Patti Hansen was discovered at age sixteen by the late Peter Gert. This photograph (by Peter Gert) is from her very first modeling session.

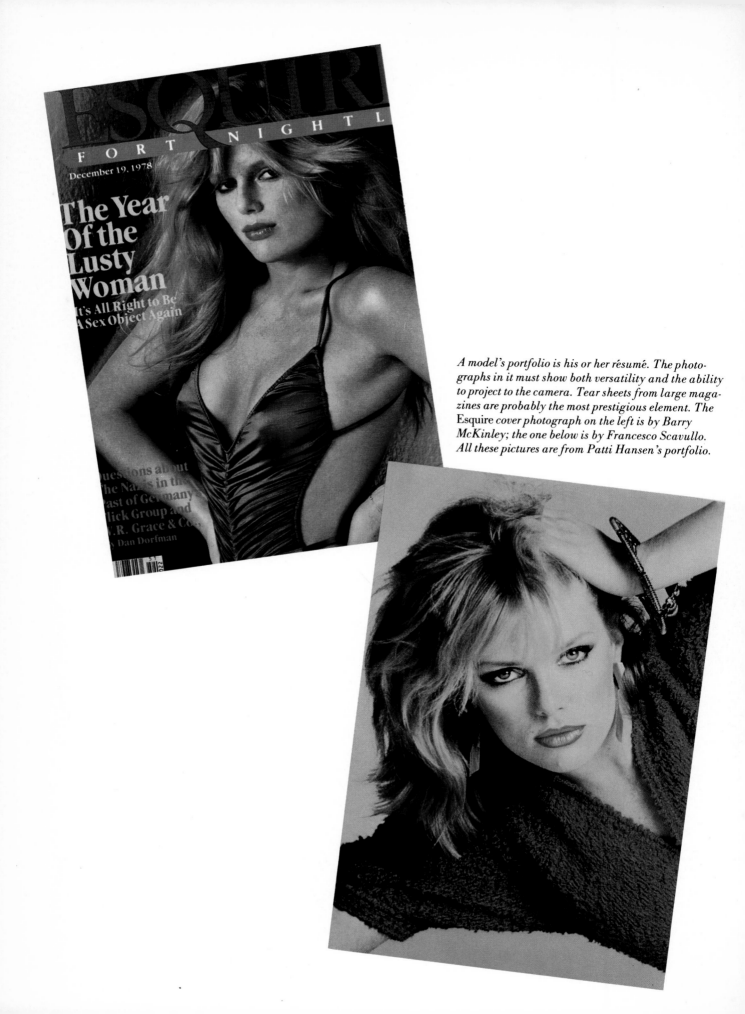

A model's portfolio is his or her résumé. The photographs in it must show both versatility and the ability to project to the camera. Tear sheets from large magazines are probably the most prestigious element. The Esquire *cover photograph on the left is by Barry McKinley; the one below is by Francesco Scavullo. All these pictures are from Patti Hansen's portfolio.*

dinky elevator to his studio. That's where I got dressed, and I didn't know who I was with and where I was. He was a total gentleman, but not knowing, I felt I was in a maze of large, dark buildings. I was in New York once before when I came in with my mother on my birthday, and I used to come in with my friend and go to Paul McGregor's to get my hair cut. I felt tough then, but now I was with an older man going into a world where I didn't know anyone. I wasn't the type that could just go to a party. I walked in and he showed me over to Kay Mitchell. I sat down next to her, and from that moment on she took me under her wing. I sat there all night talking, or not talking at all, just looking and observing all those girls with bleached hair and gold lamé pants, and wearing nothing, and it was just unbelievable. I felt like I was in some different land. Peter introduced me to Wilhelmina and I tripped, of course, fell right over and shook her hand. And she said, "Come back, I'm going to Europe, come back and show me a few pictures." I don't remember anything after that. I just blanked out and wound up back in Staten Island. So Peter had taken three photographs that day and a month later I went back to the city. I went around and the photographers said, "Go home, honey." Freckles, nothing worked, they wanted something sexy. When I did a test it was always, "Let's take off your blouse," and you knew that their eyes were just on you. They would be reading your palm and telling you, "I see you're with a young boy now, maybe you should go with an older man"... doing this whole number on you. But a week later I was working for *Glamour* in the Hamptons.

It was the summer between my sophomore and junior years in high school and I never went back to school because by that time, all of a sudden, I was making huge amounts of money. I was going to Antigua and Barbados and all those islands for the magazines. So Wilhelmina had a meeting with my family and said, "You know, your daughter has the potential of making $100,000 a year," and they were stunned . . . "Her, that little goose over there, you've got to be kidding." So I went to that professional children's school four times and never went back.

You were saying that your image has come back now to what it was five years ago.

Yes. Somebody was just saying when I came back from vacation . . . he saw me running around without any makeup . . . I still look like I did when I was sixteen, plus a few lines. But I haven't been working, I'm madly in love, and just feeling so great. And not being in the business much . . . it makes it a little hard. When you see people every day, it makes you a little shy and withdrawn. Now when I do some modeling I get so nervous I actually start breaking out. Last time I did this *Bazaar* cover the makeup girl had to put on four layers of makeup to cover it. Then once you have the makeup on, it starts all over again. I get out in front of the camera and I say, "Wow, here I am again," and it's real easy and I love to do my job because I know I'm good at it. Everyone forgets to compliment models because they think they hear it all the time, but they never hear it. It's wonderful to be complimented and on top of it all over again.

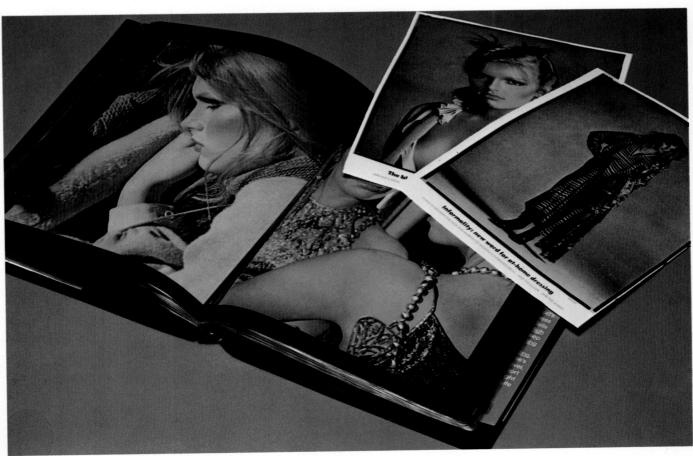

What came in between?

I went from being completely natural and jumping and screaming and carrying on with *Glamour* and *Seventeen* to the still lifes of Scavullo and Avedon . . . *Vogue* and very sophisticated. It was great because that's when I learned actually to throw everything into the camera, doing everything with my eyes instead of my body. It took time, learning that communication. Before that I had a great time, jumping around in the water. I was known as the athletic type. They would hire me for the big mouth . . . you know, this kid will do anything.

For five years I did all these jumping-jack things for young magazines and then I thought it was time to grow up, because all the guys used to look at the magazines with Karen Graham and Lauren Hutton. They never looked at *Seventeen* and oohed and aahed. So I split for Europe for a few weeks and I lucked out again there. I had dinner with Johnny Casablancas of Elite in Paris, then I met this photographer who took me to Rome the next night and I did the collections there with Verushka and Vibeke. I painted my face to hell. I had white face, black eyes, red lips, frizzy, frizzy hair like a real vamp and I did this whole issue and the cover. The photographer gave me the contact sheets and I came back and showed them to Francesco Scavullo, and the next day they booked me for an American *Vogue* cover, because now I was grown up. Before they had said you have to let your hair grow another inch, give us a few more months, maybe you can work for us.

From then on it was working with *Vogue*, the older magazines, and all the heavies of the business.

With Richard Avedon and Irving Penn?

Yes. I always had a difficult time with Penn. He's very still. He's wonderful and I am intrigued with him. I find that we have some kind of battle between us. I admire his work so much and I love the way he makes the girls look, but I don't have the right shape or form somehow. Last time we almost connected to make a great photo. Sometimes the things I think are really bad come out great, and sometimes it's the other way around. After a while I could sense what is right. I know how I should move, but half the time I'm not allowed to move that way, and with him I move into it and he shoots before I can get to it. He works so totally different from anyone else. He'll tell me to stop when I'm not there yet, and I become intimidated and it's really frustrating, because I really want to give it to him. Before I said I don't want to work for him, but now I admire him so much I want a photograph by him.

How much do you learn from photographers?

That's how you learn everything, really. One photographer makes me feel I can be a real sexy lady. Another makes me feel young at heart, and that's how he thinks. Then all of a sudden I'm working for *Vogue* and doing all these other things. I've learned how to play out different types of people. That's why I wanted to get into acting. After eight years of

A fashion photographer is often asked to shoot still lifes as part of a catalog. Hiring a separate still-life photographer is not only an additional expense but may destroy the continuity that a single photographer brings.

modeling, it gets a little restrained. I want to keep walking in a shot, I want to play out the role.

I've become very critical of myself. I know every single little line. Everyone says my nose is straight, but I know it's crooked. It doesn't bother me, but I know it and I have to make it work for certain photographs. They don't understand why I look right sometimes and other times I don't. But there are certain angles. When I'm thinner I can show my face in all different directions, but when I'm heavier I have to stretch out or tilt my face up for certain shots. There are movements for the whole body to make it look better but it's not that one side looks better. It's the shapes and forms that you make. Stretch it out and make your ass look fatter and tighter and higher, make your tits look fuller. It's wonderful, all these little tricks you can learn. It's too bad you can't walk like that.

*But your talent for modeling seems to be a
natural one.*

Once I was doing a Chanel campaign with the model Keith Gough and I was quite aware of this girl. Keith would say, "Look at her, she's just sitting there and she knows exactly how every part of her body looks," or, "did she know that every movement of her hands was so graceful?" That always stuck in my mind . . . is it conscious or unconscious? I guess it all becomes part of you in your life, certain things that you do in a photograph. You join both things together, from your real life to the photograph and from the photograph to your real life.

*Is that because you are constantly seeing
yourself through the eyes of other people or the
camera?*

Yes, I'm aware of the angles of what would be more pleasurable for them to see. There are a lot of different looks I like, so I have to figure out which one, but I always come back to the messy hair, jeans, and open sweater, and always black eyes. Sometimes I used to hate it because I became so damn critical of myself. It's frustrating when I wake up and look in the mirror, because I'm so used to seeing myself made up by different people in different photographs. It always looks the same way when I do it. I get bored, so I want to call them up and say, "Come over and make me look like something else." That's the great thing about makeup people or hair stylists. You have to give them the opportunity because you have to be constantly changing. You can't get locked in. I got locked in a lot, especially in the beginning. Now I'm getting over that. The movie was good for that. Without wearing any makeup, it got me away from a lot of hangups that modeling had started to bring on me. I began to realize that this was my bread and butter and that the more good pictures I did, the more I would get to do.

Is that maturity?

I never wanted to be that, but this last year every single part of my life changed. The awareness of so many things . . . I was crying all the time. I was so upset that I was changing and all of a sudden I realized what certain people were after. I always

knew, but I never let it bother me. Last year everybody hurt me. There were all these games being played and I got extremely depressed, and I hated being depressed because I had never been depressed before. Should I go to a shrink, what should I do? Then my friend [Keith Richards of the Rolling Stones] came into my life and took me away from all that. I guess that's exactly what I needed . . . after all this time there is finally someone I love so much and I feel it's reciprocated. Being away and learning all about him, nothing else matters. Before I was out all the time at the discos because I didn't want to be alone. It's lonely. So many kids get caught up and screw themselves around. I can see that you have to be a strong person to get it together if you don't have a strong family. I really depend on them for a lot of love and understanding, whereas there are so many kids who just hate their parents. They come to New York and do everything to rebel. Then they become stars overnight. Then they get into all sorts of things. I have nothing against people who try drugs—I've had my share, I won't talk about anything unless I've tried it—but most of them get hung up on it. It becomes automatic, running away from problems. It happens when they are all alone in New York, no one they can trust, only a bunch of old lechers who keep hanging around their doorsteps. I've watched more and more girls disappear from New York with nowhere to go and they don't know what to do. It's good for me to have my family nearby. When I come back from a trip they kid me, "Hey, ugly, you put on a lot of weight this trip . . . when are you going to quit this job and come back to live with us?" And then for them to fall in love with Keith like I have, it's great. It just completed everything. I couldn't be happier now.

Did you expect them to be so accepting?

They are extremely protective. So I would say, "Damn it, there's no one I could bring home because you don't think anyone is good enough for me. You can't do that to me. You're giving me a lot of heartaches." Then they started thinking and they were much more understanding than I was. They came to me and said, "It's cool, we understand." When you're a kid you say, "You don't understand anything, you're not in my generation." But they are so damn open and so aware. You sit down with your mother and all of a sudden you hear the truth, and then you want to stop them, you don't want to know that they might have another side than the one you have known all your life. It's just amazing. It's wonderful, it's so wonderful growing up.

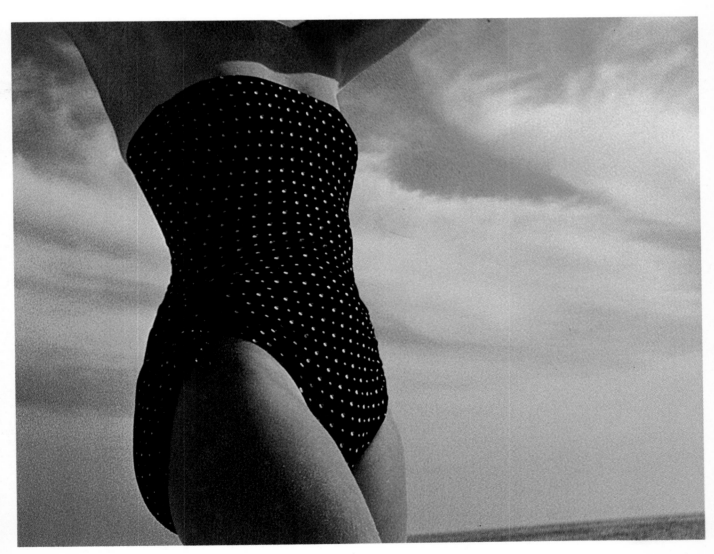

After a promising baseball career with the Montreal Expos was cut short by injury, Jack Scalia turned to modeling in 1975 and has since become one of the most recognized and sought after male models in the business. His credits include almost every major men's clothing manufacturer, the memorable ad for Eminence underwear, editorial work for *Gentlemen's Quarterly*, *Vogue*, and several European magazines, and catalogs for Bonwit Teller's, Bloomingdale's, Saks Fifth Avenue, and other department stores. In 1981 he co-starred with Rock Hudson, Suzanne Pleshette, and Brenda Vaccaro in the NBC mini-series *The Star Maker*. Jack Scalia is represented by Ford Models.

Modeling is a second career for you. How did you go from one to the other?

I started out as a baseball player. I was a pitcher, first draft choice of the Montreal Expos, third in the country. They had a lot of hopes, and so did I. I was touted as a future twenty-game winner, but an injury prevented me from going any further after three years. It was devastating, all the time and effort I put in, all the love and friendships. So after that I lived in Sacramento for a while, digging ditches, working in a Campbell's Soup factory. One day I stopped into a modeling agency there called Manikin Manor with some pictures I had from baseball. Whatever potential I had as a model, I guess they saw it. I just went in for kicks because I heard you could make thirty dollars an hour, and I was only making five, breaking my back. I had already looked into it in Palm Beach when I was playing ball, and they told me I was much too heavy . . . I would never be a model. Then I was introduced to Jimmie Granet in San Francisco, who owns the most successful agency in northern California, and he took me into Vidal Sassoon, chopped off my shoulder-length hair, and put me in a national ad. But I started learning then I couldn't get every job. I thought I should, even if it was for a blonde, blue-eyed guy. After some success there, I came back to New York to take it by storm with twenty dollars in my pocket. No agency would take me. It was a bad time for business in the recession of '75, so Joey Hunter at the Ford agency suggested

I go to Europe and grow up a little. After about a month in Milan I started to work a little. I spent six or seven months there and came back to New York. One agency wanted to put me on a test and I refused because I had done a lot of work in Europe and had a good portfolio. Then Joey Hunter took me on and I worked the next day on a go-see, and that was sort of the shape of things to come.

Did the fact that you were already a performer as a baseball player help in your modeling career?

Not really, because at that time I was extremely insecure. Performing, or modeling, fed the shell of the ego, but it wasn't the spirit, the inside of Jack Scalia. It helped me put up a front, because that is involved in performing, but that was only the shell. It made it much easier for me to take compliments, to build up the outside, but I didn't have the awareness of myself as a person. And that is especially important in the business I am in. As a model, you are suddenly making thousands of dollars and people are feeding your ego, just dealing with your physical person. That's how you learn to relate to them because that's all they want, that's all they have a chance to work with, the business being as transient as it is. There is something I call "toxic-strobe-shock syndrome," which comes from working in front of cameras too long and then believing that you're number one and should get every booking. My morals are intact, but they were very shaky. This isn't a business that deals with morals and values.

What did you have to learn to work with photographers?

Not to take anything that happens on the set personally. I'm the kind of person that would like to fix everything, so if a photographer and a client disagreed, I would want to tell them how I think it would work. I had to learn to accept what was happening. Also, there is a timing you develop with a photographer. I won't just stand there with one look, but I will keep talking and moving around without getting out of the frame, projecting different feelings. It's working as a team and getting used to different personalities, different ways of doing things, different types of lighting.

How do these differences affect you?

Now I usually know what they want. In a catalog studio they want the heavy Jack Scalia look, the raised eyebrow, or the smile, like I'm thinking, "I love this polyester suit I'm wearing. It took 200 polyesters to make it." But basically I am just myself. They wouldn't have me there unless they wanted what I can give them. They sort of know what I am about now and they will say, "Jack, give me that look." But I appreciate it when the photographer gives me some insight into what the shooting is about, so I will ask them what they want me to do. Sometimes I will look at the layouts, if it is a big promotion, to get a better idea of my role and the whole feeling. But for a basic catalog shooting and some other kinds of bookings, you know what is going to happen. Sometimes when you are new to a photographer and he is new to you, or

new to the business, he might tend to rush things trying to get the right expression . . . "Give me this, give me that, etc." They have seen the best you can do and they want that repeated immediately, but you have to get into it, and they have to get into it, you have to warm up to it, just like in baseball.

Do you do much editorial work?

When I first started, I did in Italy and New York. I did some for *Vogue, Cosmopolitan*, and *Mademoiselle*. The recognition and prestige are great, but you make no money at all. It's more interesting for a photographer. He has more leeway and creative freedom. For a model too, to a certain degree, but I know I am only getting $150 a day, which is still a lot of money. Also, you might work until one o'clock in the morning, and then the woman is featured, except for a magazine like *Gentlemen's Quarterly* . . . so you see only a hand or you are in the background. If it is a photographer I really want to work with, I will do it. But I have acting classes now three times a week, from seven to midnight, and I need the time for myself too.

Do you keep tight control over what you do, or do you leave that up to the agency?

I don't do liquor ads and I don't do underwear ads anymore. I loved doing the one I did [which was displayed on bus shelters throughout New York City]. It brought me a lot of recognition and I got to work with a great photographer,

Francesco Scavullo. The ad was well received and the money was good, but I am a shy person. I'm Victorian in a lot of ways. I believe in the family, I believe in God, I believe in my country. I'm pretty tight with those three things.

I won't work with some photographers. There might be problems when a photographer gets on your case and he is really mad at something else, or sometimes they treat you rudely, like a piece of meat. I get a little bit too strong on that point, but I guess I feel I have to make up for lost time. I try to catch myself now and just go with what is happening. You watch the pressure going from the client to the art director to the photographer. But ninety-five percent of all the people I have ever worked with have been super.

Are male models affected by being second string, because female models play a more important role?

It's been that way for a long time. But there has been a change in the past few years, with designers producing important male lines and being known for them. There can be competitiveness. I sort of chuckle and say, "I'm making the same amount as she, so what's the difference." I get an idea when I walk on the set of what it's going to be like. A photographer will say, "What do you want Jack for?" and the agency says, "We are using him for background." If someone asks you if you want to make $500 to stand behind a girl for three hours, you've got to be crazy to say no. But there are times I have turned them down.

The photographer must be aware of how the image will finally be used in a publication. Here, for example, Farber knew that these photographs would be spread across two pages and consequently left room in the middle of the shots to allow for Bride's *magazine's "gutter."*

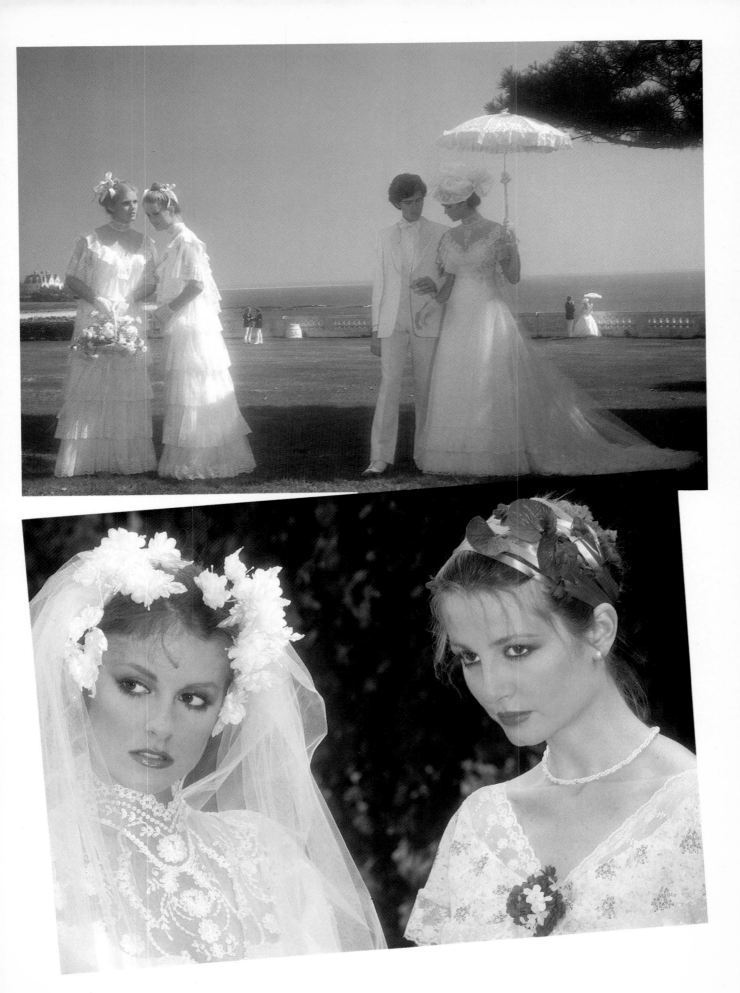

Underflair!

A few bare inches of smooth, supple, **shape-showing** maleness in soft Egyptian cotton.
In colors that dare. In stores that care.

Le French Brief by
Éminence® PARIS

Eminence International Inc., 12 West 18th Street, N.Y., N.Y. 10011.

*How does it affect your everyday life to be
recognized as a model?*

I have a hard time accepting and identifying with the
recognition I get, but it's the career I have chosen and that is
part of it. I'm sure Beverly Johnson and Patti Hansen must go
through it a hundred times more than I do, because women
models get more exposure, but now it is starting to move out
in the men's world. I have a hard time dealing with the
recognition as part of the residual effect of being a practicing
alcoholic and drug addict, feeling I'm not worth it. I lived on
that lack of self-esteem and did a lot of things to prove my
lack of worth. If you have ever seen *Raging Bull,* that is the
closest parallel to what it was like. What Robert Di Niro
portrayed about Jake La Motta in that movie was what I was
doing to myself—I mean, banging my fists against the wall
until my knuckles were broken, banging other people's heads
against the wall. The rage, the hate, the self-destruction was
my life. But I say that now with all due self-respect.

What got you out of it?

My girlfriend Joan Rankin, who is now my wife, leaving me
. . . losing friends by alienating them totally, either by
threatening them or all the little tricks I pulled . . . and then
jeopardizing my career. Clients would say, "We think Jack is
a great model but we don't know if he is going to show up. It's
a big campaign we are doing. We don't know how he is going
to look. He may be drunk when he comes in, or stoned."
Also, I think, God touching me, letting me know that I had to
do something with my life. In fact, I was on a booking in
Germany and I was on the eighteenth floor ready to jump out
the window. Either I had to accept what I had been doing in
my life and and fight back, or that window was right there.
That's not an exaggeration . . . that was my reality all the
time. I had made plans to go into a rehab center when the trip
was over. It was a two-week trip, but on the third day I flipped
out, I bottomed out. I called Joey Hunter at Ford and said,
"I've got to go now or I won't make it. I'm ready to cash in."
So I went into the rehab center then and I have taken it a day
at a time since then. I know that's all God has given me the
strength for, based on my record. If I project a week or a
month, I know I will go crazy. You get a lot of support, but
you really have to do it yourself. I realized for the first time
that I had a choice. It's the only disease in the world that
people can help to arrest by themselves, without medicine of
any sort.

*Do you think that models make too much
money?*

To be truthful, when it comes to the end of the year, we don't
make as much as people seem to think we do. A guy who
makes $100,000 a year is immediately in the fifty-percent tax
bracket, then $15,000 goes to his agency. It's still a fabulous
amount. Some people ask too much, but I think they are
worth it. They will be there at nine o'clock and give a full day.
They work and they don't complain. But the ones who pull a
star trip are part of the toxic-strobe-shock syndrome. If they
don't want to wear something, they put it on another model.
When someone has just come into the business and makes the
same rate I do, that might bother me because I've worked
pretty hard to get where I am. But if they are worth it, sure. I
still have a tough time thinking that someone is paying me
$1,500 for a day, but now some are getting $2,500.

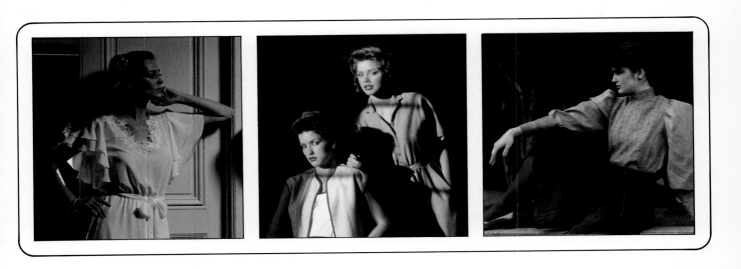

The Team

The movies, more than the other arts, make us acutely aware of levels of achievement. Every reviewer and critic dutifully covers all the various aspects of a motion picture in deciding where it went wrong and where it went right, finally totaling up a balance on which his judgment hangs. Most movies are flawed, although most also have some redeeming feature, and people, of course, have their own opinions about both. If the story is leaden, the special effects may be wonderful; if the acting is lousy, the cinematography may be breathtaking, and so forth. We may even find consolation in the music, makeup, or costumes when all else fails. It is a seductive medium.

On a different scale, the same conditions prevail in fashion and beauty photography, only everything is condensed into a single, flat image. The analogy is twofold. First, fashion photography, like the movies, involves the participation of several separate disciplines and talents; it is a team effort under the direction of a photographer rather than a director. Second, if these different disciplines are perceived as separate, there is something wrong with the picture. In a movie by Ingmar Bergman or Luis Buñuel, one does not cite the acting or the cinematography as something distinct from the picture as a whole—it is part of the whole and inseparable from it. Likewise, in a great fashion photograph, all the elements—clothes, hair, makeup, props, setting, light, the movements and expressions of the model—are seamlessly integrated. The vision and style of the picture may ultimately be that of the photographer, but their realization depends on an interaction rather than a subjugation of talents.

What was once a fairly simple confrontation of photographer and model in the early days of fashion photography has become a highly specialized and complicated process. The concept and outcome of the picture may be influenced by any number of factors. In advertising fashion the original concept, the models, the location, the layout—in other words, the total image—are usually determined by the advertising art or creative director, with input from his staff as well as the client whose product is being featured. Seldom does the photographer have total freedom, although he can have a significant impact on what is portrayed, keeping in mind that the product and message about the product are of paramount importance. His suggestions about models, locations, and people to do hair, makeup, and styling may in fact play an important role, since he is presumably hired for his expertise in these matters as well as the identifiability of his style. And, indeed, it is often the particular style and approach of a photographer that suggests an advertising concept to begin with. Once the shooting begins, he may then have a second chance to influence the final image by photographing it two different ways: strictly according to the layout, and then from his own point of view. At this point the possible changes are less fundamental. They might concern lighting, perspective, how the models are placed and posed, how the location is used, but they offer the chance to achieve greater visual impact, and often the client or art director will prefer such variations to the original plan.

In editorial fashion the photographer usually has a great

The hair and makeup artist's work is not complete until he or she sees the model under the actual lighting and shooting conditions. Beauty artists work throughout the session to be sure that the hair and makeup styles are photographing as intended.

deal more freedom and may be totally responsible for the image, although every magazine has its own general guidelines as to how far and fast the imagination can run in matters of style and taste. Here, and less frequently in advertising fashion, creative freedom often increases in direct proportion to the photographer's clout and reputation.

Into this set of variables involving photographer, art director, editor, concept, model, location, and other factors, are added the very distinctive contributions of makeup artists, hair stylists, and stylists, who are subject in turn to the same possibilities of freedom and restriction as the photographer. Once considered technicians, anonymous helpers to photographers and models, these professionals have now achieved an independent and highly visible status. Several makeup artists and hair stylists have become stars in their own right, with reputations and fame extending beyond the confines of fashion and beauty photography through their work in television, movies, theater, and dance, and the increasing importance of fashion and media in general. Stylists, though less glamourized and less handsomely paid, have become equally, if not more, indispensible and can significantly shape a photographic image through the clothes, accessories, and props they choose, as well as the sense of organization they bring to the set.

Any shooting, therefore, whether it is a simple catalog studio setup or an elaborate location production, brings together talents and egos that are often highly differentiated, each with a claim to creative originality. The possibilities for conflict between any combination of people on the set, who may number anywhere between six and thirty, are enormous, either because of personality clashes or artistic differences. Such conflicts do occur, primarily when a client insists on booking photographers, models, makeup artists, hair stylists, and stylists who don't get along. There are also people in each of these fields who will not work with certain people in the other fields.

Total disaster, however, is rare. Talent tends to find its own level, and art directors usually understand that compatability and creative interaction are essential to success. Something like repertory companies take shape, with the same photographers, stylists, makeup artists, and hair stylists working together again and again and then rearranged into other combinations by the constant infusion of new talent. At the upper levels to which most aspire, friendships and mutual respect develop to create what are often described as "family" groups of professionals. Each knows and appreciates the others' talents and is able to contribute to the total image while maintaining his or her own identity and style. But even when there is little held in common, most people who work in fashion photography are professionals who will submerge their differences in order to see the job through. The guiding principles are money, reputation, experience, and the possibility of reaching that stage when the work will be exclusively with those who are most sympathetic with one's own creative aims.

The appreciation of such teamwork is an important part of

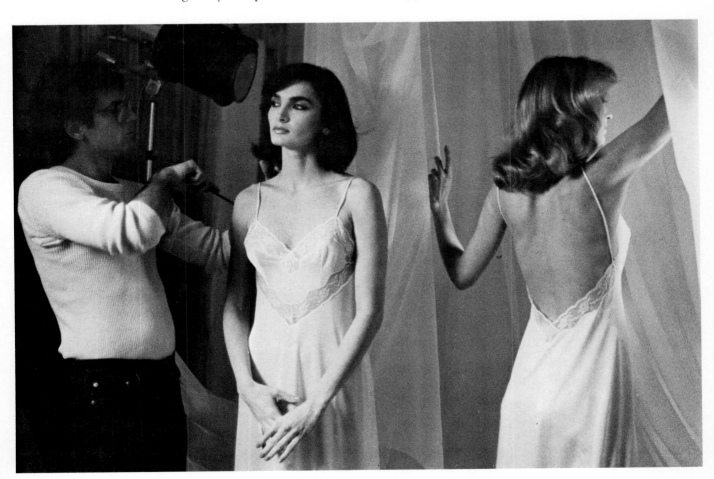

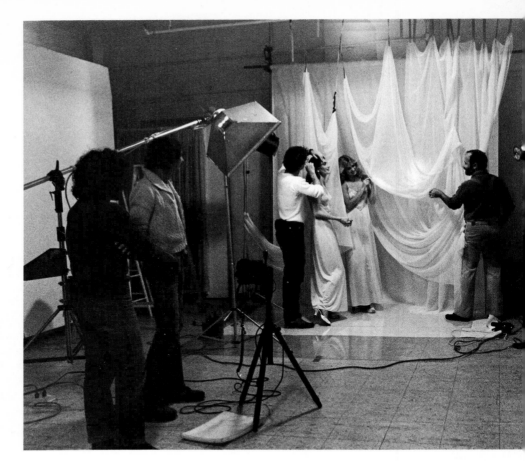

Sometimes the client will request that an exotic location be produced in the studio. Here, tenting and mosquito netting were hung from the ceiling to produce a British-colonial flavor for a series of lingerie advertisements. Tungsten lighting was used with daylight film to lend the scene a warm, sunlit glow. The male model in the background is actually the photographer's assistant at the time.

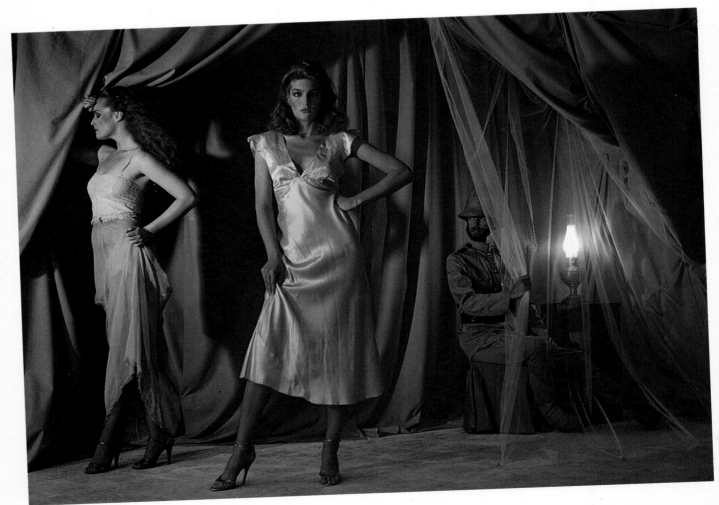

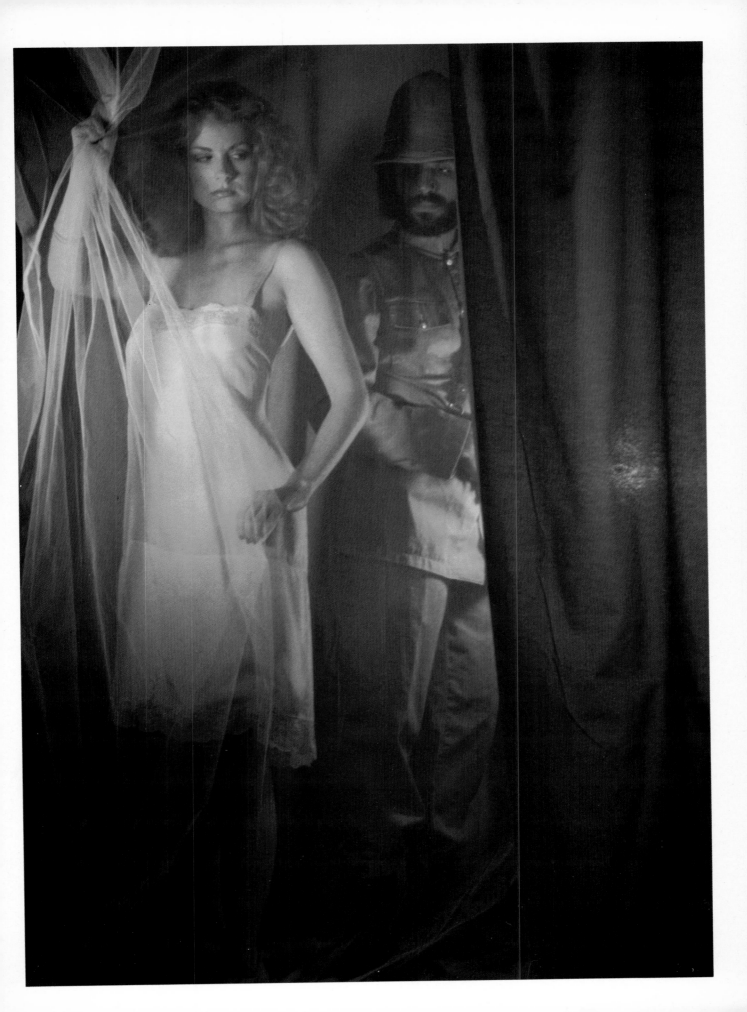

any young professional's training. An assistant to an established photographer, for instance, experiences it first hand during shootings, though his role is a subordinate one. In addition, he has the opportunity to form his own associations with young models, makeup artists, hair stylists, stylists, and designers who are also breaking into the field, associations that will serve all of them in their later careers. These test shootings also give them the chance to exercise their own tastes, perhaps more consistently even than working photographers, and to iron out problems that attend any group effort before they are put to the test in the real world.

The making of a great picture, or any picture, is finally the responsibility of the photographer himself and is the result of his ability to orchestrate the talent around him. But, in a sense, it is the makeup artists, the hair stylists, and the stylists, along with the designer and the models, who are the purveyors of fashion, of style and modernity. They are the shapers of the subject who project the attitudes of modern women and men, while the photographer fills out and organizes aesthetically the illusion or fantasy in pictorial form. This is most evident and has the greatest impact on the covers of fashion magazines, which set the tone for what the modern person is perceived to be. It may not be the most interesting form of fashion or beauty photography—it hardly touches on fashion as such at all—and yet it expresses the notion of style in its purest terms, creating the most radical form of illusion—the face of a woman shaped by the arts of makeup and hair styling. This is the domain of those specialists, and of the model herself. The photographer becomes the transmitter, the interpreter, of their collective and individual personas. In any branch of fashion and beauty photography the photographer is inevitably indebted to those he works with as the creators of his subject.

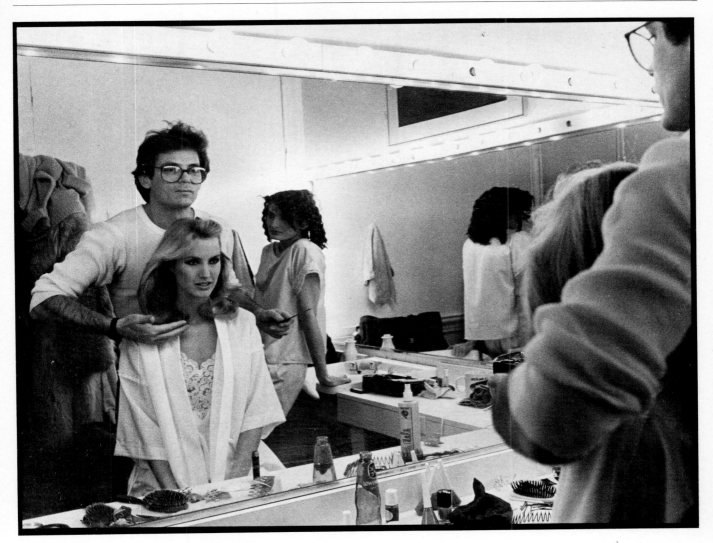

The dressing room is the province of the hair stylist and makeup artist. In this photograph the hair stylist can be seen at work combing out the model's hair while the other model waits her turn. Hair is usually done first, then makeup.

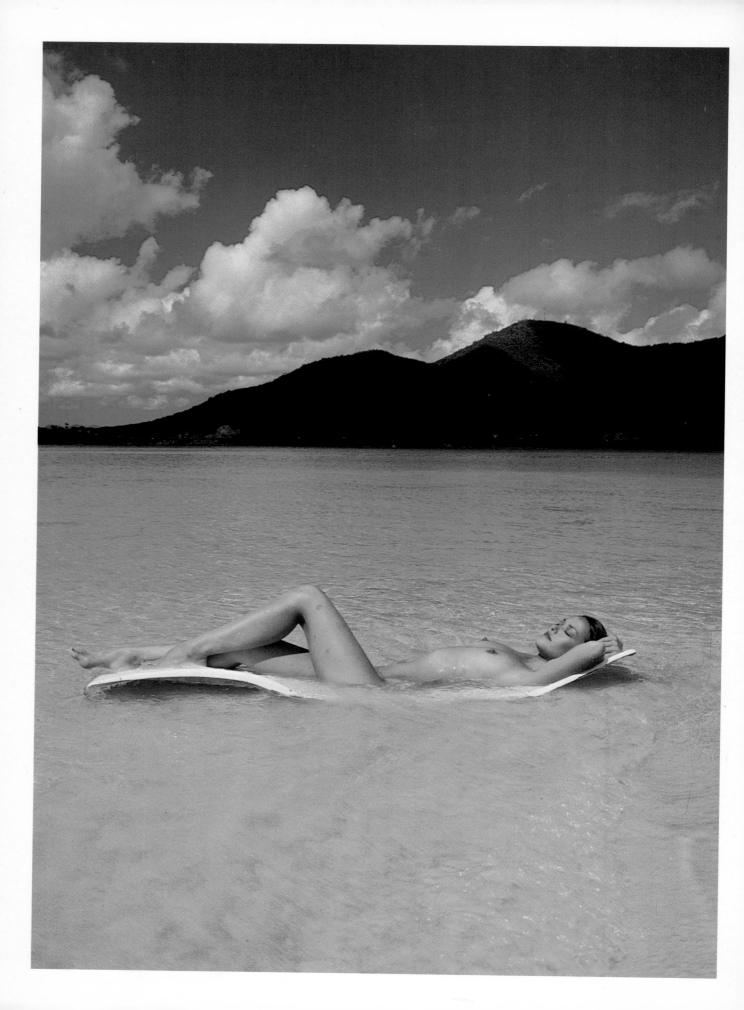

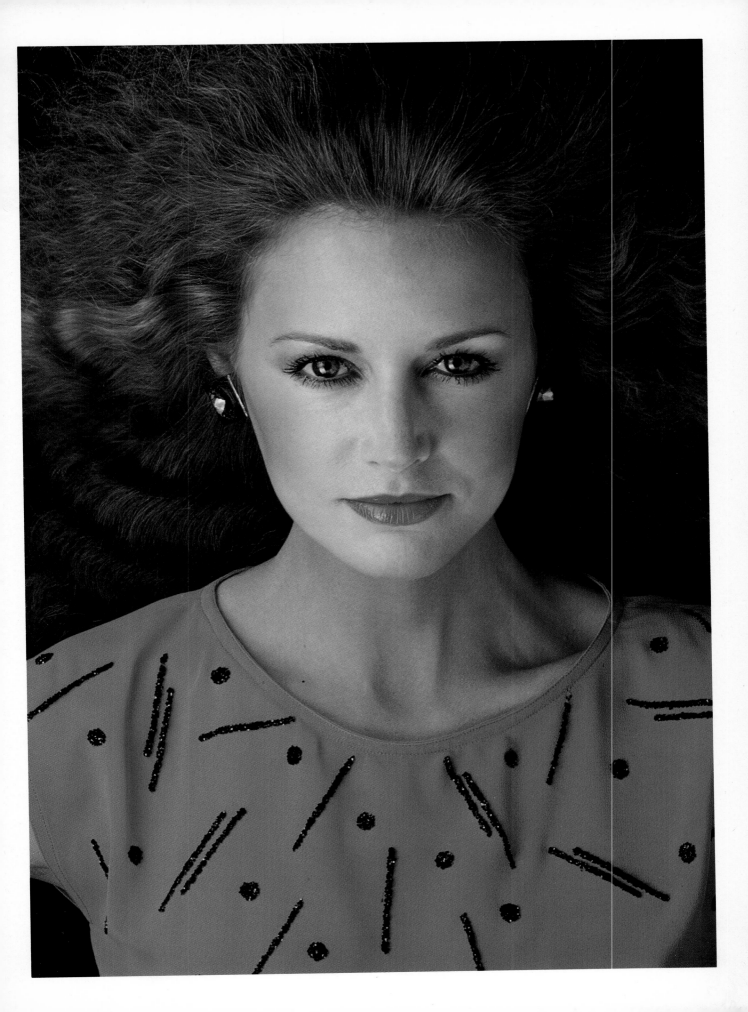

Joey Mills may be the first prodigy of makeup art, having begun in his early teens. Arriving in New York from Philadelphia in 1974 he began his career by working with *Beauty Magazine's* Susan Winer. Since then he has worked in the United States and abroad with most of the important photographers of the day and all the major fashion magazines. His screen credits include *The Next Man* with Sean Connery and Cornelia Sharp, and *The Eyes of Laura Mars*, in which he also appeared as himself, with Faye Dunaway and Tommy Lee Jones, and he created the makeup for the Broadway appearance of the Twyla Tharp dance group. The heart of his work, and of a book he is currently writing, is classic American beauty, which he has done much to redefine in contemporary terms.

What is the relative importance of the magazines and advertising accounts in your career?

I'm involved in both, and actually more in advertising. That's strictly for money, because when they do an ad they have already decided on the dress, the model, the hair stylist, and the makeup man. But when they hire you, it is from an idea they saw editorially, which helps them put their own creative idea together. Why are there some makeup artists who are $500 a day and a few who are $1000 a day? Why are there a thousand makeup artists in New York and only five or six top ones? And why is it that when you go to London, Paris, and Rome, they are the same top ones? I'll give you a perfect example. The newest magazine in the field is German *Vogue*. You are a German millionaire and you just bought German *Vogue*. You're getting ready to put your first issue together and it's time to do the most important section, which is the fashion and beauty and the cover. How do you do it? You go to the newsstand and you buy *Vogue, Harper's Bazaar, Mademoiselle, Glamour*, and you see big captions: "Hair by Harry King . . . makeup by so-and-so . . . cover by so-and-so," and you say, "I must hire these people to do my magazine." There may be somebody else who is just as good but doesn't have any covers. They might offer to do it cheaper, but you want people who are already recognized as the best.

The markup artist takes advantage of breaks in the shooting to touch up the model or compensate for the angle and heat of the lights. Here Rose Bonomo works on model Geri Carranza.

But you weren't always on the covers.

Seven years ago I was in Philadelphia, and being a star in Philadelphia is like being a star in Milwaukee. There is nowhere in America that you can have made it that would be like New York. I majored in fine arts in college and my mother was involved in beauty, so whatever that was, I made something of it. I was doing makeup for friends when I was in junior high school. I used to do a lot of sketches for the proms and things like that. But it's just something you become involved in, and if it is natural it grows tremendously, because artistically or creatively whatever you have, a lot of it comes from inside. It's not like you should go to the corner and make a right turn and then a left. It comes from you . . . you make the right turn, you make the left, it wasn't there before. So once you become that kind of person, you naturally become better and better at it . . . you understand more. If you are intelligent, you get smarter, if you have style you get more style, and you like it more than you like anything else. You know that line, "This is so much fun, and I get paid for it too"? I think anyone successful feels that way. If you don't love it, you don't get better. Doing it for money does not make you better. Doing it for money does not make you creative.

So you already had a portfolio when you came to New York?

I had a little bit of tacky junk. But I had the right idea and I started at Cinandre on Fifty-seventh Street. I did a little free-lance work and met Eileen Ford. But before that I was a model, sort of like a top model in Philadelphia, and I had already done the Mike Douglas show and a Colgate commercial. So, from my recent knowledge of what the odds are, I was lucky to know all that already. Flipping through *Vogue*, I knew everyone and who did what, so when I got to New York I didn't know anyone but I knew what they did.

How would you describe your style?

I have a kind of all-American clean makeup look that is diversified from say Grace Kelly to Brooke Shields. I talk to my subjects—clients, models, friends, actresses—when I am working with them, and out of all that they understand me. The feeling is like when a photographer says during a shooting, "Look a little sad," or, "Look a little sexier." I'm dressing up the face and telling them how to put it across in a picture. Friends can always tell my look. There has to be something, some identity, otherwise why did they book me for makeup? Even though Revlon has a look, Avon has a look, there is still my look within all that.

Who goes first on a shooting, you or the hair stylist?

It depends on what has to be done. If you are one of those girls with that fabulous frizzy hair and for the job you have to have a beautiful smooth kind of Grace Kelly look, the hairdresser might have to go first, to blow it out or set it or throw a few rollers in. If it is somebody who just came back from one of the Caribbean islands and she is tan and there is a slight

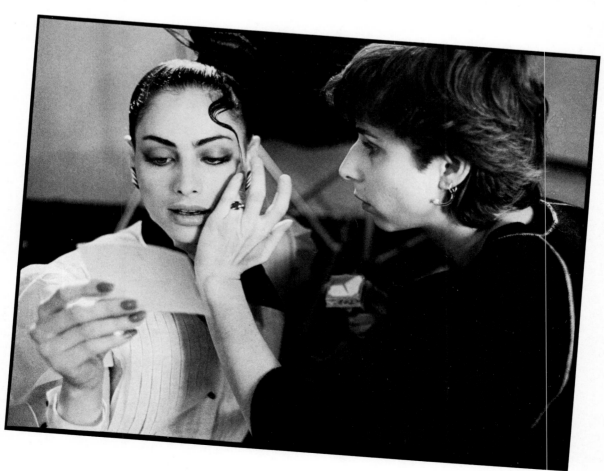

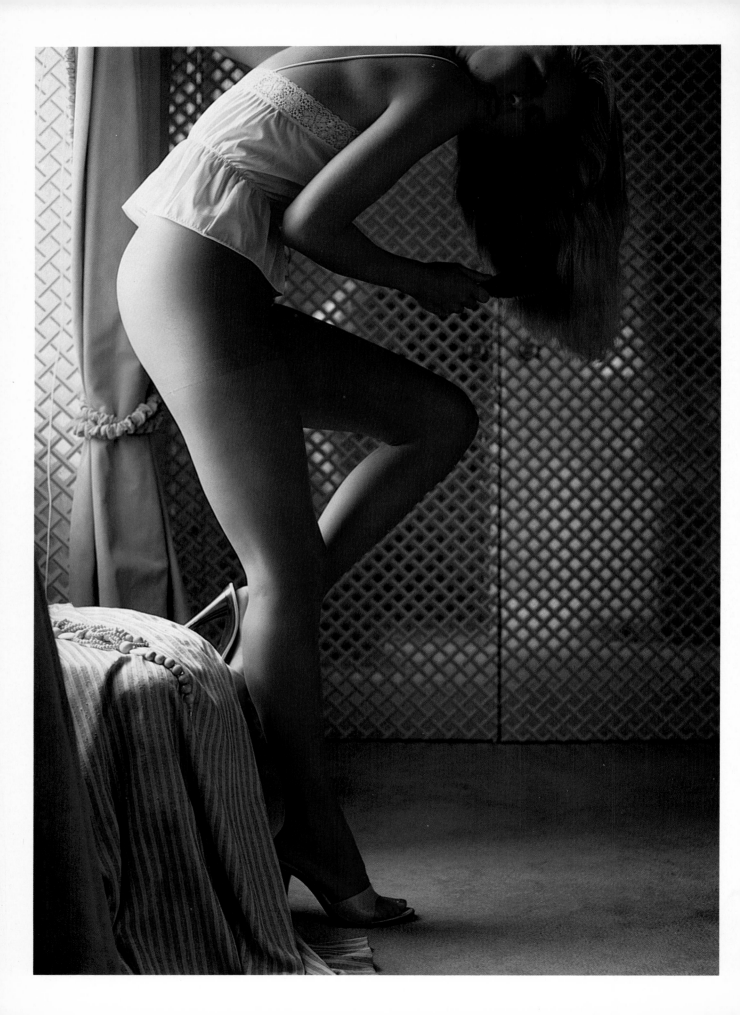

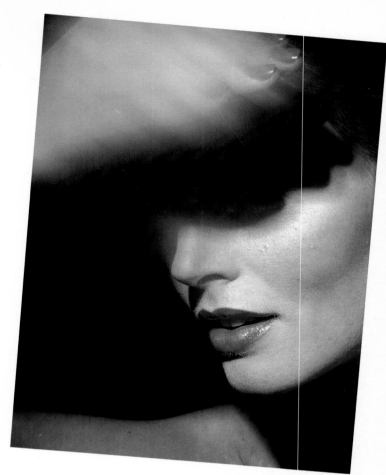

It is often virtually impossible to tell whether electronic flash or natural light has been used for an image. In the accompanying panty hose advertisement, Farber used only the natural light from a window, while in the photograph on the right he used electronic flash. The picture on the bottom is a combination of natural daylight and flash.

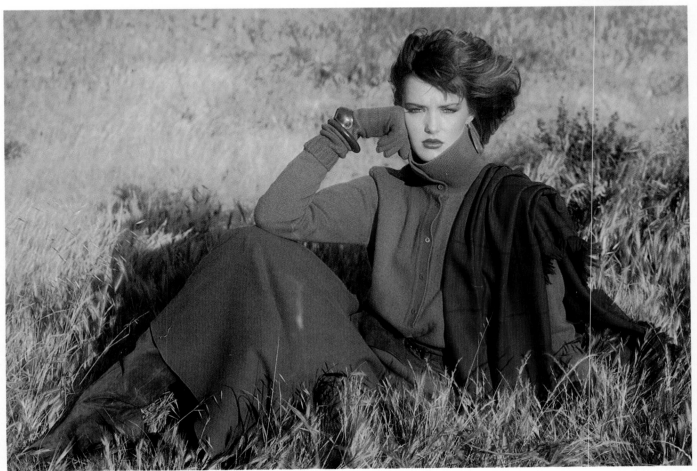

dryness, I have to put on a layer of placenta cream for smoothness. The cream is going to take a few minutes, and after that I might use an almond or natural moisturizer or some Kiehl's moisturizer over that to make the skin really smooth. That's all ten, fifteen, twenty minutes. Then I might do the basic pretty makeup and the hairdresser can set the hair totally. After we look at the clothes and talk to the art director or the photographer, I finish it and give it that particular look for the picture. It's a lot of work. The whole thing takes from forty-five minutes to an hour. You have to talk to the editor or the advertising person or the agency person and find out what their look is and what the model is wearing, if it's a top or a sweater or a fur coat. You talk about the color. There is also a difference between advertising and editorial. You follow the layouts if it is advertising, and if it is editorial you make your own as you go along. It's more of a creative effort, a kind of group, family process.

After you have done the makeup, are you still involved in the shooting?

I am constantly involved for the entire day. Usually when they shoot an ad, even though it is all laid out, they still want to try it three different ways, three different colors, three different makeup looks. It is never just doing the makeup and she goes out to be photographed and that's it. That's sort of late sixties, when models kept fixing it themselves. It's new to have makeup artists who are stars. Makeup artists were servants, but that's all changed now. There are some models,

or photographers, who will turn down jobs for thousands of dollars unless a certain person does the makeup. Certain people in the business don't understand that because they are not creative. People don't know anything about makeup. They think about some rouge, some mascara, and some lipstick and that anyone can do it.

What are the differences working with male models?

To look at them, they don't seem to have on as much makeup, no lipstick and mascara. They could have everything in the world on, but if they look great and healthy you don't care what they have on. The look is so natural now you might look at a guy and realize his nose only has to be shaded, or maybe he should just be flatter under the chin, so you shade it out. Most guys who are considered handsome have lots of lines and character, but if you saw that on a woman you would say she has aged. So you just do different things, not less. You make him look healthy, bronzy. It's as much work, but I think it's an understanding. You look at a face and decide what it is about it that is great, what is not great, what it means. On a man you are usually making them stronger. You give a woman color—peachy, creamy, beige, ivory, burgundy, red— you give a guy depth and shading and contour.

Are you influenced by changes in fashion, or the more bizarre things that happened with Punk styles, for instance?

You look at everything that is current and what people like

Fashion photographers sometimes rent specially equipped mobile homes for use on location shootings. These vans come with portable generators, makeup mirrors and sinks, ironing boards, clothing racks, and the necessary kitchen and bathroom facilities. A driver is also usually included in the rental fee.

and then make it a combination for yourself. With something new you have to try to understand and have a little confidence and security and realize that you can make it really pretty. If it is pretty, a lot of people will think it is pretty. A lot of interesting groups have come out of the Punk thing. If you are really talented, you will last through the changes. It's like Cher. She is a smart, contemporary kind of person who changes. Whatever the thing is, she is it, but then out of it she is still Cher. Or the Beatles . . . there were lots of other groups who tried the same things but weren't really talented. In other words, you have to have your own kind of classic idea. You incorporate everything else, but stay on top. Classic isn't old-fashioned, it is always being yourself, but you have to know everything around you. I do *Vogue* covers and *Mademoiselle* covers, but that's not all I look at. No, give me German *Vogue*, French *Vogue*, Italian *Vogue* every month. If there is something really fabulous in French *Vogue*, I can't be so busy

that I would miss it. I look at them all.

How do different photographers affect your work?

I don't usually get involved with people who are not really fabulous. It's always as though they are doing their first picture, and that's probably why they are big stars. Most of them call beforehand to talk about the job, so you have a while to think about it. When I work with a new photographer, the first thing I want to do is see his pictures. I will talk with him about lighting because I like to do a lot of very delicate things that lighting might destroy. I will say I am going to do something interesting right under her brow and he will say he likes it or he doesn't. Otherwise he might not have seen it because it is so subtle. Communication. But if the photographer feels you know exactly what you are doing, he will relax and just let you do it.

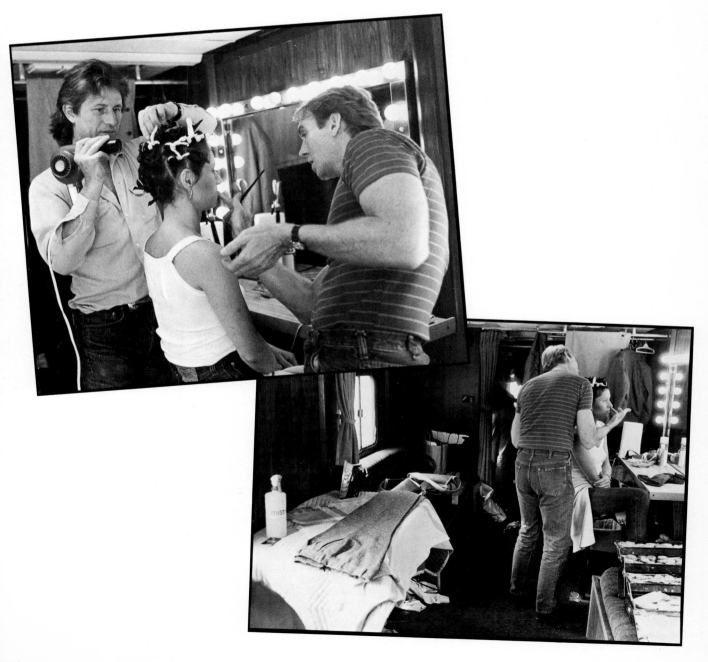

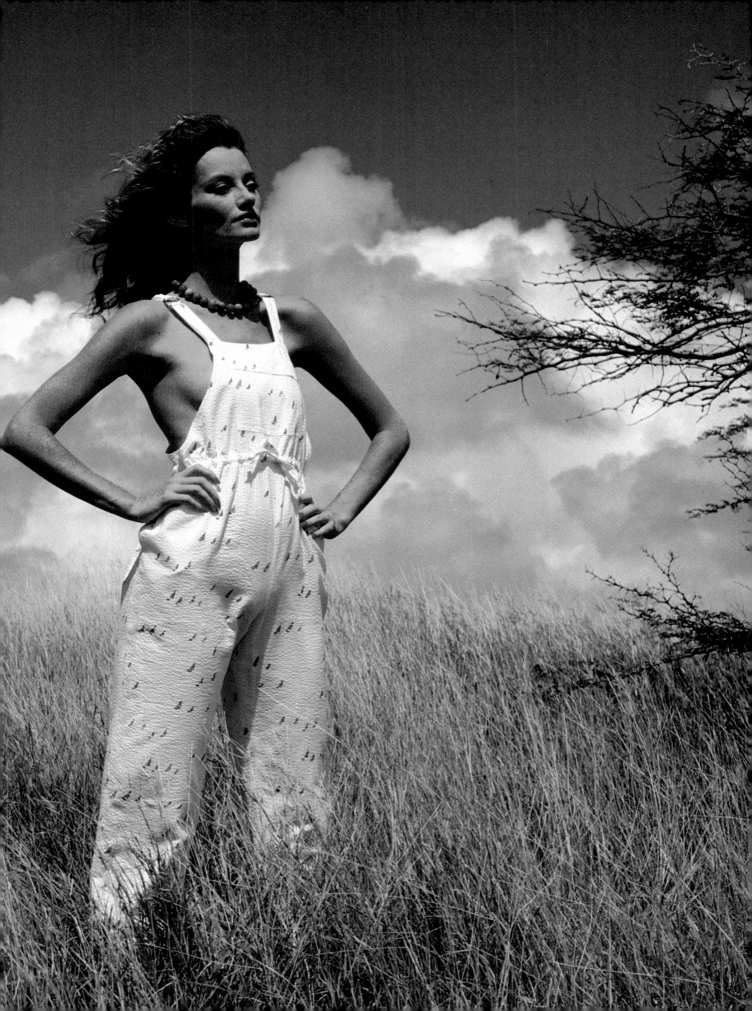

In his irreverent, informal, joyous assault on hair styling, Harry King has been the foremost innovator of the past decade. Apprenticed in London at the age of fifteen, he rose to the top of his profession at the Michaeljohn hair salon and did his first magazine work with the photographer David Bailey for British *Vogue.* Before and since his arrival in the United States in 1974, his reputation has been international and his credits as a stylist for fashion, beauty, and celebrities numberless. He has also appeared on television and lectured extensively.

How does your work as a hair stylist integrate with that of the makeup artist?

Basically, they are such good friends of mine that I have a feeling for what they are doing. But if I am doing editorial, for instance, I need a good makeup job to inspire me, because it's all part of it. Nobody realizes that hair and makeup have to satisfy so many people apart from ourselves, which I think is terribly important. The model should love the way she looks . . . otherwise she can't project fully. The editor or art director has a certain thing to put across, which may not be compatible with how the hair and makeup are done. The photographer is sometimes at odds with the hair because he has a certain look he has become stuck with.

You mean his style has not changed?

There are photographers who were very famous fifteen years ago and they have never come out it. The way to come out of it—actually there are many ways—is to go out and see what's happening, or to stick so much to what you have done, to your style, that everyone else falls in line. A lot of photographers have gone crazy with me at shootings because my mind is whizzing all the time, and once I have done something, I've done it. I can't go back, especially in editorial, if it is a year, a year-and-a-half old, because I'm not into it anymore. That's what is hard for me . . . they want something I've done.

What is the sequence of events at a shooting?

When I go in, if the girl's hair needs cutting, I might give her a haircut. We are creating an illusion, so I don't really do anything until the makeup is done and I see her in the clothes, the situation, and how the photographer is approaching it. I don't give her a hairdo and then have a cup of coffee. My haircuts are for the person first and foremost. I usually run around with a bottle of setting lotion, which I spray into the hair and let dry while the makeup is being done. When the makeup is done the transformation has begun. Then I do her hair, which fits into the role she is playing. The hair and makeup have to work together. I've heard makeup people say they have worked with hair stylists and blown them away, and the same thing vice versa. I think it is awful to compete like that. When one flips through a magazine, one should see the total photograph, the image. One shouldn't be able to say, "Look at the hair, look at the makeup, look at how she is dressed." When you see a picture by a great photographer, you should see the picture, not the clothes or makeup or hair. A bad photograph is one you can dissect immediately. It has no substance.

What do you do during the shooting?

I'm there all the time. If the model moves her head, a bit of hair might fall over her face and I have to push it back. A lot of photographers like to work with wind machines, so I have to make sure the hair blows properly. It's all fake. We are all image-makers, really. The haircut itself takes between seven and twelve minutes, but the styling is done on the set basically, because it all has to fit in. If a girl is being shot in profile, it might be brushed a certain way that in reality might look awful. If her head is upside down, then you work it so it looks pretty upside down. All those things have to be taken into consideration and I have to be fast because people lose their momentum. So there are frequent changes throughout the shooting according to the angle of the photograph, the lighting, and so forth.

How specific is a client or photographer in telling you what they want?

Sometimes they go overboard and sometimes they understand and leave me to it. I'm basically left to it because I have a particular style and people hire me for that. When I began they would say they were selling to middle America and it can't be too wild. Of course it's all nonsense, but they have their jobs to do. I used to take it personally, but I don't anymore. I know what I can and can't do now.

Is it a problem for a model going from one job to another, one hair stylist to another?

That's what a model is. It's not a problem for me. There are problems when they pick a model for the wrong reasons, if she has lousy hair and they expect miracles . . . or if the model has hair to her waist and they want a short urchin cut and she

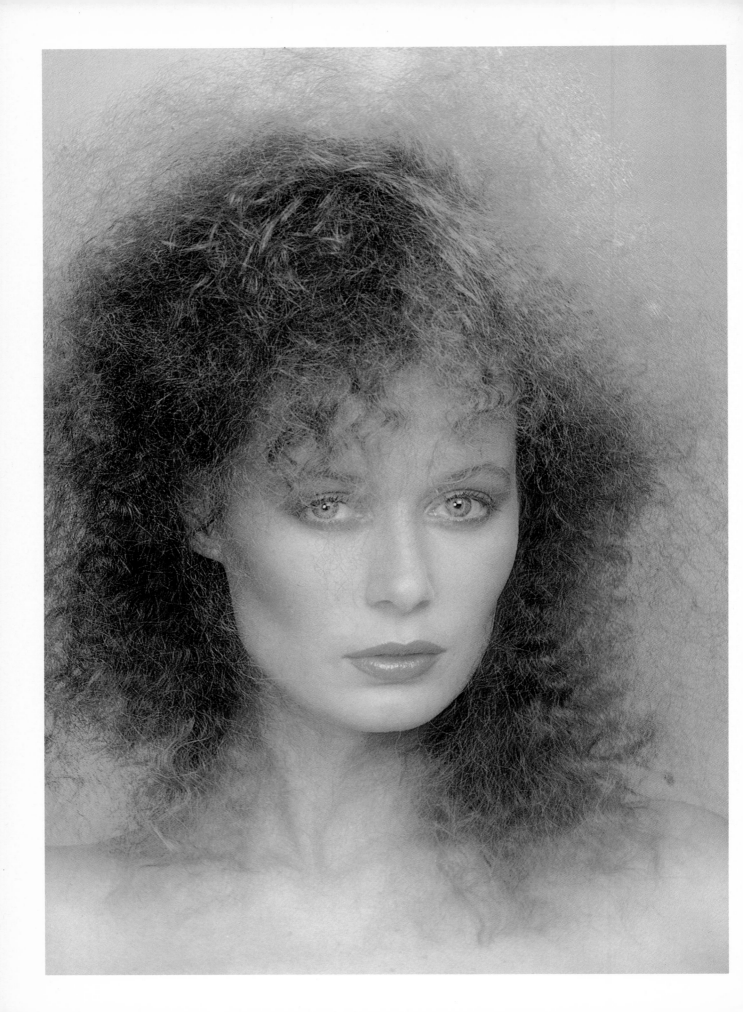

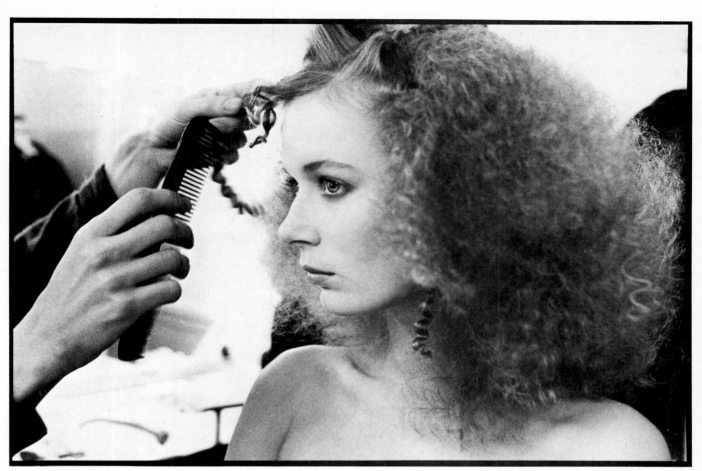

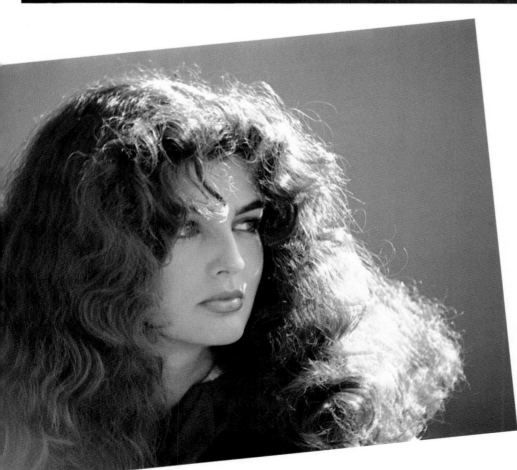

It is hard to overestimate the importance of the model's hair. Carefully arranged, seemingly loose and natural, straight or curly, the hair style dramatically affects the viewer's perception of the photograph.

doesn't want to do it. If she says to me, which often happens, that she would love her hair cut, I will do it, because a lot of people know that I can change them and make them look very sexy and snappy. All my haircuts are for the person. I use fashion . . . I don't use them for fashion. It's completely the other way around. Their personality, their life style, everything about them comes before anything else. But I would never cut anyone's hair just for a photograph. I've learned by my mistakes. In the past I have been taken aside by the editor or the photographer and told I had to do something with a model's hair. In those days I would be kind of nervous and intimidated, which I am not now. I would cut somebody's hair and it would be okay, but I have little respect for myself when I do that, and I don't do it anymore.

If you are creating a style for fashion or beauty, does that style also work in the real world?

Absolutely, because all my haircuts are for the person and need a mimimum of care. I think a haircut should be a ten-minute number . . . you should be able to wash your hair and do nothing else to it. I really don't believe in that bourgeois thing of sitting for three hours and having your hair primped and pulled. It's okay if you want it, but in today's society there is no time for it anymore. There are too many other important things, one hopes, to occupy one's time. It still happens. I go back to London about five times a year to work or visit and I go into the place I used to work and see the line of Rolls Royces outside and the ladies sitting there being done inside. I can't comprehend it anymore. The same thing happens here, but with people working it is happening less and less.

Have attitudes changed about hair stylists, makeup artists, models, particularly when they are men?

I came in at the very end of the sixties in England, and then there was always talk about the dumb models, which really annoys me now because we are all put into categories, which I think is a great shame. First of all, we travel more than most people, we see more of other people's situations, and that is one of the greatest forms of education, so there is a whole learning process that other people don't have. It's funny, because some of the male models will talk about their hair and portfolios, but the girls talk about a lot of different things. The roles are reversed in that sense, because in this business men are more like accessories, especially if a woman is in the shot. If a man is in a picture by himself, I don't think it is such a bad thing, but there will always be people who will say that being a male model or a ballet dancer or a makeup artist or a hair stylist is a sissy's job. It's typecasting, a very narrow thing, but the people who say those things—goodness knows what their lives are like. We look at them like they are from another planet. We all laugh at the knit-suit people.

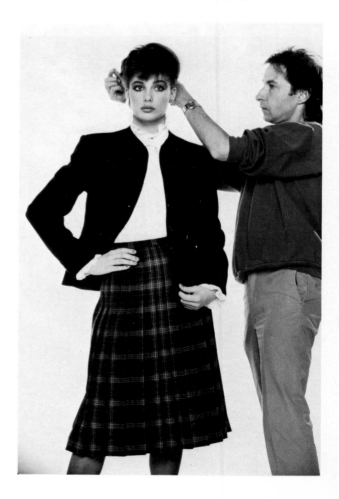

Here Harry King is touching up model Kelly Labrock's hair on the set of a shooting.

Do you consider your work fashionable, or in fashion?

I hate the word fashion. I don't think of myself as fashion. Some people follow fashion everytime something new comes out. It must be very confusing for them. One should follow what suits one. I'm a firm believer in individuality, so I continue in a certain way that a lot of people can identify with rather than trying to be new, new, new all the time. There is style and there is fashion, and people who have style disregard fashion. They use it. I try to deal with style, which I think is a lot different.

Then your real concerns go beyond fashion?

What really motivates me is what is happening in the world. In a recession, for instance, one behaves differently. I don't wake up and think, "I must think of a new hairdo." I try to convey a social condition. I couldn't possibly describe it. It's just a feeling. For instance, we are now possibly coming to the end of a tremendously bland time. We know enough about health and efficiency to last us until we all drop dead. Every article is about how healthy you are and how healthy you can be. I love that healthy look and outlook. I love independence and individuality. I love even the blandness in a way. People know about jogging, they know about clean hair; they know about good haircuts; now they want to go out and forget about it. They have that all day and at night they want to do something else with themselves. When I first started doing editorial work here my work was very free and easy . . . brushed-through hair, very shiny, no hairspray, you know, ruffle your hair and it's perfectly okay. Now one can still have that, but because we are in a recession one has to take oneself out of it in a way. Nothing to me is bizarre if it fits. Punk was the biggest influence of the seventies. Nothing else happened fashionwise, but now it is finished. There will be more fantasy in a very real way, not like the sixties, but so that you can take it or leave it, so there will always be a sense of amusement about oneself.

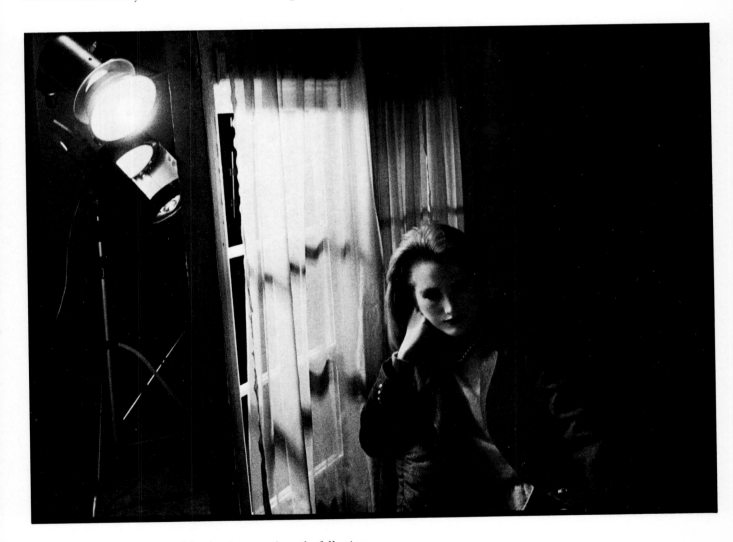

The setup shown here was used for the photograph on the following page. Although the model seems to be resting by a window with warm daylight pouring in, she is in fact in front of a prop window suspended in front of lights in the studio.

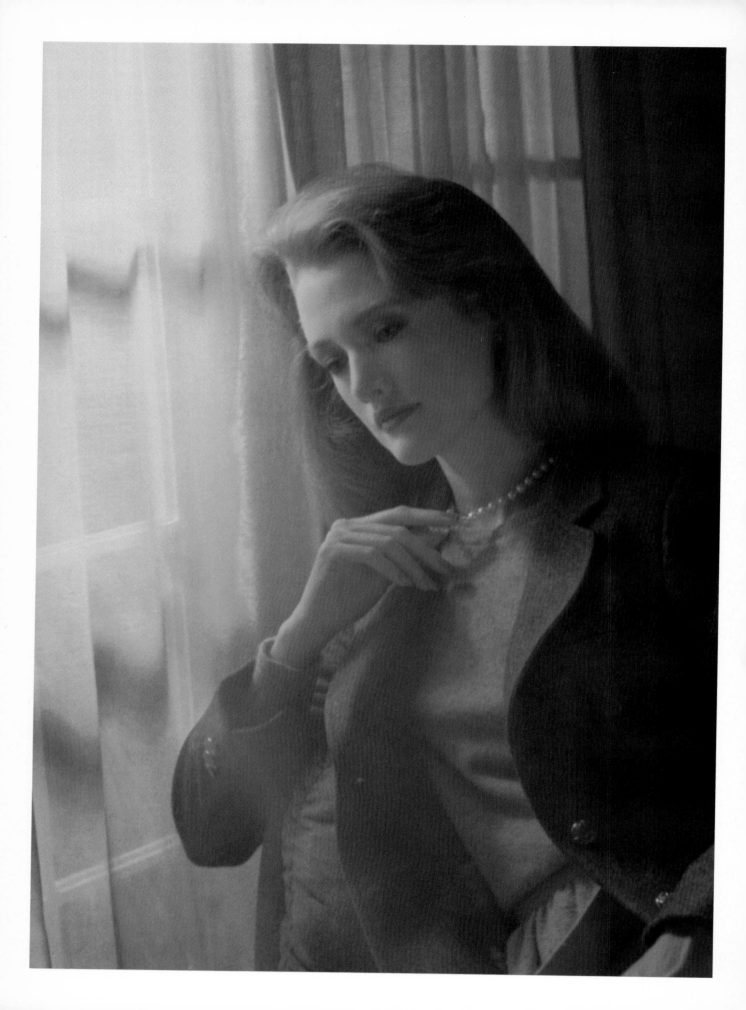

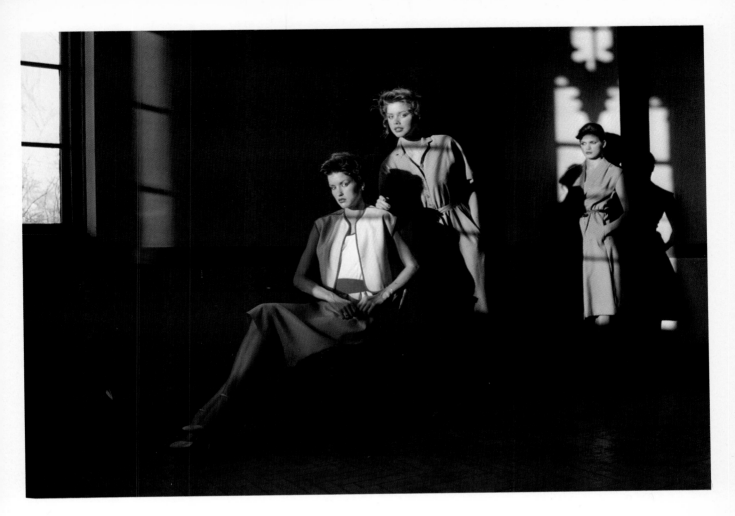

"Warmth," the reddish yellow cast that often appears in color film, may be caused by several things. In the picture above, the warmth is due to late-afternoon sunlight, which is naturally redder than the light at noon. In the picture on the left, the warmth comes from tungsten lights. Tungsten light is much yellower than daylight, and so when a daylight-balanced film is used with tungsten lights, a yellow tint appears.

As a stylist since 1968, Leah Feldon has worked on print ads and television commercials for Revlon, Clairol, Avon, Wrangler, H.D. Lee, Vanity Fair, London Fog, and Lady Manhattan, among many other clients in the fashion and beauty fields. She studied art at the University of Miami, worked in editorial production for *The Saturday Evening Post*, started as a stylist in the studio of fashion photographer Neal Barr, and launched a career in New York as one of the busiest and most creative free-lance stylists in the profession. Since her book on fashion, *Womanstyle*, was published by Clarkson N. Potter in 1979, she has been a regular fashion contributor on The Today Show as well as various local talk shows. Her second book, *Dressing Rich*, was published by G. P. Putnam and Sons in 1982.

What is a stylist?

A stylist is the person on the photographic team who gets the accessories and clothes together. She may also get props and sets, but mostly, in high fashion at least, she is responsible for the clothes. It requires a really good eye and a pretty good mind so that she can interpret what the art director wants and what the photographer wants. There are so many people to please in a shooting, you have to understand what their commercial needs and tastes are, yet you also have to keep your own taste in it, and that is where the difficulty comes in. Everybody gets their hands in the pot and everybody has a different idea. That's why it is best when the photographer and art director have worked together for a long time and why photographers work with the same stylists over and over again. They can say five words instead of five hundred and get the message across.

Who normally hires the stylist?

There is no one set situation. A stylist can be hired by the photographer, the advertising agency, or the client directly. For television commercials you would be hired by the production house. Your client is the one who hired you, and that is where your main loyalty lies. But your job is really to make the whole team effort work. You can't have too big an ego. If someone doesn't like the earrings you got, you have to understand that they might not like them because they remind them of earrings Aunt Mary wore back in 1952. So

you should always have alternatives with you because if you bring only one thing, somebody is bound not to like it.

How specific are they in designating clothes and accessories?

That varies a lot. When Revlon's new fragrance *Jontue* was about to come out, I was hired to do the styling for the publicity folder they put out for the department stores. They didn't really have the exact image of whom they wanted to buy this perfume yet. They weren't really sure what market they wanted to appeal to. So they told me she is somewhere between 18 and 35, vivacious and independent but also very soft and feminine. There were different images—running in a field, playing tennis, going out to dinner—about fifteen black-and-white pictures I had to get things for. The idea was to give the right mood for every possible situation this *Jontue* woman could be in. It was the most freedom and the most fun I've ever had on a job.

Another client might want you to get a blue hat, two gold bracelets, and one nose ring. For those jobs you just put yourself on automatic pilot and do it. Even on catalog jobs, some shootings are freer than others. For some they will send the jewelry and shoes all numbered to go with each dress. You don't even have a choice. Basically you are a dresser. For others they will send two cartons of accessories and let you do what you want.

How do you get clothes when they are not supplied by the client?

You can go to the fashion houses and borrow them. For most cosmetic ads, for instance, they give the designer credit on the side of the page. But for television spots or liquor or car ads they might not. In that case you have to buy things in the shops and department stores. But again, it's always wise to buy more than you actually need so you can present a choice to the client. What you don't use you can return.

Do you study the layouts for an ad or editorial spread?

Absolutely. You have to know what the setting is, what the background colors are. If the background is red brick, you don't want to use colors that will fade into it. I always try to think of juxtaposing colors, so that if the shooting is in a green forest, I might use red for contrast. You have to consider all these factors. Before I started styling, I worked at *The Saturday Evening Post* in editorial production, which would seem to have nothing to do with fashion except that you do learn about producing ads. I knew, for instance, that in a bigger ad everything stands out more and you have to adjust accordingly. A pair of shoes becomes much more prominent.

How do you get to be a stylist? Is there any training for it?

It's a strange field and most people don't even know the occupation exists. It's different now than it was when I started in 1969, because then most photographers had stylists on staff. They weren't just stylists, but studio assistants. They

As well as helping select props and settings, a stylist works with pins and tape to make the clothes look their best in the final photograph. Often the clothing supplied by the client is not the exact right fit for a model, and the stylist must then tuck and gather it out of the camera's view.

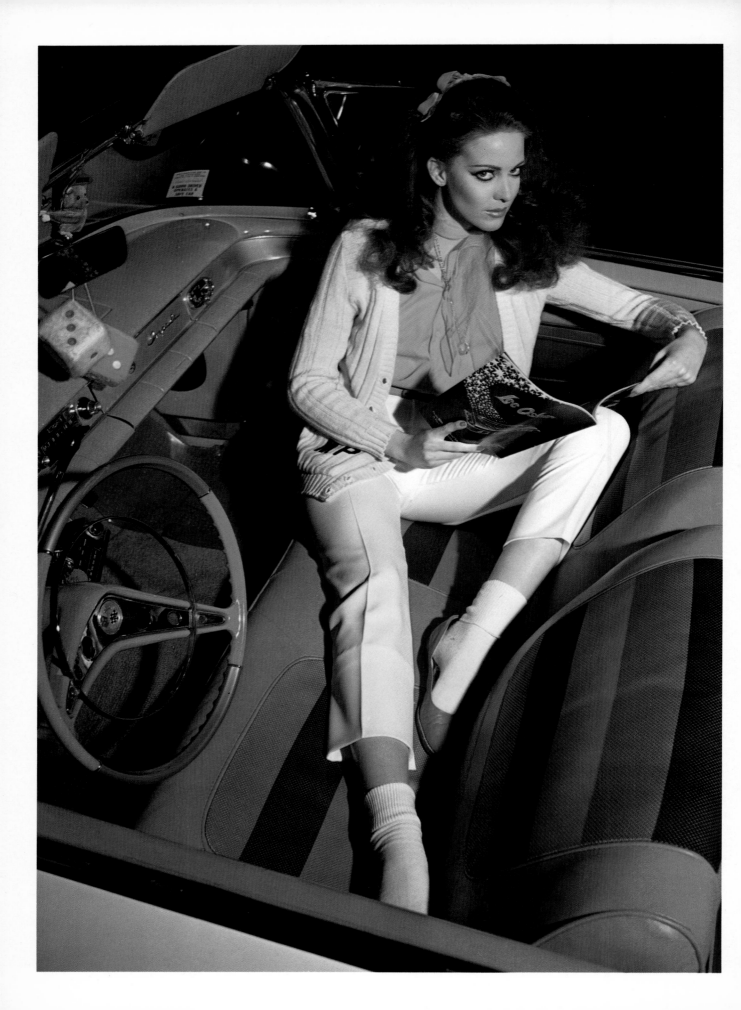

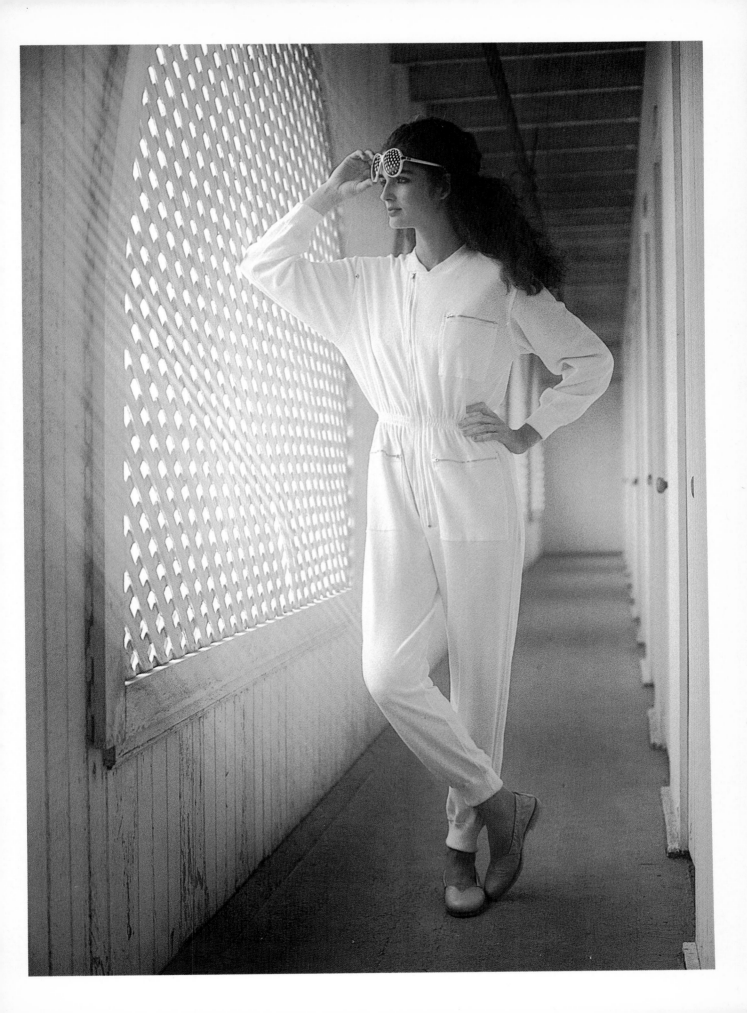

made coffee, picked up the clothes left by models on the floor, did the checkbooks and other odd jobs. Now most stylists are free-lance. But that was a great way to start, even though I got paid very little. When I went on my own I immediately doubled or tripled my salary. Probably the best way to do it now is to work on a fashion magazine as an assistant editor or for an ad agency. You go on shootings, meet photographers and models, establish contacts with potential clients, and generally see what has to be done. You also establish contacts in the garment industry. You get to know designers because they depend on you for editorial exposure, and they can be helpful later for jobs and when you have to borrow clothes and accessories for jobs. Or you might also start as an assistant photographer and learn about it from that point of view, or as an assistant sytlist. Sometimes I don't have time to go out and get things for a job so I hire someone to help. And then on a shooting she hangs clothes and irons for me. Most stylists don't get the kind of money that would pay for something like that on a regular basis, but it is a possibility. I have recently heard that some of the fashion schools like Fashion Institute of Technology in New York now have courses in fashion styling.

What kind of money do stylists make?

They have always been comparatively underpaid in this business in respect to what they do for an ad. Without the clothes she chooses and her presence on the set making sure everything is hanging right, they wouldn't have a picture.

When a model is getting at least $1,000 a day now, the stylist is getting only $250 to $350. When I started I was getting $150 a day and models were getting $450. Then hairdressers were beginning to get $300 a day, and the models were doing their own hair, so that the stylist really was much more important than the hairdresser. She is not underpaid as far as the rest of the world goes, but certainly compared to the people she works with. Models don't have to do anything anymore. They don't even have to bring panty hose . . . all that is taken care of by the stylist.

Do you think models have changed in that respect?

Models have changed a lot. They used to be more professional. I mean, it was a job to them. If they had had a fight with their husbands or boyfriends the night before, they would still show up on the job smiling, all their undergarments in tow, their stockings in good shape, and a couple of extra pairs of shoes they were asked to bring along for the booking. Now they sometimes show up without makeup . . . "Oh, I thought there was going to be a makeup man here." Everything is taken care of for them. A model in 1965 would no sooner walk out the door without her makeup bag and everything else than chop off her head. They are spoiled today. They become instant stars. Put them on the cover of *Vogue* once and all of a sudden everybody is hiring them. They get started so quickly that they don't have time to appreciate it. I don't know any models who are really

When the clothes arrive at the studio with descriptive identification tags attached, the stylist carefully follows the tags, lay-outs, and any special instructions. At other times it is left up to the stylist to se-lect and procure shoes, jewelry, and other accessories to coordinate with the particu-lar outfits.

disgusting or awful, but the young ones just aren't as professional.

Is that difficult to deal with as a stylist?

It really depends on your own head. If you are well-adjusted you don't really mind stroking their egos. You really see what other people need and make things go as smoothly as possible.

Has the fashion image of women become less stylized and more human?

For the most part, yes. But it doesn't really have any choice but to follow that pattern. Photography and fashion are just following the times, after women's lib. Women work every day and they have to wear clothes, so they simply have to show those things. But putting clothes on a woman to make her look her best is still a piece of art.

Did you feel the effects of women's lib personally?

Not really, because I wasn't in the corporate structure. I was in a very different, almost remote kind of field. Also, fashion has never been that male oriented. Women have always been in fashion, although now women photographers have become more prominent. People say that women's lib affects the women a lot, but it also affects the men. An art director ten years ago might have been more hesitant about hiring a woman photographer, but now there is less of that. We are still in the aftermath of bra-burning, but in another ten years people will probably be even more relaxed about it.

Have you ever had a decisive influence on how a shot was done?

A lot, because the more I worked with photographers the more they would appreciate my own contribution and taste, and they would give me more freedom to contribute. I would not only get the clothes, I would sometimes make them. When I worked on the Wrangler ads, I would make belts to go with the jeans, and for London Fog one time I made Chinese pants. In the case of a young photographer or a photographer who had been in another field, such as sports, they often need some help in fashion. If they don't know how to direct models I suggest certain things and they usually see it right away. It is just that their eyes aren't there yet. Good stylists know these things . . . they understand composition as well as fashion. Probably the most important thing a stylist can learn is art, because photography involves color combinations, the balance of different proportions and elements, textures. If you know that and understand that, you can put clothes together with those things in mind; you can put a picture together. My own background is in art and design. Art history isn't a bad background either because you study why a painting works and why it doesn't. Another good preparation would be clothes design. And then, if you work for a fashion magazine, you can't help pick up a lot about what fashion is, what style is, from the people you are working with. Any way you can get the exposure is valuable. It's not a conscious training. It is just being around anything that teaches you why things work aesthetically, and then you can relate it to fashion later on.

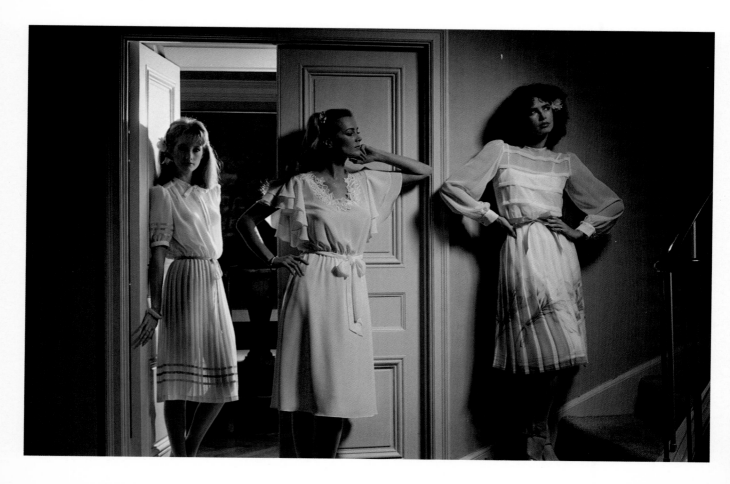

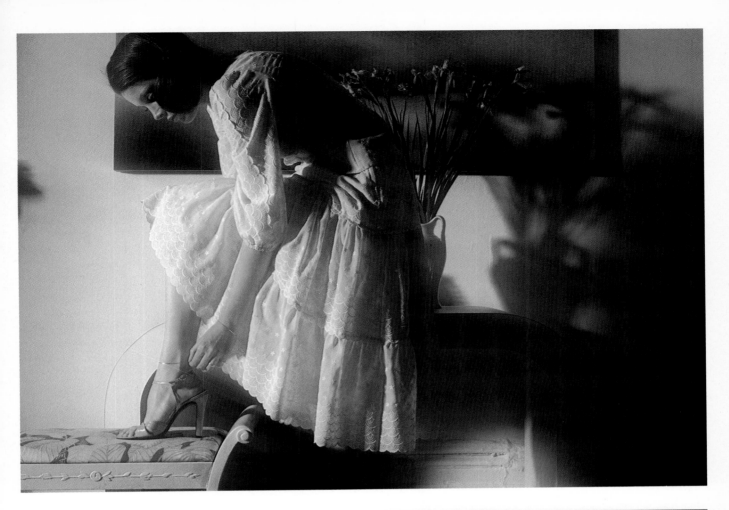

The shot on the facing page and the one to the right are both advertising clothes. The one above was done for a jewelry client. Often when the client is more interested in evoking a mood than in describing a product, the advertising agency will hire a fashion photographer even though the product is not a conventional fashion item. This way the style of the shot may help gear the product to the right market.

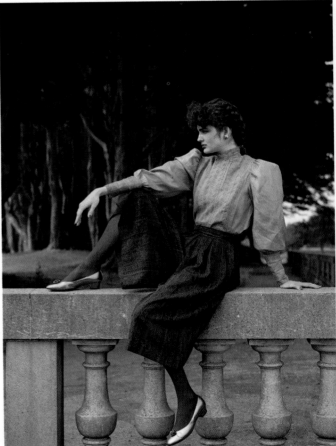

Leland Bobbé established his own studio in New York as a professional fashion photographer in 1980 after assisting in the studio of Robert Farber for two-and-a-half years.

*Is it necessary to be an assistant to a
photographer before going out on your own?*

It is really the best way to learn about the business. It's hard to dive in and all of a sudden be a fashion photographer. Working as an assistant I learned about getting a portfolio together and taking it around to potential clients, about the importance of having or not having a rep, about how to get jobs and how to deal with art directors, clients, and modeling agencies. A photographer has to be not only a technician and an artist, he also has to be a businessman. He has to know how to charge for a job and how to bill for expenses. When I was working for Robert Farber, I never felt any qualms about asking him what he got for a shooting. He was always very open with me. I am sure that some photographers wouldn't say, and some assistants wouldn't ask. It depends on their relationship. I would ask not just to be impressed, but so that I would know for the future what to expect and what to do myself. You learn what the different rates are for a newspaper or a national magazine, a day rate and a page rate, a black-and-white ad or a color ad.

How did you get into photography?

I first started taking pictures as a hobby. At the time my main career interest was music, but since I was not a composer I felt I was expressing myself more with a camera than I was with music. In the long run, I felt I had a better chance as a fifty-year-old photographer than as a fifty-year-old drummer. I met

Robert at the opening show of a gallery where he was one of the photographers. Photography was still a hobby for me, but the gallery liked what I was doing and they invited me to be in the show, so I was up there on the wall with all those professionals. I was still playing in the band and hadn't thought of professional photography, but a year later the band broke up and I decided it was time. I called Robert and he remembered my work in the show and invited me to his studio. Before the appointment he called back and asked if I could print black-and-white. So I went in and printed for him and we got along well, I think partly because his first exposure to me was through an art show, which is the way he came into the fashion business himself. I had no professional experience. I had never used an off-camera strobe. I didn't know a flash meter from a regular light meter. But, although he had a file of people with all kinds of experience who wanted the job, he felt that I had a good eye and a lot of enthusiasm and I guess that was most important.

What does an assistant do?

Basically it involves doing all the manual and preparatory work on a shooting . . . making sure there is enough film, that the cameras are loaded, the lights are set up, the equipment is packed and unpacked. I also did all the black-and-white printing.

What did you do during a shooting?

I would stay close to Robert and at the same time be helpful and social with the models and art director and stylist in a low-key way. As I worked with him longer, I tried to know what he wanted ahead of time—what lenses he would need, where to move the lights—so all he had to worry about was setting up the picture the way he wanted it and working things out with the art director. At times he would ask me what I thought of a certain setup and I would give my opinion. Sometimes I would suggest something and he would try it two ways. But you have to remember that you are the photographer's assistant, you are working for him. If you see another angle to shoot from, you mention it only to the photographer and no one else, and hopefully, if you have a good relationship, he will respect what you have to say.

What would you advise someone who wants to become an assistant?

First of all, getting a job as an assistant is not at all easy because there are many more people who want to be photographers than are already working. Every photographer has a file of people who want to be assistants. Although I didn't have one, in most cases photographers would probably require that you have a portfolio. You should seek out the photographers whose work you like, who you think you can learn from, not with the idea of copying but to be in a sympathetic creative environment. All you can do is keep calling. More often than not, they will say there are no jobs available. Some people get into free-lance assisting. You can usually make more money that way because you can set a day rate, which is from $60 to $75. But you don't have the

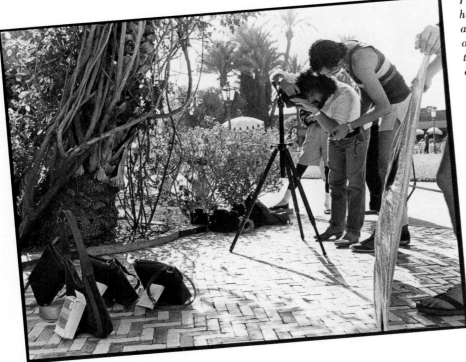

The assistants are the photographer's right-hand men or women. Here one assistant holds a reflector to add fill light to the shot, while the other monitors the exposure settings. Note how the subjects of this still life are supported by empty film boxes.

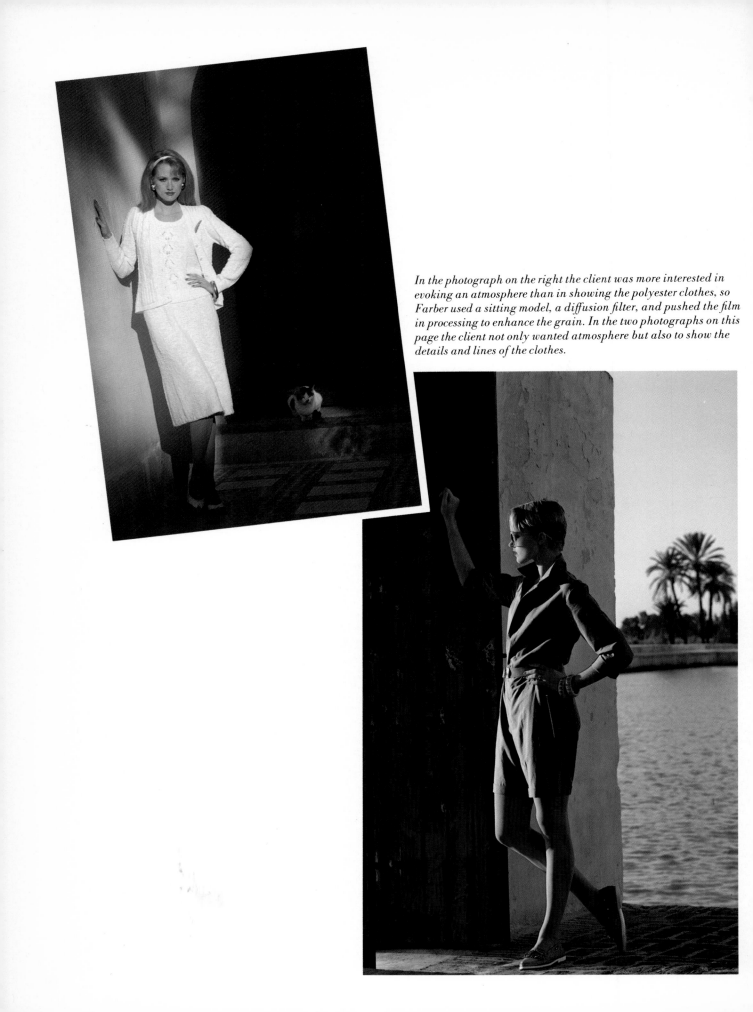

In the photograph on the right the client was more interested in evoking an atmosphere than in showing the polyester clothes, so Farber used a sitting model, a diffusion filter, and pushed the film in processing to enhance the grain. In the two photographs on this page the client not only wanted atmosphere but also to show the details and lines of the clothes.

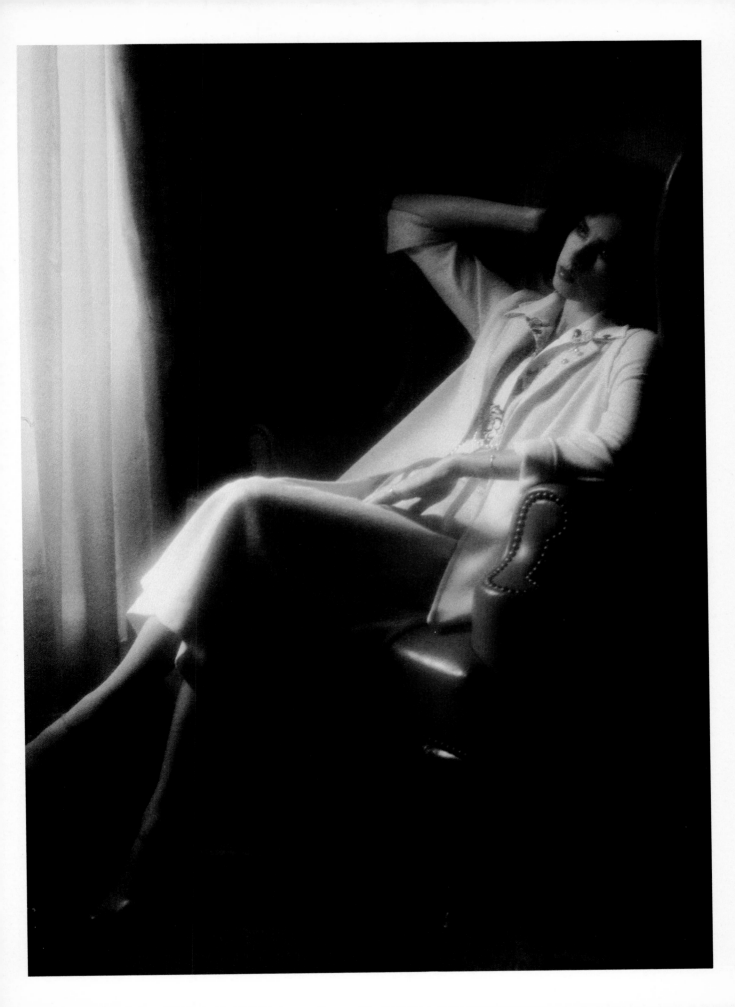

advantages of working in a studio, using the equipment and doing tests, and learning about the business from the inside.

What kind of training do you need to be an assistant?

I had some school training after I had been taking pictures for a while, but initially I taught myself about cameras and film and the darkroom. It was only after I had learned the basic steps of black-and-white photography and started doing color that I took a course. But I don't think formal training is necessary. The most important thing is seeing and having the eye. The technical part just comes. There are a lot of assistants who have gone to Rochester Institute of Technology or Brooks in California and know every bit of equipment and how to print color, but their pictures are the same old things you always see. You do have to have basic technical skills, but you are always learning.

But realistically, what do you think most photographers expect of an assistant?

Probably less about seeing and more about technical expertise. He is the one who does the seeing. One important qualification is that you print well, because you are printing for reproduction, for use in ads, and the photographer wants top quality. Every photographer has his own style of printing, so you have to print the way he wants it to look. Some studios specialize, with one assistant in the darkroom, a second on the shootings, and a third to assist the second, doing the gofer work.

What are some of the discouragements?

It can depend on who you are working for. Some photographers think an assistant should be seen and not heard, so they are talked down to. They are definitely low men on the totem pole. The assistant is making $50 to $60 a day and the model is making $1,000 to $2,000. At the end of the day, when you realized how hard you worked and how much everybody else is making, it can be hard to deal with, but you have to realize that you are doing it as an apprentice and that it is a learning experience and an investment and hopefully it will pay off later.

You have to know your place and you can't look at the clock. It's not like working from nine to five every day. You might get a rush print order at five o'clock and you need prints by nine o'clock the next morning. You just have to grab a sandwich and print until eleven or twelve at night. It's often long hours. Sometimes it means coming in on weekends. You may end up doing a lot of things that have nothing to do with photography . . . painting a wall or a chair or cleaning up, or getting lunch for all the people at a shoot. It may not always be as glamorous as you think it is going to be.

Were you able to do your own work and prepare a portfolio when you worked as an assistant?

It wasn't until about five or six months after I started that I did some tests on my own. It was the first time that I had access to professional models and, because I was working for

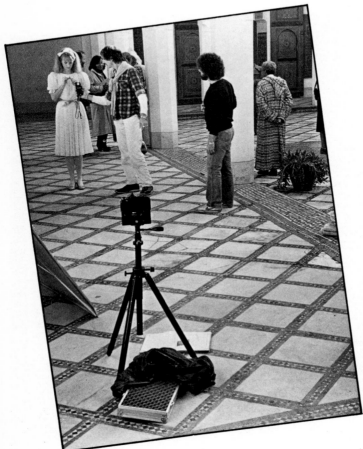

One of the assistant's main tasks is to measure the level of light in all parts of the scene and concentrate on the exposure while the photographer concentrates on the expressions and image. In so doing the assistant plays an important part in the final photograph.

someone who was known and respected, I could call up agencies and make appointments with girls who were interested in testing. I didn't have the equipment myself and I didn't have the money to buy it, but Robert encouraged me to test anytime off-hours, evenings, and weekends when the studio was available. Some photographers are less generous.

How do you know when to stop assisting and establish your own studio?

It's an individual matter. You have to know when you are ready to go on your own, because if you go before you are ready, you are going to starve. Being an assistant doesn't automatically mean you are going to be a photographer some day. To get over those first couple of years on your own, you have to have some money packed away. You aren't going to pay your bills on what you make at the beginning. Not only do you have to have a studio, you also have to have equipment. I had to invest $4,000 in strobe equipment, but I was lucky because I was living in a loft, so I had enough space to convert part of it into a studio by ripping down walls and putting up others. My overhead was much lower than if I had to go out and rent a studio as well. Somehow you have to get the money for these things and look on it as an investment. You have to have the confidence you will make it back in a couple of years. Because of the expenses, it is not uncommon for photographers starting out to share studio space and equipment, although they will keep their own names and get

their own jobs. It's a real struggle in the beginning. You wake up one morning without a job, and the next morning, and the next. Then you get one and make a lot for one shooting, then back to nothing. It takes a while before you are working on a steady basis.

How is having your own studio different from assisting?

Certainly in terms of money, although it takes time and a lot of work to get started, but also in terms of respect when dealing with modeling and ad agencies. I had the experience of meeting a model a few years ago when she didn't have much to say to me, and now she is in my studio hoping I am going to book her for a job. There is a whole different attitude. A model and an assistant may start at the same time, but the model will usually begin making money a lot faster. After six months or a year she will get off the test board and start working, while the assistant is still struggling to get a portfolio together. Generally it takes longer for a photographer to get going than anyone else in the business. Someone estimated that it takes a good photographer five years and a great photographer three years to get going from the time he opens up his own studio. When you are assisting, people don't really consider you a photographer . . . it's only when you go into business for yourself. A good period of assisting will speed up the process. It builds confidence.

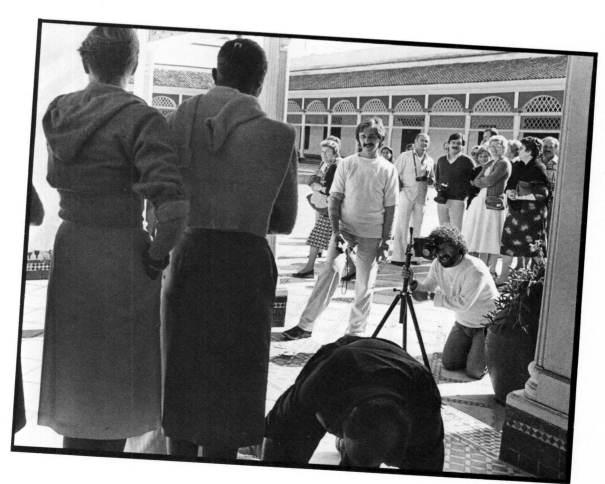

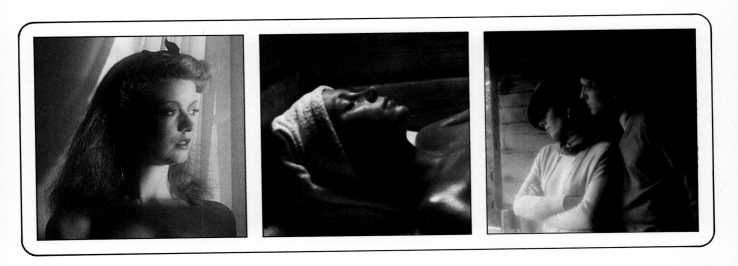

The Business

The photographer cannot, like the painter and sculptor would rather not, survive on the fringes of economic solvency. Equipment, studio space, creating a portfolio, and self-advertising comprise a tremendous and inescapable overhead. Furthermore, though a fashion photographer's work is largely creative, it is imbued with economics. He is an entrepreneur, in business to provide services for clients. But more importantly, he is in a field whose main function is selling, though it may also undertake to entertain, report, educate, and even express aesthetic values. Everything the photographer does, whether it is in editorial or advertising fashion, is connected with selling. That defines the medium and therefore the photographer himself as part of an economic system.

Part of the selling is of himself. It involves creating and refining a portfolio that is indicative of his talents and seeing as many advertising and magazine art directors as possible. In a place like New York, with its overwhelming number of agencies and magazines, this requires extensive research by the photographer to determine exactly whom to see, and a willingness to live through weeks and perhaps months of rejections before achieving a modicum of success. The most advantageous way to start is with the magazines, though they pay less and are no less difficult to crack than the advertising field. An editorial layout, which carries the photographer's credit line as well as those for the makeup artist and hair stylist, is seen by every art director and editor in the business and does more to open up jobs in advertising fashion than any form of publicity.

Once the photographer has established a strong and distinctive style and a steady flow of work, he must then continue to prove that he can fulfill the needs of clients imaginatively. The success of his business depends on how well he nourishes his own creative development rather than being trapped in a predictable pigeonhole, despite the fact that many clients are themselves reluctant to try new approaches. Styles change in photography as well as in fashion, and the photographer must constantly be aware of his own position in relation to those changes, remembering that the simplest and most personal visual statment is always the most contemporary statement.

An artist can impose his vision on the world and hope that the world will respond and understand. A fashion photographer can do that too, but he needs the support of those who make decisions in order to remain in business. Being in a creative field, his work will be valued by some for its innovation and freshness, but he must also be prepared to adapt and to put his personal vision at the service of more mundane goals in order to be economically viable. He is split between businessman and creative talent, with each feeding the other.

As a businessman he is his own agent. He makes contacts, maintains them, and promotes himself by showing his work, getting editorial exposure, and by using various forms of

Locations can be in foreign countries or close to the photographer's studio. Both of these photographs were shot within a few miles of Farber's studio. The one on the left was shot at Radio City Music Hall, and the one on the right at Columbia University.

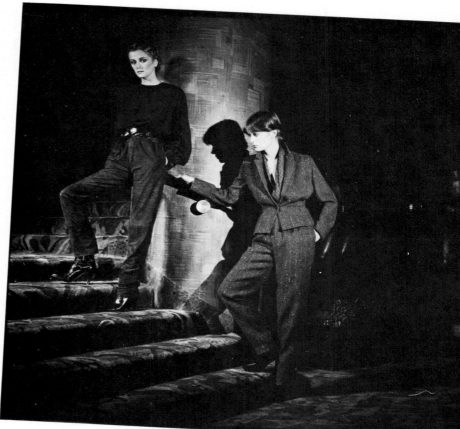

advertising. He makes arrangements for shootings, books models, hair stylists, makeup artists, stylists, and assistants, and coordinates the entire team. He negotiates his own contracts with clients for the alter ego who will be taking the pictures. Along the way he may acquire help in the form of an assistant photographer, a studio manager, a secretary, but it is important that he know the details of his own business intimately and at first hand. Finally, he may want to take the option of working through a rep, an agent who can unburden him of much of the time-consuming but necessary work of seeing clients, publicizing, negotiating contracts, and billing jobs.

Because he is concerned strictly with business, a good rep can often do more for the photographer than the photographer himself, while freeing him to concentrate on assignments and the refinement of his work. In a field that is becoming increasingly complicated, both in its financial and legal arrangements and its degree of specialization, the rep can perform the important and invaluable function of simplifying a photographer's professional life. But it is a delicate relationship, one which is measured by success, but which also depends on many levels of understanding, both because the talent's business is extremely personal to him and because a great deal of trust is involved. The photographer still maintains control, but he is putting himself in the hands of someone else. That is why it is necessary for both the talent

and the rep to be circumspect in launching a relationship and why, among other reasons, those relationships are not often long-lasting.

Another form of representation is the stock photography agency, which provides one of the extra benefits enjoyed by someone involved in a uniquely modern form of communication. What the photographer creates during his career can have a value far beyond the initial fees paid for it. Through a stock agency the same pictures can be sold over and over again for advertising, magazines, books, posters, and corporate use, creating an added income for many years and offering another means of exposure. The opportunities are such that it can become an adjunct to regular assignment work with very little extra effort or cost.

Fashion photography is very definitely a business, which is also its greatest danger. One can overemphasize that side of it, or simply become grooved in the routine of making money to the extent that everything else is ignored or forgotten. That could not go on for very long without the creative input, and therefore the profits, dwindling. It is sometimes difficult to keep the two complementary sides of the profession in proportion, particularly in the flush of financial success, but in the end that success is only a by-product of what the photographer started with—his talent and his own shaping of that talent.

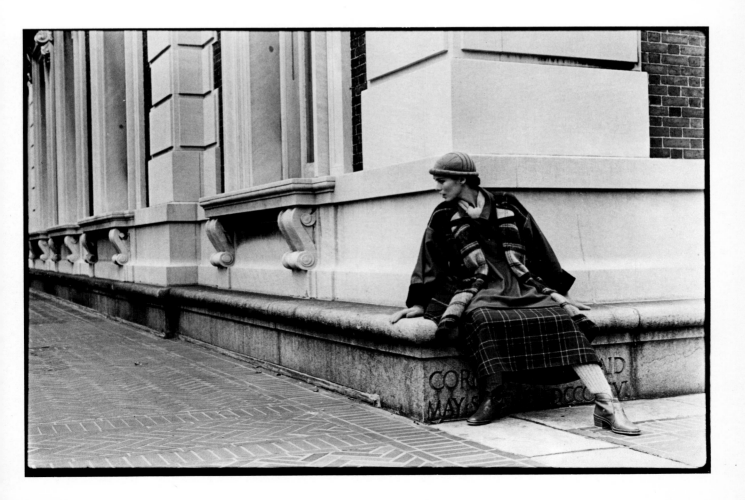

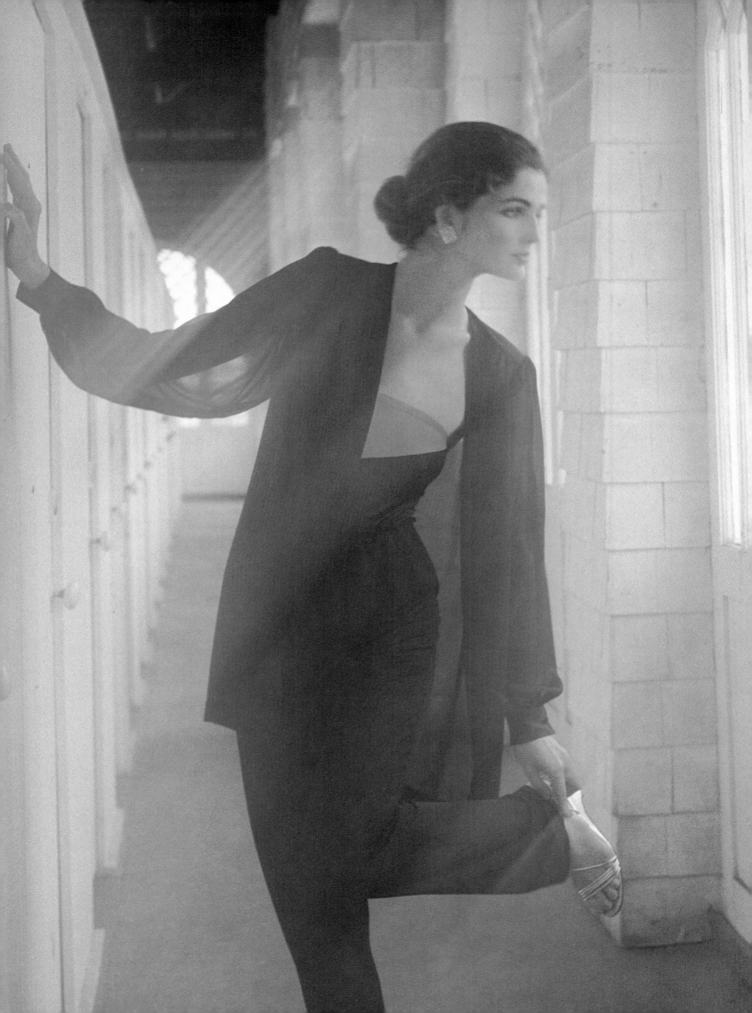

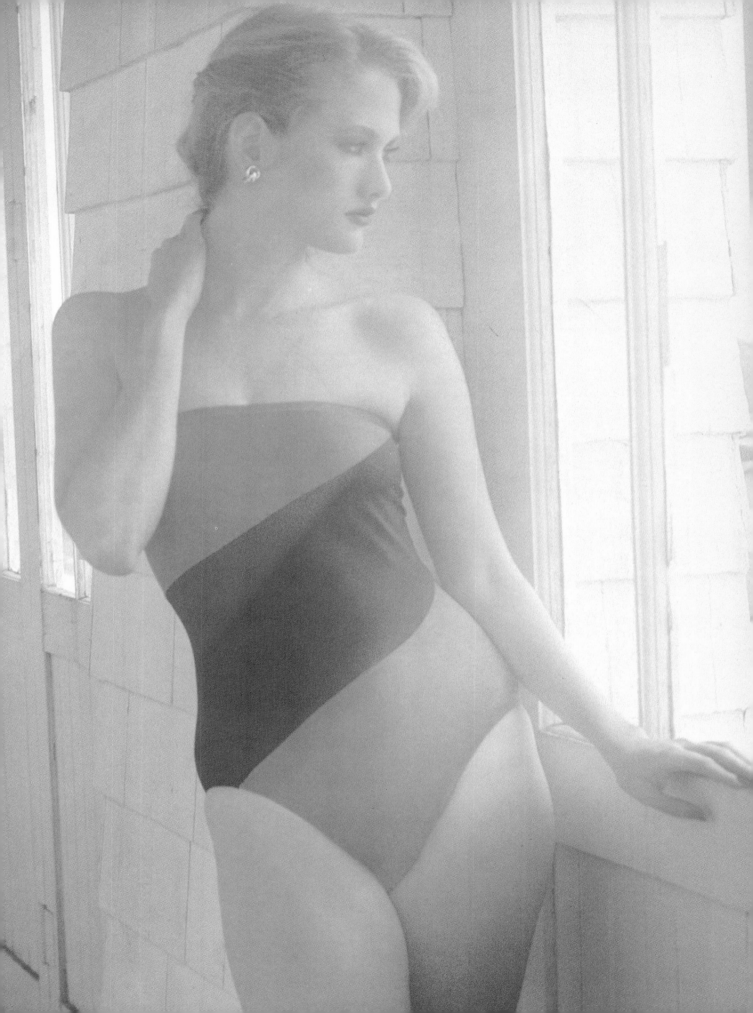

Harvey Kahn is one of the most experienced and respected artists' and photographers' agents in the business and was a founder of SPAR (Society of Photographer and Artist Representatives). Over the past thirty years he has represented many prominent illustrators and photographers for the advertising media as well as fashion photographers, among them Bert Stern for fifteen years and illustrator Bob Peak for twenty-three years.

Should a photographer take on an agent at the beginning of his career?

Most photographers are not ready for a rep when they are starting out. Very few are knowledgable enough in the field to know what is wanted of them. It's advantageous for a young photographer to be out in the field for a period of time. It could be six months or six years. He has to instinctively know what is wanted of him. I have seen many portfolios of photographers who have been in the field for ten years and they still don't have a grasp of it.

Is an agent essential for success?

It's not mandatory. Certain photographers have never had an agent. Others have been through many, so basically they don't want one. They fight it, and are doing well without representation. But I think it has been proved more times than not that the correct agent can open a lot of doors. Yet the wrong agent can be worse than no agent at all. He can be premature in trying to get into certain areas, and art directors have long memories. They remember a photographer at a certain stage and he has to prove at every stage that he is capable of answering their needs. The young photographer is often so hungry for an agent that he will grasp onto any person who says he is an agent. I've seen some part-time housewives create havoc for a talent.

What are some of the advantages of having a rep?

An agent can usually get better prices than the talent because

A photographer may shoot anywhere from one to thirty rolls of film to attain the desired photograph. Before the results of the shooting are sent to the client, the photographer usually spreads the slides out on a light table and edits them. He or she then sends the client only the best.

he is expected to discuss business. Many art directors and editors become annoyed if the talent is so crass as to talk about money, and if he is a good businessman it may go against them. An agent instinctively knows when to walk away from problems. The talent may turn down a job saying it is not enough money, and then in a couple of months, when he has some dead time, he would love to have that contact back, but he has closed the door. There are more tactful ways, and an agent can keep the door open. On the other hand, many photographers are too quick to say yes because they want the job. The talent is involved in creating and shouldn't have to be always grabbing his portfolio and going around. He is more valuable behind the camera. When he is busy is exactly when the portfolio should be circulating so that when things get slow, the work will be there. Supposedly the agent has been working all through that time so that there is a more even flow of work.

What comes first, the client's needs or the photographer's talent?

They have to meet halfway. The client has to be open and the photographer has to be there to offer his wares. Years ago I think it was a more important issue, but it is wide open today. Clients are hungrier than ever for new things and the schools are doing a great job today of turning out talent. But the photographer has to learn how to think. He can learn all the technical aspects in a very short time. The schools have taught everyone the same things in four years, but they have forgotten to teach them how to think.

Do you insist on exclusive representation?

If I get a job for the talent and he is jammed up with work he got from a midwestern agent or a house account, I might be turned off by that. The next time around I might give the job to another talent I represent exclusively. Photographers develop friends in the business and they should pursue them, but even if they get jobs on their own, the agent should be entitled to a commission. Supposedly the agent is working all the time for his talent. That means he is showing his portfolio to ad agencies and magazines, making phone calls, traveling to California or Chicago, or taking someone to lunch. For an experienced agent, one or two phone calls can be the equivalent of a whole month's work for somebody else. The art directors know who you have but unless you get around and remind them, they will forget about you. It could be a mailer or an ad in the right journal. The important thing is that clients know I won't bug them. When I call it will be meaningful. I have something to show them. The agent who constantly badgers prospective clients is doing an injustice to the talent because he is not selling things by the dozen. The client somehow has to remember who you represent and call on you when he has the need.

What advantage does a rep have in contract negotiations?

He can usually do better than the talent because there are a lot of things to consider, for instance, whether the money should be in advance for certain jobs so that the photographer won't get stuck if it is stopped in the middle. On some of these

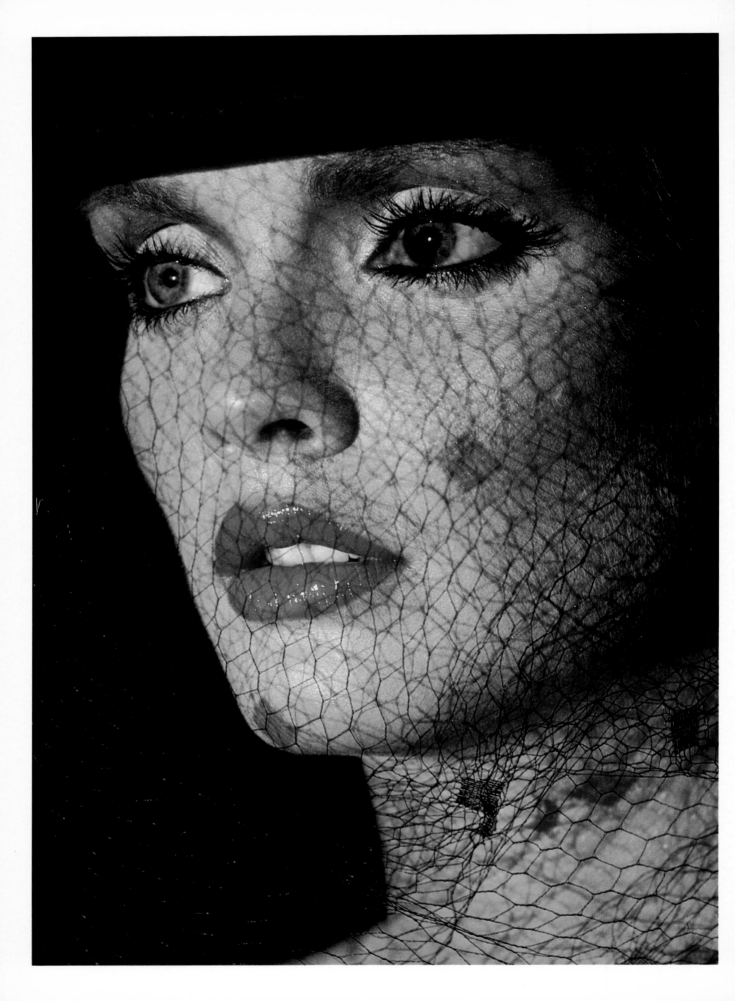

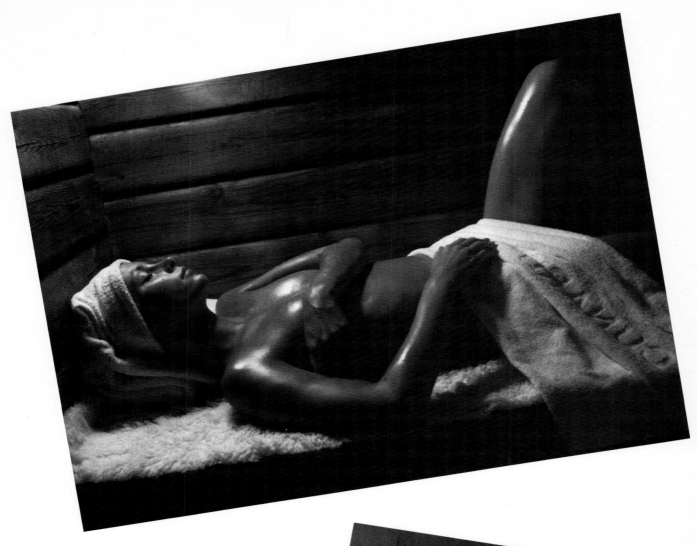

Beauty and health shots are two very strong types of images for stock use. In the photograph on the left, Farber used strong direct light to add sparkle to the woman's eyes and lips and to pick up detail in the veil. In the beauty shot on the right, he used diffused light to show the subtlety of the model's complexion. The health photograph above was taken as part of an assignment for the Cunard Line aboard the QE II. For this shot the model's skin was oiled, and the actual lights of the sauna were used by Farber for exposure. The result is a combination of a stylized and authentic image.

contracts you have to be a Philadelphia lawyer. They can fill them with all kinds of innocuous phrases that are very dangerous. For instance, the "work for hire" agreement is not a contract, but something clients use to get around the new copyright laws. It makes anything you do for them their property so that you become a hired hand rather than a free-lance entrepreneur. That doesn't mean you don't sign those agreements, but that you should be very careful about them, and the talent isn't always aware of all the ins and outs that the agent can iron out because he may be so anxious to get the work. It's a matter of instinct, whether you can trust a client, what their histories are, what you hear in the trade about working with them, how many people have been ripped off, and so forth. You are flying by the seat of your pants because you are balancing what the client wants to do, what he is dangling in front of the talent, and the talent's fear that the agent might be so commercial and pushing for more money that he will kill the deal. But it's just a matter of making sure it's fair. The talent is likely to say, "Yes, yes, yes," whereas the agent will work things out and get more in the end.

I don't want to overstate the contracts. When you have a working relationship with a client over the years, it's a matter of legality and that's all, because there is a mutual trust you have. He is not likely to take advantage of you because he needs you. The problem with many artists and photographers is that they walk in with chips on their shoulders, worried about being ripped off. I often get calls from people without reps who are concerned about what they are getting into because they have heard so many stories in the trade, and I can usually tell to calm down, that they are working with a very reputable guy.

How much are you involved in guiding a talent's career?

First of all, you have chosen the talent for their strengths in given directions . . . therefore you had better accept that. It's a very tricky area. There are trends, for instance, in advertising today, and it is helpful for the agent to be aware of them and discuss them with the talent. Periodic discussion is very important. You can be so involved in business matters or so steeped in making money that it backfires. I think one of my successes in hanging on to talent is seeing problems before they happen in the marketplace. The talent only wants you because you are bringing him work, and when that starts going down you are in trouble. At that point the talent will always blame his agent anyway. They will tell me their agents are doing lousy jobs, and then I look at their portfolios and I know why they aren't getting any work, because they are not changing with the moment. The art director won't tell the talent that, he will tell the agent. After he splits with the agent, the talent will go around himself to art directors who, if they are not that forthright, will tell him that he is as good as he was five years ago but now he is using so-and-so. It's not easy for an artist to change, but it has to be done.

Professional photography is a business, and the photographer must keep track of financial and legal obligations. The larger model-release form shown here is used when the model is not affiliated with an agency or when the photographer is using nonprofessional talent. The smaller form is a voucher used when working with a model affiliated with an agency. This voucher contains a model release, and both the photographer and the model sign the voucher to confirm the hours worked, the fee, and the rights granted.

How has the agent's role changed over the years?

With the economy the way it is today, the agent is more important than ever. The photographer needs so much money to live . . . his overhead has skyrocketed, and unfortunately the fees have not kept pace, except for a handful of people, the superstars. The rep should get better prices, and that's why I'm annoyed at most of my fellow reps. We are in business to make as much money as possible, like any other business. We are fortunate in that we can take on more talent, but the talent himself is limited to how many hours he has in a day, so he must be helped by getting higher fees, and the reps have not been fighting as hard as they should be. The fashion field is murder because there are so many hungry photographers who will go against their best interests and take jobs at any price. But the real pro can charge more money because he is going to save the client money by knowing what he is doing and shooting in less time. Even if he saves an hour, he is going to cut their model fees. That's why they are happy to work with an experienced agent, because they know that the agent will not take on a talent without good reason.

Advertising and promotion are as important to a professional fashion photographer as they are to any type of business. Reproduced here are Farber's paid advertisements from The Art Director's Index *(far right, top)*, American Showcase *(far right, bottom)*, and The Creative Black Book *(right)*. There are a number of publications in which professional photographers advertise, and each claims a different situation and audience. The photographer must decide on an advertising budget in a businesslike manner.

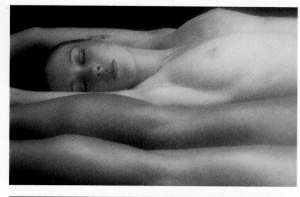

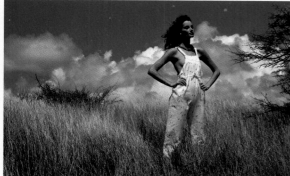

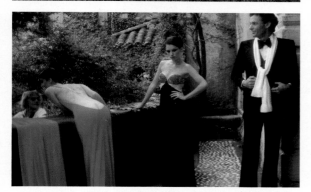

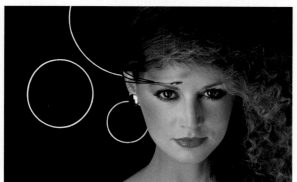

Unlike most of today's commercial photographers, Robert Farber's first public exposure was gained through gallery exhibitions, television interviews such as The Today Show, and his three highly successful books, Moods, Images of Women, and Professional Fashion Photography.

As a result, he was asked to apply his style to commercial projects for clients such as: Bally, Geoffrey Beene, Bill Blass, Bloomingdale's, Burlington, Caesar's World, Columbia, Cunard, Gillette, Givenchy, Ralph Lauren, Lever Bros., Master Charge, Max Factor, Monet, Nikon, Ortho Pharmaceutical, Paramount, Redkin, Revlon, Helena Rubinstein, Sassoon, Seagrams, Schick.

robert farber

New York
(212) 564-0031
London
240-5603
Paris
508-8698
Milan
80-39-64

Robert Farber
108

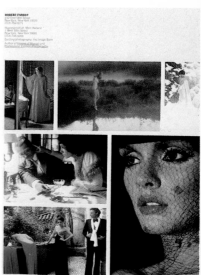

Larry Fried is executive vice-president of The Image Bank in New York, a stock photography agency he founded with Stanley Kanney in 1974, which now has twenty licensed offices in fifteen countries around the world. His distinguished career as a free-lance photographer began in combat during World War II, when he served as an army sergeant on the European front. Since he came to New York in 1950, he has had the rare distinction of shooting more than one hundred color covers for *Newsweek*, 200 covers for *Parade*, and 250 stories for *The Saturday Evening Post*, among his assignments for every major magazine. Fried is a three-time past president of the American Society of Magazine Photographers and the co-author of the society's guide to business practices in the profession, first published in 1972.

Who buys from stock agencies?

Advertising accounts for probably seventy-five percent of our business worldwide, publications and corporations for the rest.

How many photographers do you represent?

Between two hundred and three hundred. It fluctuates because I release photographers when we find out that we are not the appropriate place for them, even though we did think so when we signed them. It may turn out that they don't have enough of the right kind of pictures or the reaction from the clients wasn't too positive, or they are not happy with us because the results are not quick enough for them. We also add every year because we are constantly looking for new photographers. Periodically I go to Europe and throughout this country to talk to leading photographers and sign the appropriate ones.

What is appropriate for you?

Somebody who has a very large file of good individual pictures . . . not usually photojournalists, but rather photo-illustrators. If we could draw a composite image of the photographer, he would probably be in his late thirties or early forties with twenty years of background . . . he is successful and has a file of anywhere from 10,000 to 40,000 or more images available for us to look at, of which we will take a varying percentage. He expects to earn anywhere from

$5,000 to $100,000 a year with us and he is willing to sign a contract that gives us the exclusive right to market his file, which means that he cannot market them through any other selling medium. He can market them himself if someone comes to him directly and wants to buy a picture that is not a duplicate or similar to what we have. More than anything, he sends us pictures regularly. He can't make a deposit of photographs and just forget about it and expect to get interest. We have to have new material frequently to put in front of our licensed offices.

How does a photographer shoot for stock?

There are several ways of going about it. The most natural way is to find out from the agency you work with what is needed, what are the agency's clients looking for. Some photographers initiate their own projects, with guidance from us, and are making a great deal of money because they don't waste a lot of film. They know exactly what is needed and they go do it. For instance, it is very nice to take pictures of the autumn leaves in New England, but when shooting for stock, you should know that elderly people, well dressed and healthy looking, will outsell that a hundred times. The boy-girl thing, romping down some tropical beach, is also popular. The cliché pictures are still the ones that sell the most.

Do you get a lot of pictures from spin-offs of assignment work?

The bulk of the work we get comes from spin-offs of personal or assignment projects. When they were shot, it was not particularly with stock in mind. One of the problems I have is educating photographers to think in terms of stock. It is the best of all investments, if you think of it in terms of time and film and whatever other expenses it takes, and you pro-rate the return for the next ten years. A photographer can earn $2,000 to $3,000 a day on assignment. If he is also shooting for stock, and he knows what to shoot, he can earn an additional $15,000 to $20,000 for that day over the next year. We helped a photographer last year who wanted to shoot stock and went to Florida with 500 rolls of film. On assignment he could earn $10,000 in a week, or $30,000 in three weeks. From the stock shots he did there he has already earned that much from a week's shooting, and I would be surprised if in ten years those pictures didn't earn $250,000.

Are there many photographers who aren't earning money from stock sales who could be?

A lot of photographers don't realize what they are sitting on. They have to be reminded that they are in business, that what they have in their hands is merchandise. That's a crass way of talking about this art that we all love, but Picasso understood it and no one thought less of him as an artist when he died with an estate valued in the hundreds of millions. He knew the value of his work. I don't think it is necessary to starve in a garret to be a fine artist. Very frequently the widows and children of great photographers come to us. The daughter of a great, great *LIFE* photographer came in a year ago. The father had died and left very little money, but an entire room loaded with Kodachromes . . . forty years of photography of

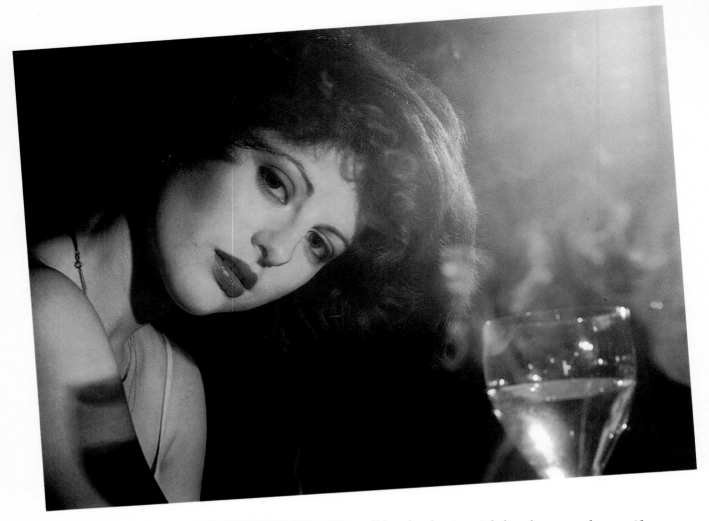

Although a shooting might have been set up for a specific client, the outtakes may later make good stock photographs. If the subject is beauty, and the look is not dated by clothing or identified with a particular brand name, the stock image can earn the photographer money for years to come.

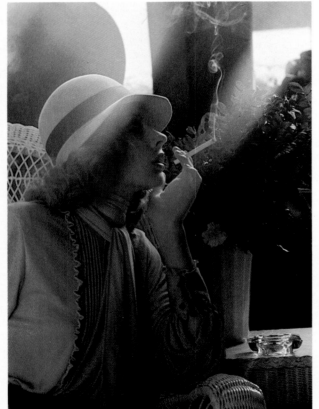

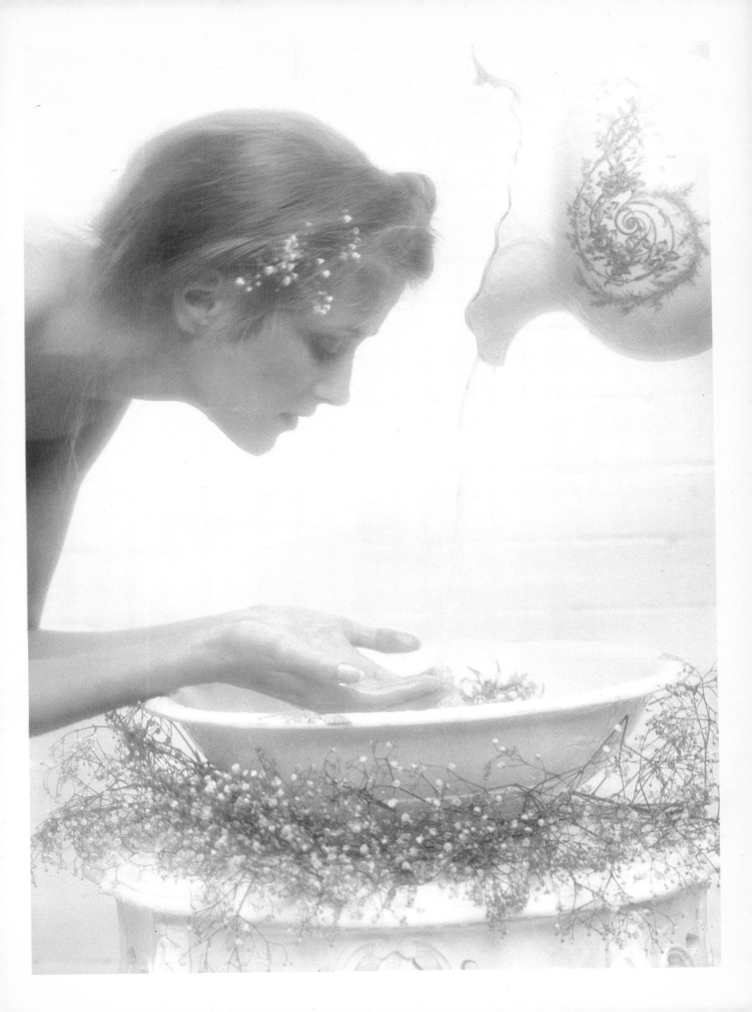

which about seventy-five percent were Kodachromes. It was not cataloged, not identified, no captions, just fabulous pictures. She brought in a few Kodak boxes to give me some idea, but she knew nothing about it. I started to look at this work and I was ready to cry, because none of it was identified. If it had been, the daughter and her sister and widowed mother could have had an income for the rest of their lives. We couldn't do anything with them because we didn't know who had the rights to what and we felt the legal problems would have been enormous, since our primary sales are in advertising, where you must tell the purchaser something about the picture such as whether or not model releases exist, etc. Selling a picture where maybe the rights had already been sold to a competing product could cause a lot of problems. We did tell them that if they could ever clear up any of this, then we would be interested.

What rights does the photographer have to sell photographs when he has taken them on assignment?

It is very important that wherever possible you only sell first rights and never sign a document called "work for hire." That is the catch phrase to get around the copyright act. Of course you can sign it, but you must realize that you are signing away your copyright, complete ownership of the pictures, to another party, and you never again have rights to those photographs. If they pay you enough, sure, but enough must be the income that picture could bring over many years. It's very short-sighted just to take the money up front because somebody offers it to you and you're not busy that day and you could use a few hundred bucks. But if you think ahead to the future and are practical about it, you can do exactly what you want to do and then have it pay off in the years you can't or don't want to shoot anymore. It's different if you shoot a box of Wheaties or anything that has strong product identification . . . that has no stock value. Then you give them any rights they want, as long as they pay you for it. Even if you went out on a quick assignment where you were shooting something that did have good stock value, but the client was willing to pay you $5,000 or $6,000 for a buy-out, then that's good business. Photographers ask me if they should never do a buy-out. Never is a long time. If the price is right, you are in business.

How important is it to get releases from the people you are photographing?

Very important, as long as you remember that no release will protect you if the photograph damages the person. We recently had an example with a well-known photographer who shot a wedding assignment for one of the biggest magazines. It was a full-dress wedding . . . beautiful girl in white, very handsome boy in tails, an all-American couple . . . you couldn't ask for better stock pictures. The photographer, being very bright, recognized this and got them to sign releases in front of witnesses, who also signed, as the form calls for. In return he gave them a full set of pictures. We

received the pictures from the photographer with his regular stock submissions. We were very happy to see them because it looked like a Hollywood production and we started to sell them. One of the clients was the advertising agency for a national company that was running a series of ads to show how they are interested in public welfare. The picture they used showed the couple as they were leaving the church and it came out in a full-page ad in national magazines against alcoholism. The copy line read something like, "Which of these people will become the alcoholic in the next ten years." The bride and groom came from very wealthy families and we heard directly from their lawyers asking us to cease and desist. Even though we had an ironclad model release, we instantly agreed not to sell them anymore, told the company not to run the ad again, and pulled the picture back. I only cite this to warn young photographers that a release is good to a point, but it doesn't protect you from a lot of things. If a client buys a picture and retouches it or crops it or injects something else into it, you could have problems.

Don't you have any control over how a client uses a picture?

No. All you can do is try to write it into the purchase order that the picture cannot be used in any other way than the way it was presented. But there is usually no right of final ad approval. Certain photographers may want to exercise that right, and they may have the authority to do it, but a picture agency can't do it.

What is the usual fee for a person who has signed a release?

It varies a great deal. If it is a professional model, they have their own rates, which can be anywhere from $75 an hour to several hundred dollars. It could be a royalty arrangement, ten percent on every sale of the picture paid to the model in perpetuity. Or a photographer will very frequently get a release signed just by giving copies of the pictures.

What are the possibilities for fashion photography in stock?

They are not too great because of the rapid changes in fashion. But most fashion photographers do a lot of beauty, and that is a very good stock category. The problem for the photographer is that he is usually working with professional models, and very few models and modeling agencies will sign releases for anything other than the job at hand. Many fashion and beauty photographers today are using unknown models who are willing to take a percentage, but certainly the top models are very hard to dicker with. A lot of photographers now, as I used to do years ago, are getting models from acting and dance schools when they shoot for stock. I had a whole group of drama coaches and dance teachers who would send young dancers and actors to me because they also needed pictures. Admittedly, they are not as easy to work with as professional models, but it is one way to do it.

The offices of a large stock house (like these of The Image Bank shown here) are designed to keep the thousands of photographs organized and easily accessible. These offices are outfitted with numerous light tables for the use of clients and staff.

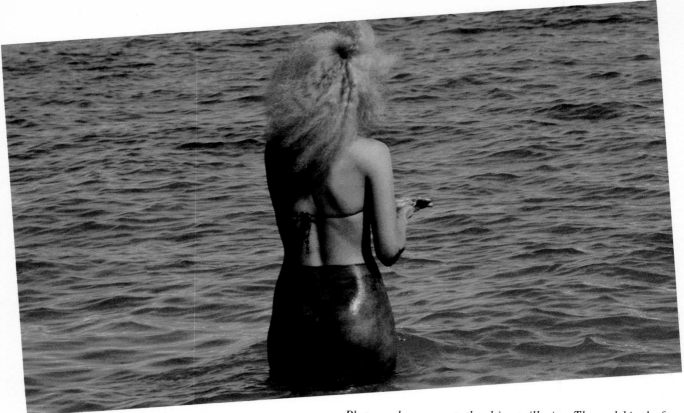

Photography can create the ultimate illusion. The model in the finished photograph on the right is wearing nothing but a pair of boots. The "jeans" were created by body-painting artist Stan Peskett for a client who wished to advertise that their jeans fit as if they were painted on. The painting started at 3:00 A.M. so that the shooting could begin promptly with the Jamaican sunrise. In the two pictures on this page, the model can be seen washing off the "jeans."

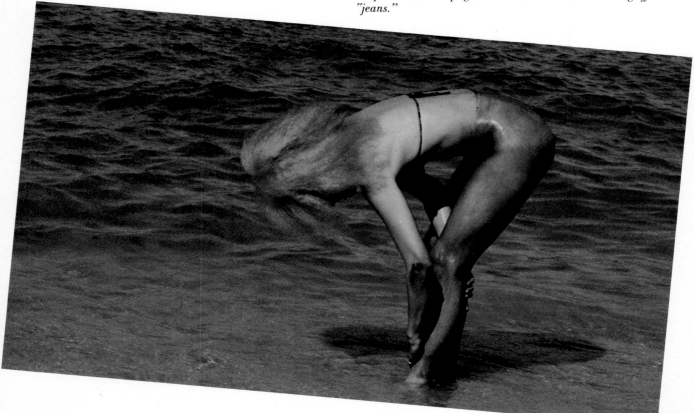

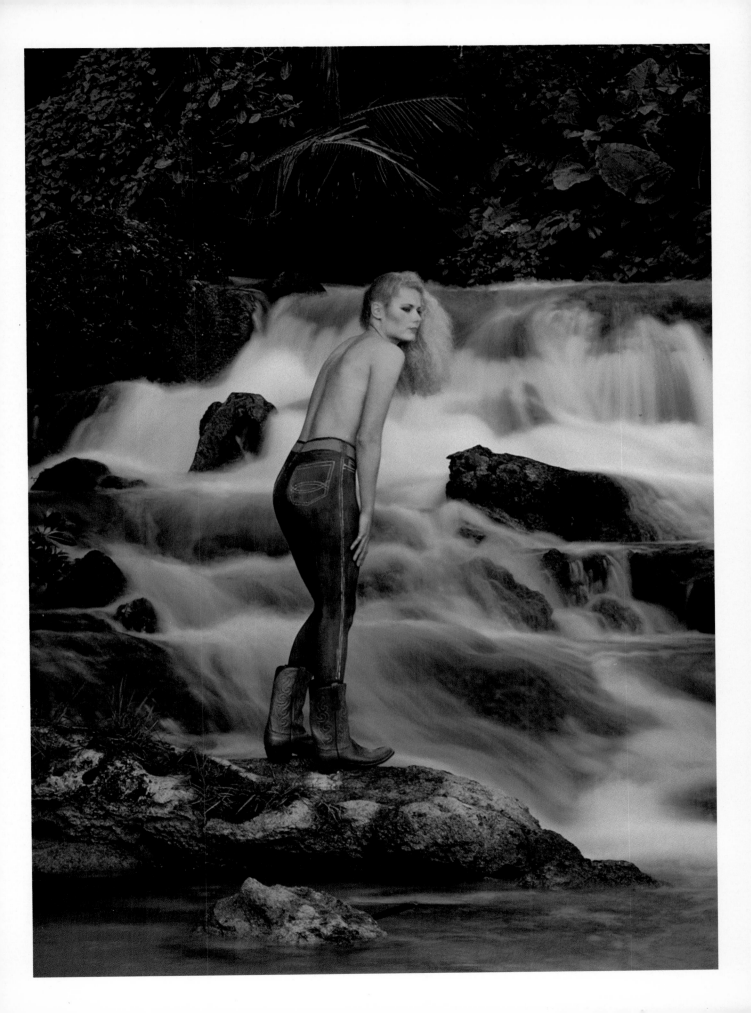

*What is saleable from the kinds of things
fashion and beauty photographers usually
shoot?*

They are interested in attractive people doing things related
to themselves and their environment. It can be done on
location, in the city or country or at a resort, or it can be done
in the studio if you have projection backgrounds or you build
sets. But the seamless paper type of picture is a thing of the
past for the moment and not too many of our customers are
interested in that.

*How do stock sales affect the market for
assignment work?*

A lot of photographers are concerned about losing
assignments if we prosper, but it never seems to work that
way. Any art director who wants to shoot is not going to buy
stock. He will want to go on the job, to supervise it . . . it's his
own idea so he wants to execute it. And there is frequently a
product involved which is new, so it has to be shot. Stock has
very little effect on assignments. What does have an effect is
recession periods. When they stop assigning the stock picture
business goes way up, because then they still need pictures
and something must fill the gap. Our prices for stock are not

cheap by any means. In fact, they are pegged, pretty much, on
what we would charge if it were being done on assignment,
but what the client saves is the two-to-one ratio of expenses to
fee, since everything is so expensive . . . travel, hotels,
models, and so forth. We started in the recession of 1974 by
design because we anticipated that people would come to us
when they cut back on assignments. But if someone wants a
picture of Hong Kong harbor at sunset, they would be foolish
to send a photographer when there are thousands of
photographs already. On the other hand, if someone wants a
specific model in a specific outfit in front of the Statue of
Liberty, of course he can't get it in stock. We have also found
that many buyers who were only marginal users of
photography have gotten into the habit of using good
photography after coming to us for stock, so we can have a
positive effect in creating new assignments. Also, the
photographers get terrific exposure to all our advertising
clients, who either come here or call and have pictures sent to
them. They see the work of all these people on a continual
basis, so the couple of hundred photographers we represent
don't constantly have to have exhibits at every advertising
agency—their work is exhibited every day.

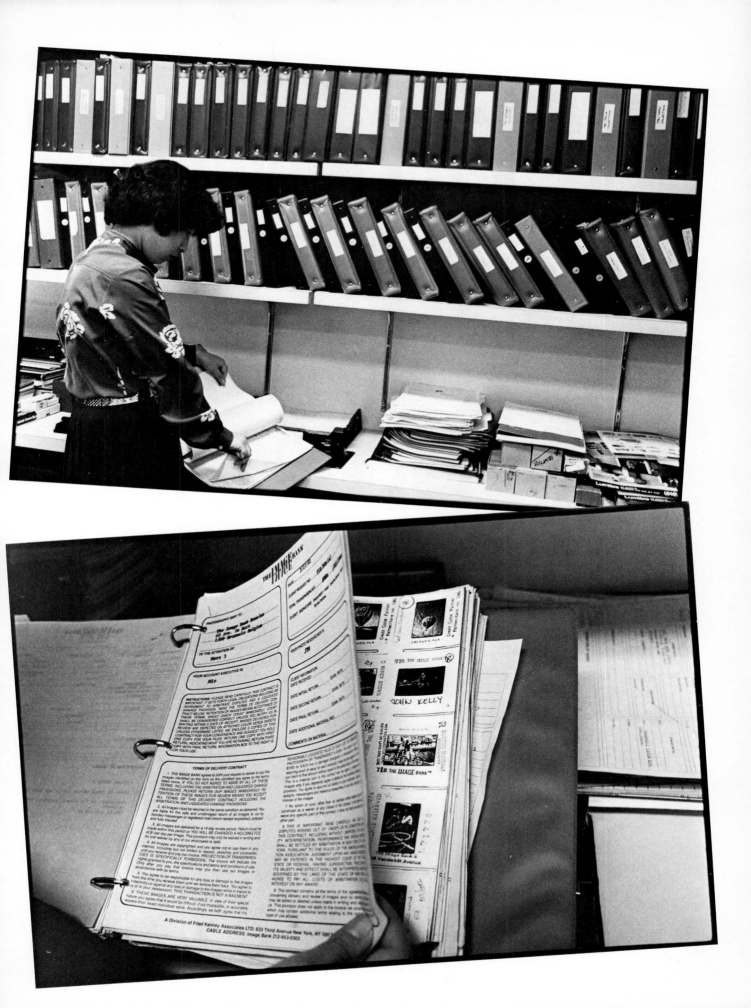

Three different combinations of lighting and processing were used for these three pictures. The picture on the facing page was taken with a combination of natural light and bare-bulb flash and was processed normally. The one on the top of this page is lit by natural light alone and processed normally. The picture on the bottom was also taken by natural light but was pushed two-and-a-half stops in processing to enhance the grain in the film. The overall softness of the image was created by a diffusion filter.

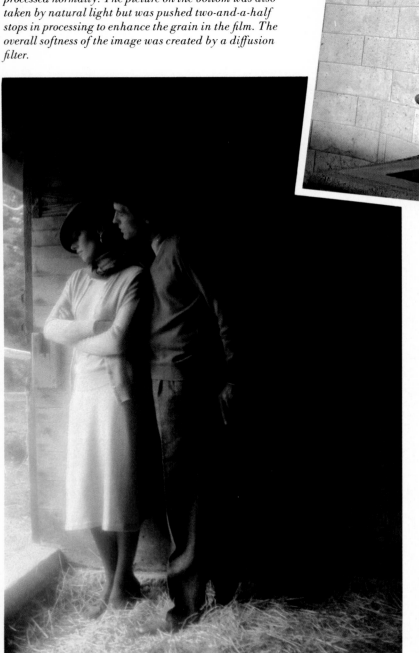

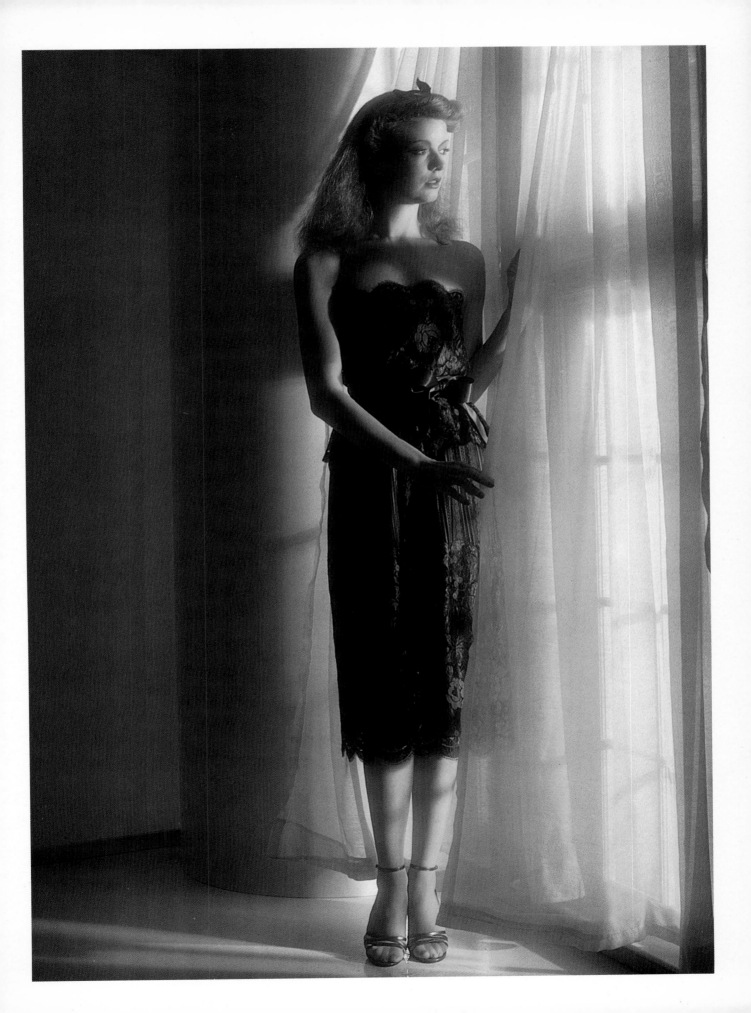

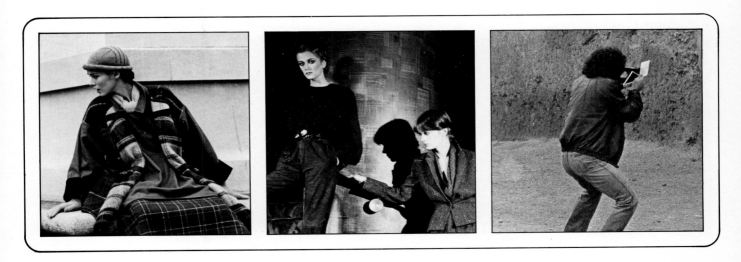

C o n c l u s i o n

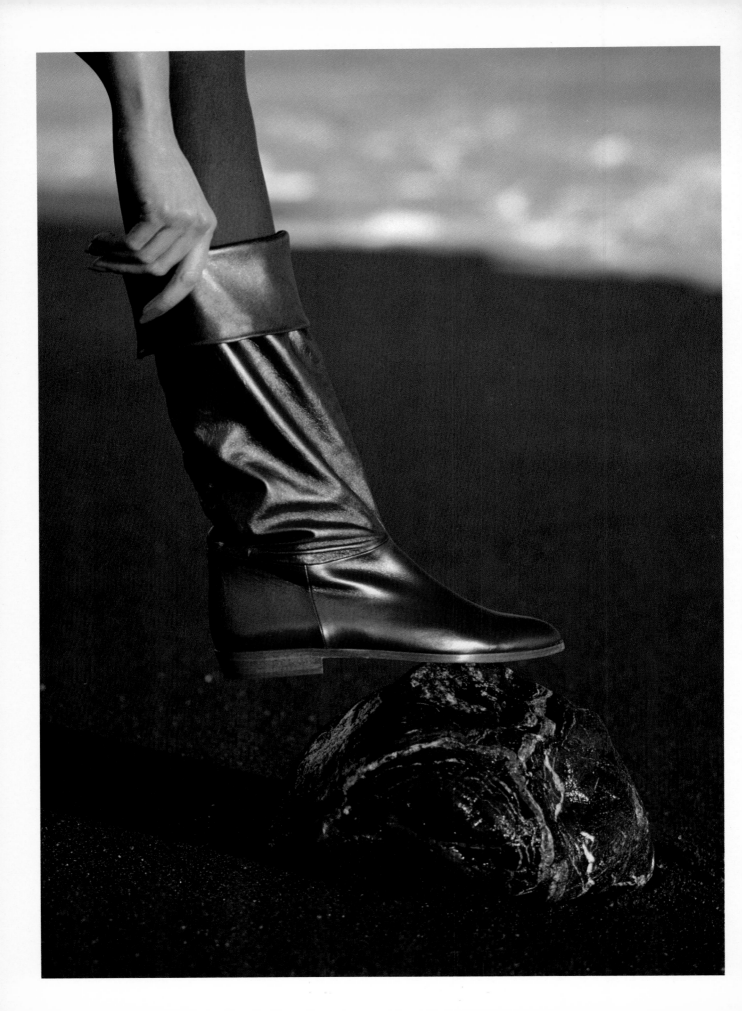

The role of the fashion photographer is deeply ambiguous, and that says more, perhaps, about the nature of the endeavor than anything else. As a function of promoting and reporting on products for consumption, fashion photography is intensely commercial, and yet it encroaches on art as does no other commercial medium, at times achieving an artistic status of its own. Its primary purpose is to sell, and yet it can transcend that purpose in a way that would be impossible in advertising cars or toothpaste. The traditions of fashion photography have depended on, but evolved separately from, the interests they represent. As a means of expression the medium exists, to a large degree, for its own sake. One is aware of the great fashion photographers—and for that matter, the great hair stylists, makeup artists, and models—quite apart from their connections with products being sold. Their work is valued for itself.

Fashion photography has always operated on the edge between art and commerce, as the distinction between editorial and advertising fashion indicates. This dichotomy accounts for the medium's creative vitality and for the fact that its most innovative practitioners have been among the finest photographers of the century, from Edward Steichen, Jacques Henri Lartigue, and Man Ray to the present giants of the field. The interdependence between art and commerce, an essential element since the beginning, has actually broadened as fashion photography has developed into a collective effort dependent upon the integration of a variety of disciplines.

In many situations the photographer and his team are simply highly paid technicians carrying out the client's preconceived plan. But the field as a whole could not flourish long on such a strictly programmed level. The life of fashion itself is based on changing concepts of beauty *and* practicality. It depends on a constant renewal of vision—on an imaginative transformation of the human presence that is far from superficial. Fashion imagery animates the mind's most fundamental aesthetic and emotional processes, those that affect the way we appear and relate to one another. In our time it is the fashion photographer who brings the complex interplay of color, form, and psyche into focus, offering a frame through which we can see an idealized and heightened version of our everyday reality.

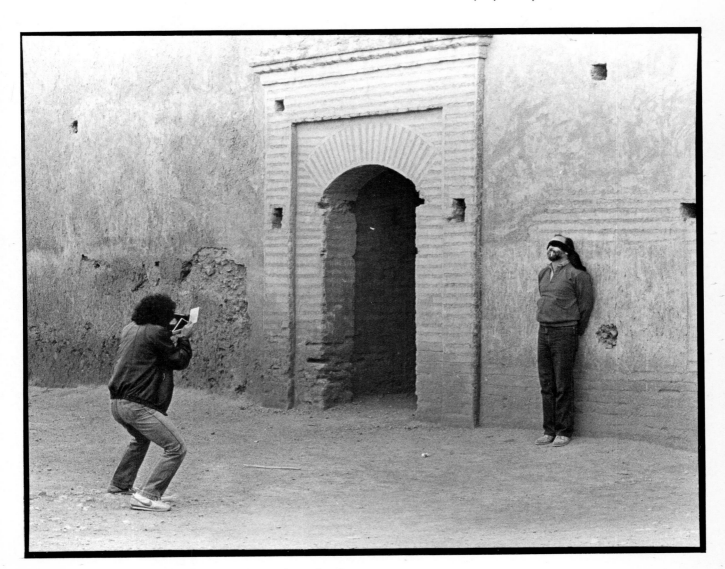

Just as in the rest of life, a little humor provides a welcome break from hard work. This picture shows the photographer "shooting" the creative director on location in Morocco.

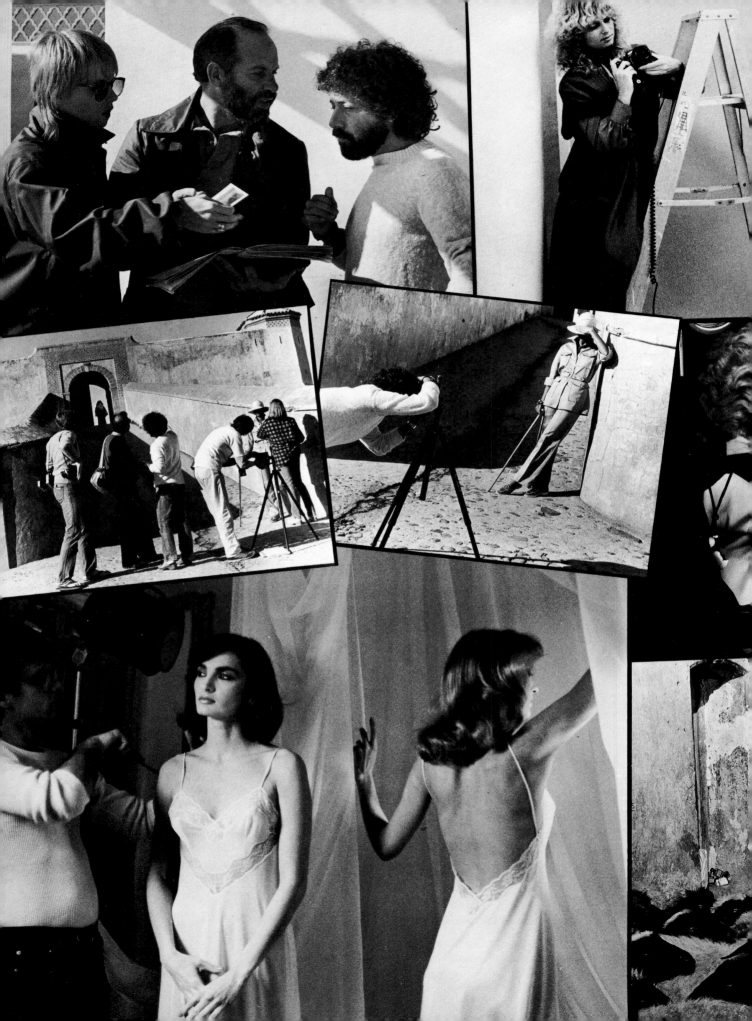

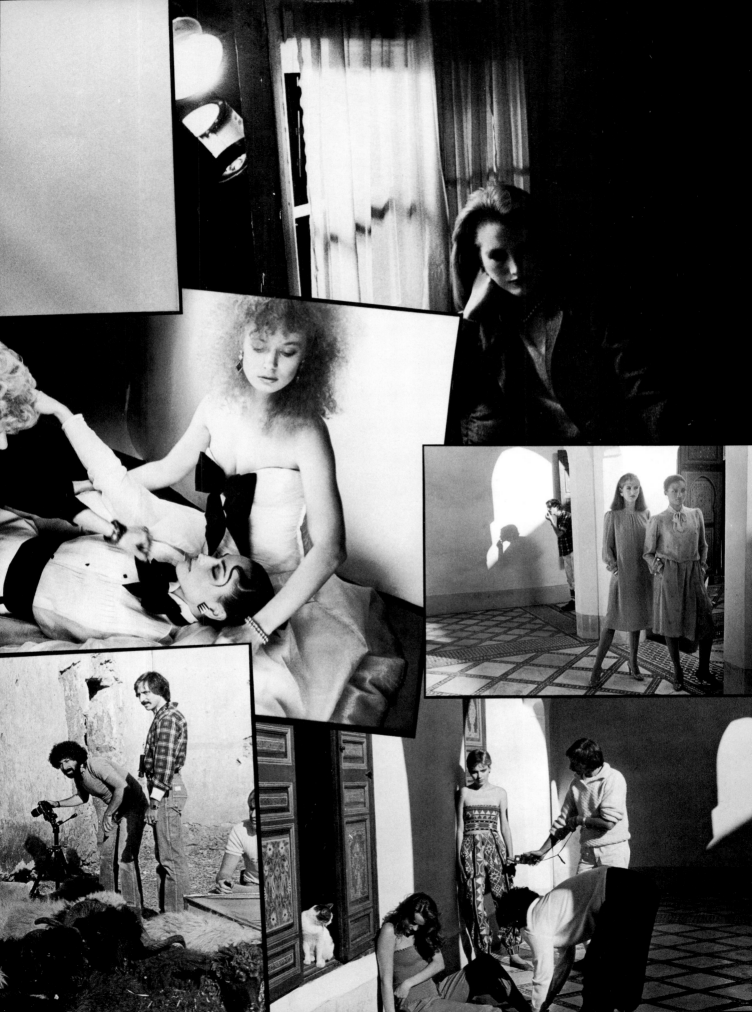

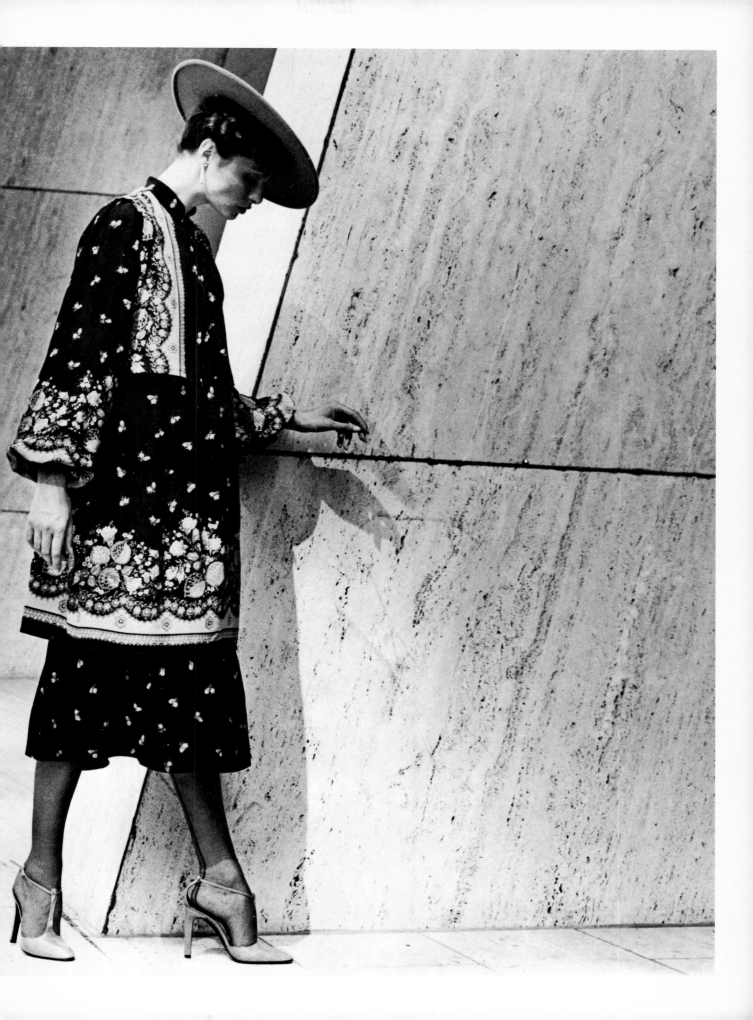

T E C H N I C A L N O T E S

The films used for the photographs reproduced in this book are as follows: Black-and-white photographs were taken with Agfa ASA 100 or ASA 400 35mm film and processed in Rodinal. Color images with a grainy appearance were accomplished with Agfachrome ASA 64 or ASA 100 pushed to ASA 400. All other color photographs were taken with Kodachrome 64 rated normally.

Black-and-white prints were made on Agfa Brovira BN111 paper.

The lenses I own range from 18mm to a 500mm telephoto. I use an $f/1.4$ 35mm, an $f/1.4$ 50mm, and an $f/2.8$ 180mm most often for fashion. For beauty I most often work with an $f/2.5$ 105mm, a 105mm macro, and an $f/2.8$ 180mm.

The studio lighting was done with Balcar/Tekno equipment. I use the Rapid 600 and Monoblocks. My favorite type of lighting is directional light. To achieve this with strobe I use the following Balcar accessories: Optical Spot, LB61 light box with a grid, LB80 strip light, or grid spots. For conventional soft light I use the Frabel soft box or Jumbo-2 zebra umbrellas.

—Robert Farber

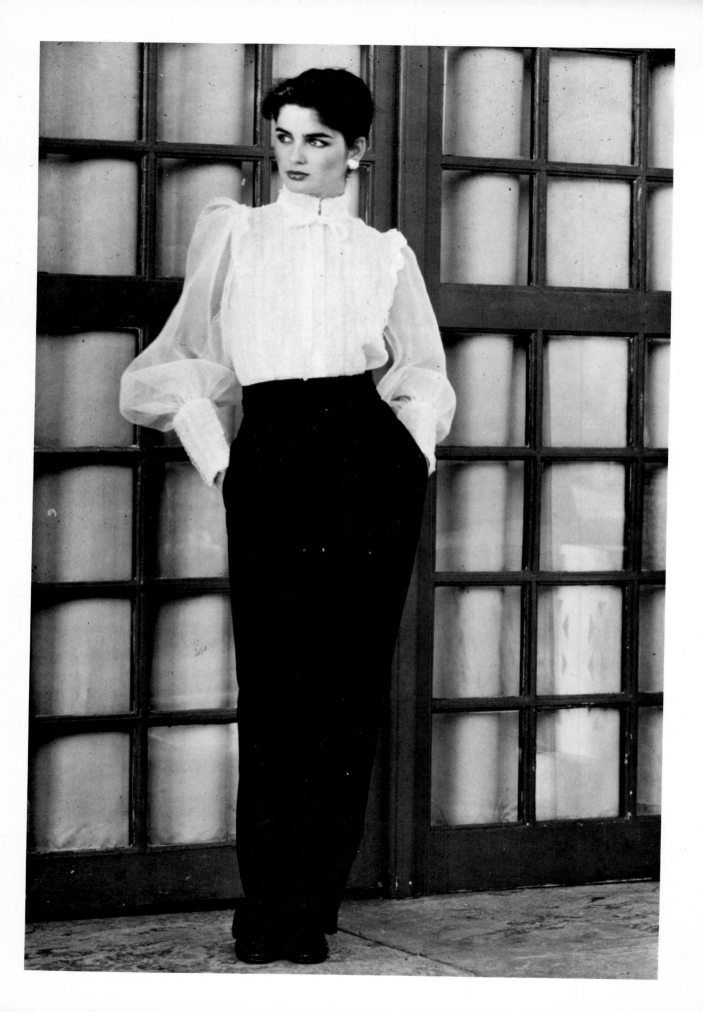

LIST OF MODELS

The following is a list of models as they appear in the book:

Edited by Michael O'Connor and Anne M. Russell
Designed by Brian Mercer
Graphic production by Ellen Greene
Typeset in Bodoni Book 10/11